THE POPULAR ARTS OF MEXICO

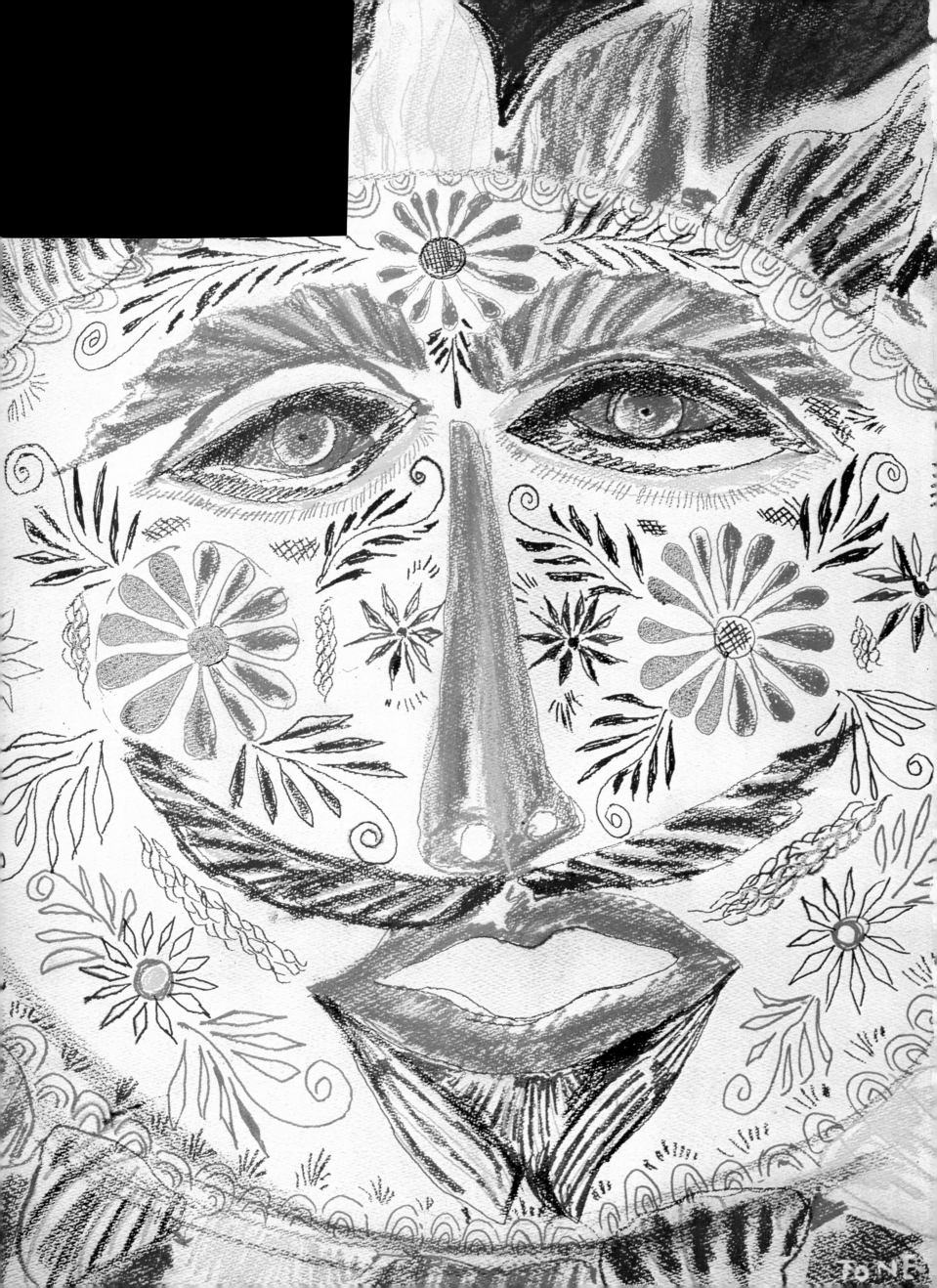

The Popular Arts of Mexico

BY

KOJIN TONEYAMA

with a foreword and notes on modern Mexican folk crafts by

CARLOS ESPEJEL

Director, Museo Nacional de Artes e Industrias Populares, Mexico City

Japanese text translated by

RICHARD L. GAGE

WEATHERHILL/HEIBONSHA
New York & Tokyo

This work was originally published by Heibonsha under the title *Mekishiko no Mingei*. Richard L. Gage translated and adapted the Japanese text written by Kojin Toneyama and, for the present work, Carlos Espejel contributed a shortened version of an essay he had written under the title *Las Artesanías Tradicionales de México* (The Traditional Crafts of Mexico), published in 1972 by Sep-Setentas, Mexico.

First English edition, 1974

Published by John Weatherhill, Inc., 149 Madison Avenue, New York, New York 10016, with editorial offices at 7-6-13 Roppongi, Minato-ku, Tokyo 106. Copyright © 1972, 1974 by Heibonsha, Tokyo; all rights reserved. Printed in Japan.

LCC Card No. 74-76105 ISBN No. 0-8348-1030-1

TABLE OF CONTENTS

NOTES ON MODERN MEXICAN FOLK CRAFTS, *by* Carlos Espejel

Photographs by Kojin Toneyama, Hideo Horiuchi, Toshio Ichijima, Susumu Wakizaka. Photograph on p. 18 courtesy of Museum of the American Indian: Heye Foundation.

LIST OF COLOR PLATES

82. Bead necklace with pendant silver fish, the *pescado blanco* found in Lake Pátzcuaro. Janitzio.

83–85. All Souls' Eve. Janitzio. Sketches by author.

86. Poncholike garment called *jorongo*. Janitzio.

87. *Inset*: Folk-craft shop. Tzintzuntzán.

88. Well-designed brushes. Janitzio.

89. Wooden figurine of old man dancing. Janitzio.

90. Wooden toys of a fishing boat called a *mariposa*, or butterfly, and a white fish. Janitzio.

91. Childlike brushwork depicting Golgotha on green-glaze pottery dish. Patambán.

92. Large green-glaze pottery plate. Patambán.

93. Green-glaze pottery water jug in the shape of a pineapple. San José de Gracia.

94. Pottery jugs in the square at Ichán, one of the "Eleven Villages" (*Once Pueblos*) in the vicinity of Lake Pátzcuaro.

95. Cloth doll. Michoacán.

96. Man and pottery vessel. Patambán. Sketch by author.

97. Wooden figurine and mask. Zirahuén.

98. Woodcarvings. Tocuaro.

99 and 100. Hand-wrought copper vessels. Santa Clara.

MEXICO CITY

101. Judas dolls, papier-mâché figures made for Holy Week. Mexico City.

102. Judas doll. Mexico City.

103, 104, and 105. Judas dolls in the shapes of skeletons. Mexico City.

106. Papier-mâché figures. Mexico City.

107. Papier-mâché skeleton musician. Mexico City.

108. Altar decorated for All Souls' Day. Mexico City.

109. Papier-mâché demon mask used in carnival time. Celaya, Guanajuato.

110. Papier-mâché donkey mask. Celaya, Guanajuato.

111. Painting decorations on a papier-mâché skull. Mexico City.

112. Papier-mâché monsters. Mexico City.

113. Dog and cock made of wire and papier-mâché. Mexico City.

114. Skeleton mariachis of wire and papier-mâché. Mexico City.

115. Demon pursuing skeleton newspaper boy; both are made of wire and papier-mâché. Mexico City.

116. Skeleton musicians. Sketches by author.

117. Two skeletons at cock fight. Sketch by author.

118. Small papier-mâché demons. Mexico City.

119. Hair ornament of horn. San Antonio de la Isla, State of Mexico.

120. Straw doll and wooden, fish-shaped noisemaker. Mexico City.

121. Toys decorating wall: bull's head, witch, bird, sombrero; on the shelf below: deer and charm. Mexico City.

122. Shop selling medicinal herbs and other remedies. Mexico City.

123. Talisman (*diablo*) against evil found in a medicinal herb shop; it is made of a dried and decorated stingray. Mexico City.

124. Small boy dressed in Indian costume for Corpus Christi. He sits in toy pony cart before the Cathedral in Mexico City.

125. Decoration for Corpus Christi. Parts of donkey's body are made of corn leaves. Mexico City.

126. Selling decorations and trinkets. Mexico City.

127. Indian kitchen utensils. Mexico City.

128. Symbolic grass-hut ornamented with flowers, pottery, and picture of the Virgin Mary. Mexico City.

129. Photographer's stall in courtyard of the Cathedral in Mexico City. Large picture on left is background for photographic portraits.

130. Children on festival day. Mexico City.

131. Small boy with festival toys tied to his back. Mexico City.

132. Sunday flea market. Mexico City.

133. Brilliantly colored sarapes, sold at Xochimilco in Mexico City, are a great tourist attraction.

134. Sunday market in Mexico City.

135. Fighting bull. Painting by author.

136. Impressions of carnival. Mexico City. Painting by author.

137. The Cathedral in Mexico City on festival night.

138. Seller of carnival masks in the Zócalo of Mexico City.

139. Man and two children in native costume performing Aztec dances in the Zócalo of Mexico City.

140. Paper cutout of cock playing a guitar. Mexico City.

141. Hanging lantern made of tin. Mexico City.

142. Colonial-style sunburst mirror; the frame is made of wood. Mexico City.

STATE OF MEXICO

143. Waterfowl in unfinished wood. El Naranjo.

144. Fork holder in the shape of a cat holding a mouse in its mouth. El Naranjo.

145. Basket in the shape of a rooster. Tequisquiapán.

146. Basket with lid. Toluca.

147. Basket. Toluca.

MEXICO CITY

148. The Museo Nacional de Artes e Industrias Populares is located in front of Alameda Park in Mexico City.

149. Large wooden dish with floral decoration. Uruapan.

150. Blue glass decanter and wine glass. Guadalajara.

151. Black-faced pottery dog and pig coin bank. Tonalá.

152. Figurine. Isthmus of Tehuantepec.

153. Carved eighteenth-century wooden candlestick in the shape of an armadillo. Chiapas.

154. Gourd ornamented with low-relief carving.

155. Carved coconut.

156. Earthenware lion. Metepec.

157. Pottery figurine. Acatlán.

158. Small figures representing bullfighters. City of Puebla.

159. *Left*: Small dish ornamented with rabbit and plants. Tonalá. *Right*: Nineteenth-century dish decorated with incised line patterns and paint. Hidalgo.

160. Nineteenth-century decorated chest. Olinalá.

161. Tiger mask. Guerrero.

162. Ceramic two-headed beast. Ocumicho.

163. Masks from Puebla and Michoacán. Old string instrument is from Guerrero.

STATE OF MEXICO

164. Doves at the entrance to potter's workshop. Metepec.

165. Terra-cotta sun mask. Metepec.

FOREWORD
by Carlos Espejel

Mexico has a great and ancient craft tradition. In the pre-Conquest period, which ended with the advent in 1519 of Hernán Cortés and his followers, the Indians of Mexico worked with almost all available materials to produce a wide variety of objects for daily use as well as for use in religious celebrations, fiestas, and dances. Vestiges of the abilities and the artistic sense of the early craftsmen can be seen in the works of their modern successors.

Some crafts, which survived the Conquest, were enriched through the utilization of new techniques brought by the conquering Europeans. In other cases, imported techniques became naturalized in the hands of local artisans, who gave them fresh forms of expression. In so doing, these artisans created a new and authentic Mexican folk art. Crafts that could not find a place in the lifeways imposed by the conquerors tended to disappear.

Today's crafts are neither completely Indian nor totally foreign: they reflect both their origins and later influences. Even in the humblest of crafts, the Indian spirit shows itself in form, color, or decoration.

Until not too long ago, the products of local artisans were well up to traditional standards, but in recent years various outside influences have caused a noticeable decline in workmanship. Folk-art objects have become popular with tourists and Mexicans, and the resulting demand has tempted some craftsmen to turn out more but inferior work. Moreover, as the country has become industrialized, many persons who were entirely or partly engaged in handicraft industries have begun to move into more profitable enterprises. Finally, the young no longer wish to dedicate themselves to traditional family activities, and this, coupled with the disappearance of the older master craftsmen, is gradually causing a diminution in the country's craft riches.

Those folk-art objects which are in the greatest demand today no longer fulfill their primordial functions for specific and well-defined social groups. Thereby they have lost their original purpose and have become status

items for those with money. One consequence of this is that the cost of folk-art items has gone up considerably; another is that popular art is no longer an art created by and for the common man.

I am quite sure that some of Mexico's crafts will disappear sooner or later. There will always be craftsmen and popular artists in the country, but I feel that today we are observing the last generation of authentic craftsmen.

Even so, craft activities are still very important. Thousands of families make their livings as craftsmen, and current production is entirely absorbed by the ever-increasing demand for folk-art objects. If one goes to an artisan's house, he will never find objects for sale: it is always necessary to place orders in advance.

Certainly, the problem facing contemporary craftsmen is not one of lack of market, since they can sell all they can produce. In my opinion, the two most serious difficulties faced by Mexican craftsmen today are low profit margins and outside interference in traditional ways of work.

In order to better his income, a craftsman may produce more or he may use raw materials of low quality. In either case, the artistic value of the finished product declines. He may also seek other kinds of work to improve his financial position, in which event he deserts his craft.

Due to the ever-increasing interest in folk-art objects, dealers, private buyers, and even casual tourists interfere with the natural production of the craftsman by making suggestions for modifications in technique or design that have little to do with the traditional ways in which the objects have been produced or used. This interference merely increases the problem of how to maintain the uniqueness of the traditional folk crafts of Mexico.

After the Mexican Revolution (1910), official circles urged a reappraisal of popular art, since those who made the Revolution were in search of Mexico's essential personality. But, even now, it is a difficult task to find ways to aid the large number of craftsmen who, if left to work in traditional ways, will produce only a limited number of objects and will remain poor. Nevertheless, unless we Mexicans find ways to promote and to preserve all that we have of value in the field of folk crafts, within a few years the crafts will vanish, and existing folk-art objects will serve the sad task of reminding us of an exciting past in which a part of our society had the time, the abilities, and the love required to make folk-art masterpieces.

I think the publication of this book on the popular arts of Mexico by Kojin Toneyama, painter and personal friend, is important. He has traveled throughout Mexico, and he has studied our ancient cultures, as well as our modern popular art. His profound admiration for the folk arts of Mexico is clearly reflected in this work. Perhaps this book will serve to remind us once again of the value of our own traditions and will encourage us to preserve a fundamental part of our cultural heritage.

AUTHOR'S INTRODUCTION

Friend, when I am dead,
Make a cup of the clay I become.
And, if you remember me, drink from it.
Should your lips cling to the cup,
It will be but my earthy kiss.
 —MEXICAN FOLK SONG

Mexico is a land of murals, folk art, fresh springs, time, memories; a land where those who dwell in rural areas can still live unsullied by the grime of our modern civilization; a land where men and women, descendants of the great Indian cultures that flourished before the advent of the conquistadors, continue to support folk arts that have their origins in pre-Conquest times. This book is concerned with those folk arts and with the lives of the people who sustain them. In paintings, photographs, and notes from my travel journal, I have tried to give the impressions I have gathered over many years of the individuals and communities responsible for the survival of the popular arts of Mexico. I have not tried to be all-inclusive; I think that I have touched upon the highlights, but personal predilections have, of course, influenced my selections.

The reader will note that I have sometimes ignored the exact limits of the three major geographical divisions under which I have grouped the paintings and photographs illustrating this book. For example, though the villages of Michoacán are found in an area overlapping western and central Mexico, I have included them all in the central portion and I have treated the regions along the shores of the Gulf of Mexico as part of southern Mexico. Omissions have also been made: it was with reluctance, for instance, that I excluded from this work the Yaqui, Tarahumara, and Seri groups of the northern part of the country. Perhaps at a later time, the omissions can be rectified.

I was first drawn to Mexico fifteen years ago because of my interest in modern Mexican painters. But after a time in the country, I found myself being captivated by a strange, older culture that was part of and yet apart from the contemporary Mexican scene. This essentially rural culture, for which no adequate single label exists, is basically a mixture of aboriginal and Spanish ideas and customs. (For want of a better term, one can call this culture "rural Mexican," as long as it is understood that some of its members have emigrated to the cities carrying with them their special traditions.) In the traditional art motifs and colors of rural Mexico, long distant

times persist in a mood of myth and magic, and an ancient aesthetics, which has much in common with modern art, including pop art, is discernible in spite of the remoteness of its origins and the relative lack of sophistication of its modern practitioners. Whenever I have the chance, I visit two special groups: the Huichol, descendants of the Aztecs, and the Lacandón, descendants of the Maya. In the designs they use, it is possible to trace aesthetic concepts that may be found in Miró, Chagall, and Picasso. I often refer to the old, yet new, Mexican folk art as "jungle pop art," for it is produced mainly in backward areas by uneducated people. It makes no difference, however, that the people who produce the art cannot read or write their own names: for them art and education are one and the same thing.

Though related to pre-Conquest techniques and traditions, modern Mexican folk art is not pure, for it has assimilated influences from the conquistadors and even from Asia. (The Talavera tiles introduced into Puebla in the sixteenth century show both Spanish and Chinese influences.) Consequently, major traditions have continued to exist but they have been modified and made multifarious.

Most folk art in Mexico is produced by rural families under cottage-industry conditions with women and children, as well as men, taking an active part in production. The way rural Mexicans live, especially in the highlands, is incredibly austere but it may be that this very premodern, primitive way of life is the support on which rests the charm of the popular arts of Mexico. Perhaps nature, so severe in the eyes of others, is a natural fortress protecting these people from the encroaching waves of modern civilization.

During my travels in Mexico, I have learned a number of interesting, sometimes profoundly moving, things. I have seen how climate, natural setting, and history can inspire a people to treat the subject of death with humor. I have also seen a violent and rich sense of fantasy born of poverty. On a technical level, I learned, during my stay in the village of Tzintzuntzán, Michoacán, the secret of the wavy lines made on the local pottery: they are the result of using homemade brushes tipped with squirrel and donkey hair. I was also surprised to see how sophisticated items, such as the fanciful terra-cotta figurines made by Teodora Blanco in Atzompa, Oaxaca, can be made with exceedingly primitive tools and kilns. But perhaps the most personally enriching realization in all my wanderings over the highlands, mountains, and plains of Mexico was the encouraging assurance that, in the flood of the machinery-first, technologically oriented ideas of our world, there is still a place where human hands, eyes, and brains are given precedence.

The popular arts of Mexico, while preserving tribal, cultural, and aesthetic individuality, belong to one vast current of traditional art. Therefore this book is not intended to be a catalogue of Mexican folk art: instead, it is a work devoted to the overall tradition as seen through the eyes of a twentieth-century artist.

From the
Author's Journal

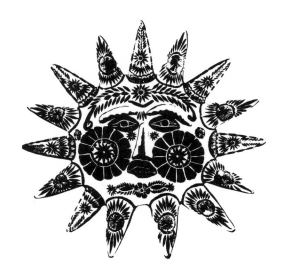

NAYARIT

The Huichol. Direct descendants of the Aztecs, the Huichol people suffered invasion by the Spanish in the sixteenth century; but instead of submitting to the conquerors, they chose to flee to a remote mountain region in the northern part of the state of Nayarit. For a long time they persevered in their dislike for outsiders and in their adamant resistance to contacts with Spanish culture. In 1722, however, the conquerors finally got the upper hand, and soon Franciscans and Jesuits established churches in Huichol territory. Even today a crude statue of Jesus dating from the eighteenth century remains in the church of the village of San Andrés. Still, Spanish influence never overpowered native traditions. Continuing to force a living from a severe climate on land located 2,000 meters above sea level, the Huichol still maintain faith in a number of ancient local gods. They live largely on corn and produce strikingly colorful folk-craft objects and beautifully ornamented native costumes.

Indeed the clothing of the Huichol people vies for excellence with any in Mexico. In primitive mountain villages, Huichol women weave and embroider richly colored hats, sarapes, a kind of shoulder bag called a *bolsa,* and belts, or *fuyame,* from which are suspended small red bags. The trousers of Huichol men are decorated with embroidery patterns representing birds, corn, and deer. On their feet they wear leather sandals called *huaraches.* The women adorn themselves with brightly colored necklaces.

For many years I had longed to visit the Huichol people, who are almost living folk objects themselves. I had been especially captivated by a talisman made by them and called the Eye of God (*Ojo de Dios*). This oddly modern-looking object (Figs. 1 and 16), composed of diamond-shaped patterns in colored woolen yarn attached to wooden-stick crosses, is used to ensure abundant food and healthy growth for children. This talisman led me to some intriguing speculations on the cultural affinities between North and South America, which I shall

Eye of God talisman. Nayarit.

discuss more fully later. Here let me say only that the geometric forms and color combinations employed resemble those used by North American pop artists. For those of us who have lost religious faith, this Eye of God, a fine example of jungle pop-art, is very moving.

The beautiful folk motifs created by the Huichol are more than ornamental, for they are intimately related to incantations and prayers to the numerous tribal gods, some of which are animals. Because it is thought to run from east to west, the deer is a manifestation of the sun; it is therefore a good god. The snake, on the other hand, is crooked, like rivers, and is thought to represent lightning and mountain roads; it is a bad god. The rabbit is believed to symbolize the moon. (This is an interesting parallel with Oriental tradition: the Japanese too call the figure vaguely outlined on the surface of the moon a rabbit.) The hawk is a benign divinity associated with the sky. All of the designs embroidered on Huichol clothing—including corn, deer, birds, and many others—have religious significance.

Huichol women make gourd vessels (Figs. 18–20) ornamented with elaborate designs in red, yellow, white, and blue beads. A coat of beeswax is applied to the interior of a vessel, and a woman, picking up beads on the point of a needle, presses them into the wax, which holds them in place. Although these people have never seen or heard of Picasso, Miró, or Chagall, the designs they create have a loveliness approaching the moods of the works of these and other modern masters. It takes from a week to ten days to complete a beaded bowl.

One of the most important rituals of the Huichol involves eating peyote, a small cactus the liquor of which induces colorful and vivid mental visions that seem to alter the world of reality. The Aztecs also used peyote, the pure principle of which is mescaline; through its consumption they believed they could win the favor of the gods and foretell attacks by enemies. It is said that they went so far as to wage wars for the sake of obtaining peyote. Not only is peyote a psychedelic; it is also a tonic. The Huichol argue that, after eating peyote, it is possible to travel for as long as five or six hours in the mountain heights without drinking or eating and without becoming tired. In all likelihood, they associate the bright colors of peyote-induced visions with their gods.

Visit to San Andrés. For a long time, my attempts to reach the Huichol country met with frustration at every turn. Indeed, I could not even buy an adequate map of the state of Nayarit. The Huichol villages are located in rugged and mountainous terrain, which is dangerous for the lone traveler. The nearest large city, Guadalajara, Jalisco, is about 300 kilometers from the settlements. It is true that air transport as far as Guadalajara is available, but from there to Tepic, Nayarit, where short-distance biplanes can be hired, it is necessary to rely on bus, horse, or shank's mare. Many difficult mountains and valleys must be traversed, and in the course of the trip, many nights must be spent out-of-doors. To make matters worse, native guides are usually unobtainable, since the Huichol are an inward-looking people who dislike associating with outsiders.

But the outlook for a possible tour of their villages brightened in mid-November, 1966, when, after an absence of seven years, I arrived again in Guadalajara. My original purpose in visiting the city was to examine the splendid new Jalisco Folk Art Museum, which had recently been completed in a corner of Agua Azul Park. Working at the museum then were three young Huichol men, a former chief named Pascual, and his wife. They all lived in a bedless, second-story room in the museum. The same room served them as a workshop where they made such traditional Huichol folk-art objects as pictures in woolen yarn (Figs. 4–13), Eye of God talismans, and woolen hats. To amuse themselves, from time to time they beat drums, played a homemade violin, sang, and danced.

I made almost daily visits to their workroom to sketch and to record their songs on a tape recorder, one of the modern devices that caught their attention and opened a way to the development of friendly relations. Although all of them have Huichol names, in Guadalajara they were called by Spanish names. The oldest of the younger men was dark-faced Jesús Valenzuela Ortiz, who was twenty-seven years old and married. Tall Julio Valenzuela Ortiz, a skillful maker of wool-yarn pictures, was married and twenty-five years old. The youngest

was unmarried Tiburcio, who was only twenty-one. As our relations grew increasingly amicable, I told the young men of my plan to visit some Huichol villages and asked if one of them would go with me. Finally it was decided that Tiburcio would return to his village of Santa Catarina and take me along. On the day before our departure, Jesús recorded a tape message to introduce me to the chief elder and the other occupants of the fifteen houses in the village. Then, with a tense look on his face, he went on recording, speaking to his wife, his mother, and his father. He ended with a song. As a souvenir for his parents, Tiburcio purchased a radio: sound was to carry something of modern civilization into remote Mexican mountains.

The director of the folk-art museum, Jorge Ramírez Sotomayor, wrote a letter of introduction on my behalf. Moroji Kumazawa, a nisei born in Guadalajara, was to go with us to interpret. We bought razors, blankets, scissors, mirrors, and kitchen knives to present as gifts.

At nine in the morning of the day on which our journey began, I visited the museum to find everyone but Tiburcio asleep. He was working on a wool-yarn picture. Only thirty minutes remained till departure time. I tried to hurry him, but he told me to wait a little longer: he could not stop working yet. I then said that I would wait for him at the nearby bus terminal, which I did. But he did not turn up. Virtually a split second before the bus departed, Jesús arrived bearing Tiburcio's luggage but otherwise quite alone. What had happened? I do not know, but these young people seemed to have no conception of time.

The bus was about to leave, and still no Tiburcio. So, in spite of his vigorous resistance, I dragged Jesús on board. Immediately the bus started out towards Puerto Vallarta.

The weather was fine. The mountains were visible, and golden butterflies danced over masses of yellow flowers blooming in the grass plains. As the bus raced along, insects bounced off the glass of the windows. While still in Jalisco, we passed through Tequila, in the region famous for the drink of the same name, and Magadalena, noted for its opals. Finally, we arrived in Tepic, the base of departure for visits to Huichol villages. In the evening of the same day, wearing a big grin, Tiburcio appeared at my hotel with Kumazawa. He was exasperatingly unperturbed about having missed the bus. Later, acting on the strength of what Jesús had told me, I searched here and there in the village until at last I found the pilot of a Cessna and chartered his plane and his services for the next day.

Our party the next morning consisted of myself, Tiburcio, and Kumazawa. Because of bad weather, we could not put down at our intended destination of Santa Catarina; instead, we were forced to land at San Andrés, a village located on a mountain highland. The runway was a partly cleared field, dotted here and there with pine trees; the settlement was small.

After we landed, a man and a child came to meet the plane and led us to the village schoolhouse. The child was one of the school's pupils, and the man his teacher. The latter, a Huichol, lived with his wife in the schoolhouse.

When we had deposited our luggage in the school building, the teacher took us on a small tour. We looked into a thatched-roof temple, and saw the building where the village elders pass judgment on lawbreakers. Behind this building was a smaller one; it functioned as a jail. Inside the jail, the floor was of earth. In the center of the prisoners' room were the two halves of a large split log. One half had a number of deep grooves cut into it. A prisoner is forced to put his ankles into two of the grooves; the other half of the log is then laid on top of its mate, adjusted so that the two halves fit neatly together, and the whole is then secured by a bolt. The fettered prisoner is left alone in the pitchy darkness to repent his sins. In an open space in front of the jail is a stake to which offenders are bound for whatever time is specified in the sentences passed down by the village elders. Punishment for violation of the village's rules is decidedly severe.

While explaining local customs, the teacher also mentioned the names of some of the more than fifty Huichol gods, all of whom are nature deities. The names were pleasant to the ear: Takauchi Nakaue, god of the universe; Tayo, god of the sun; Ariwame, god of rain; Tate Haramara, god of the sea; Tate Wari, god of fire; and

Takuchi, god of the earth. Stone images of the gods are kept in a craggy, mountainous place, but we were unable to visit it, since the trip there would have taken several days.

The teacher also spoke of a festival that was to begin that night and last for several days. He suggested it might be worth attending. So, while the afternoon sun was still high, we set out for the festival site. A young man, who doubled as guide and porter, carried luggage and boxes, some of which contained offerings for the gods. First we crossed a plain of dried grass; then, after walking through a forest of pines and oaks, we traversed a wooded valley. The only sounds we could hear were those of the wind rustling in the pines and the murmuring of a nearby river. Pine cones as large as a man's head lay in the powdery red dirt under the huge trees. The air was clear and fresh. But the place was not without its dangers. There are not many coyotes in the region, but snakes abound. Still, the most dreaded creature is the scorpion, whose sting causes intense pain and may result in death within a few hours. As a precaution against this, the schoolhouse in San Andrés is always stocked with an antivenom serum.

As we walked along, we suddenly heard a choked sound that seemed to come from a stringed instrument. Imagining it to be part of the celebration, we thought we were near the festival site. But, suddenly, to our surprise we saw a lone young Huichol walking along the road playing a homemade violin. He gave us a chance to witness the charming way the local people greet each other. Just as the violin player came into view, an elderly man happened to appear. The young man removed his hat and bowed; the elderly man stretched out his hand and placed it lightly on the youth's head.

Finally, we arrived at an arid grass plain where the celebration was to be held. In the distance was a range of mountains that seemed to change color with each passing minute. We could see that preparations were in full swing, and smoke rose from the thatched temple building where the festival would begin. In front and on both sides of the temple were small, open, pavilionlike buildings, in the innermost of which women and children had already gathered. The first person to raise his hand in greeting to us was a man with unkempt hair who looked startlingly like my idea of a demon. When I took out my camera, the man grew visibly agitated. My guide quickly informed me that I must refrain from taking photographs as the Indians feared the camera would rob them of life force.

After the sun had set and while twilight still lingered, silently from the forest and plains around the temple site the people of the village began to assemble. The men bore offerings, and the women, whose faces were painted for the occasion, led or carried their children. A closer examination revealed that the men too wore red-paint circles on their cheeks. Some had added flower patterns in white paint inside the circles. In addition to people, dogs and cattle attended the festivities.

When it had grown completely dark, torch bearers appeared. With the arrival of night, the air grew colder, and young and old gathered around the several bonfires in the open space in front of the main building. Women were busy making tortillas, the main fare of the evening. The more leisurely men sat around the fires drinking a potent liquor called *tepe,* smoking homemade cigars, laughing, and joking. Many women were grouped at a fire near the temple building but they never drew near the men.

From time to time, however, some of the men approached us to ask for cigarettes. The middle-aged demonlike man I mentioned may have heard of the offerings that we brought, for he came repeatedly to proffer liquor and tortillas and to insist that we "have a drink." I tried tepe and found it to be something like a Huichol version of vodka. At the first sip it produces a sensation of cold throughout the body; then the stomach suddenly seems to be on fire, and the hands and feet seem to glow with warmth.

As mountain goats tied in a nearby grazing place bleated in the night, dogs wandered around the bonfires sniffing and begging for odds and ends of food. Finally the festival got under way. It was the celebration of the final corn harvest of the year (Figs. 25–30).

What I have been referring to as a temple was in fact little more than a circular thatched hut with an earth

floor. In the center of the room a fire burned. The elders of the village occupied benches, the chief was in the center, and many old men, women, and children sat on the ground around them. The elders began a recitation by intoning a verse and the men seated around them repeated it in chorus. The choked sound of a homemade violin, very much like the one we had heard on the road, accompanied the monotonous, long, but rhythmical chanting.

As the fire in the middle of the room filled the hut with light and illuminated the faces of the participants in the festival, the chief offered liquor to the elders, who, after drinking, returned the courtesy by offering the cup to the chief. The leading reciter gradually became caught up in the passion of his text until he was totally entranced by the verses, which were part of a lengthy epic recounting the past glories of the tribe. The singers reminded me of the Ainu, a people of the Japanese island of Hokkaido, who chant epics called *yukara* at their festivals.

Periodically, women with candles in their hands went out of the hut to make incantations under the starry sky. At a stake in the middle of the open area was tied a bull destined to be sacrificed to the sun god in gratitude for the corn harvest. Another sacrifice was to be made involving a mountain goat. The striking black-and-white piebald bull, clearly visible even in the dark, seemed to sense approaching death: for a while he resisted being tied. Men intoning chants and women holding candles formed a ring around the bull. But his time had not yet come.

In what seemed the middle of the night—actually ten o'clock by my watch, which I checked by the light of the fire—the small mountain goat was suddenly surrounded by a group of shadowy human figures, the most important of which was the *marahacame,* the shaman who would kill the animal. And equally suddenly the animal's last cry melted into the night in a long thin trail. The shadowy people continued to chant, and then a single burst of fireworks shot into the dark sky.

After two nights of continuous chanting, it appeared that the festivities were gradually moving towards a climax. Scrawny dogs rummaged for food. Some people slept, some talked, others poked into fires. As dawn approached, women began preparing tortillas. Children milled about the fires in a strange mood of excitement. Feeling very tired, I stretched out full length on the red earth—the first time my whole body had come in contact with that ground—and looked up at the myriad stars glittering in the sky. They seemed very close; a falling star flashed a trail across the blackness. Women with candles formed a group around the sacrificial bull and adorned his forehead with flowers. The first light of the day on which the handsome bull would be offered to the sun drew closer.

Even after sunup, chanting, drinking, cigar smoking, and scraping of the violin continued. Finally, at about five o'clock, copal gum was lit in front of the elders, and a man began to play on a drum covered with deerskin. To dry the moisture in the drumskin and thus to adjust its tone, someone occasionally thrust a torch between the legs on which the instrument stood. The voice of the main chanter grew more intense and higher as his intoxication advanced to a new stage.

As if in answer to the Huichol prayers, the sun did not forget to rise. Soon pink light glinted off the chill dew on the grass of the fields. I stepped out of a hut into the unforgettable morning air as golden shafts of sunlight brought new life to the entire scene. Still the voice of the entranced chanter floated from the temple hut. The stars faded, leaving an incredibly clear blue sky. The handsome bull at the stake was still alive and hale.

Upon hearing a strange noise, I turned to see a young man on a chestnut horse dashing from the pine forest. Galloping to the front of the temple, he leaped agilely and quickly from his mount and, removing a white blossom from his mouth, presented it to one of the elders. The flower is called *vela de noche* (candle of the night) and it is said to give off an aroma only at night.

A children's festival took place in the blazing heat of midday. A circle of young children sat on the ground around an Eye of God. In the center of the circle, the chief, a fat man wearing a hat adorned with squirrel tails,

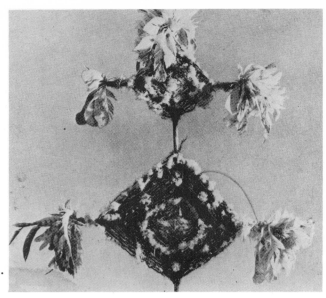

Ritual object. Central Australia.

sat and played a deerskin drum. As young men in hats trimmed with feathers joined the participants, someone accompanied the chief's lengthy recitation with maracas.

At last, when the sun reached its zenith, the shaman and his helpers killed the sacrificial bull and offered its blood to the divinity. The flesh of the bull and of the goat was parceled out at the conclusion of the festival, to become an important part of several meals for a number of families.

Festivals are an essential part of the lives of the Indians of Mexico. Indeed, they cannot imagine life there without them. This celebration of the final corn harvest announces the end of autumn, but it does more. It recalls memories of the Aztecs, who offered living human hearts ripped from the breasts of sacrificial victims in the fervent desire to strengthen their gods.

Riddle of the Eye of God. My first trip to Mexico was made in the summer of 1959. As I have noted in the Introduction, I was originally interested in seeing the country itself and in examining works of painters inspired by the Mexican Revolution, such as Diego Rivera, José Orozco, and David Alfaro Siqueiros, and of others like Rufino Tamayo. As I wandered through jungles and over mountains, however, almost without being aware of the shift in my own emphasis, I began to take a deeper interest in the fantastic image of Mexican culture of the remote past. In some parts of the country, there are ancient temples, stone monuments, and idols ornamented with glyphs and patterns so complicated that they seem to be some kind of puzzle. In the vicinity of these relics, many Indians continue to live lives not too different from those of their ancestors who raised the monuments. The Oriental shape of the bone structures, the sunbrowned skins, and the glittering black eyes of the people captured my attention, as did their distinctive costumes, clay vessels and images, and the occurrence of the Mongolian spot in many of the children. The Indian languages, customs, and the very thatched houses in which they live inspired in me, a Japanese, a sense of racial affinity. In my eagerness to continue studying the culture and art of these people, I traveled all over Mexico, into Guatemala, and Honduras. In 1970, just before an exhibit I held in Mexico, I went as far as South America.

During this trip I paid a visit to the Amano Museum, next door to the home of Yoshitaro Amano in Lima, Peru. After the visit to Professor Amano, I also called on a private museum on Calle Bolívar in Lima, and while there I happened to discover something that struck me as interesting. At the head and foot of one of the mummy bundles, a typical relic of the Incas, I discovered a number of crossed sticks decorated with woolen yarn in what was a very close approximation of the Eye of God talismans made by the Huichol. I never suspected that the Incas had used this object in their mummy bundles. But I recalled that the year before, at an exhibit of folk art held at the Tokyo National Museum, I had seen a somewhat similar object—ornamented with feathers—produced by the natives of central Australia and part of a collection brought to Japan from Cologne. Instantly I was struck by a line of cultural tradition represented by the Eye of God. The line stretched from Mexico, through Peru, and to Australia. Furthermore, I could not imagine that the distribution of such a simple artifact over a wide part of the Pacific area could be entirely accidental.

Human beings first appeared on the American continents near the end of the great ice age, when the level of the seas dropped, making it possible for primitive Asiatic peoples to cross from Siberia to North America by way of what is now the Bering Strait. Waves of people, now seeking warmth and going farther south, now turning again north, made long, slow treks over beaches, isthmuses, and mountains, eventually populating both North and South America. The first wanderers in the New World lived by hunting and gathering. Beans were cultivated as early as 5000 B.C. in Mexico, 3000 B.C. in Peru. Corn made its appearance in Mexico around 3000 B.C. and in Peru around 1500 B.C. A settled agricultural way of life meant that men could craft and build. They began making pottery vessels for daily use, then pottery idols, and, later, stone temples as places for important religious rituals. During the last millennium B.C., religious fervor and activity reached a peak in the creation of huge centers of worship like those produced in the same age by the mysterious Olmecs of the Gulf of

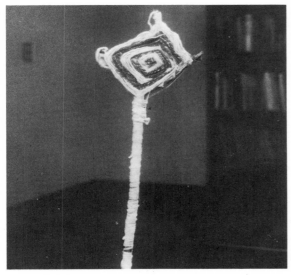
Object found with a mummy bundle. Chancay, Peru.

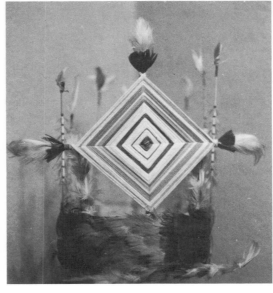
Amazonian Indian headdress.

Mexico and by the Chavín people, whose massive and powerful stone carvings and handsome pottery are some of the glories of ancient Peru. As surprising as the simultaneity of this creation of great religious centers is the pervasiveness of the Jaguar cult, which held sway over the minds of both the Olmec and the Chavín people.

For me some of the most emotionally arresting relics of the religion of ancient Mexican rural peoples are the terra-cotta fertility idols made in the hope of rich harvests in the arid highlands of the country. The legs and breasts of these figures are exaggerated. Sometimes they carry children or dogs, and sometimes they have two heads. The joints of the arms and legs are made in such a way as to permit the limbs to move. The facial expressions of the idols inspire in the mind of the viewer an awareness of the wisdom and placidity of the people of the past and seem to recall to modern man emotions that he is now on the verge of forgetting.

But to return to the main discussion, on the day following my observation of the object resembling an Eye of God, I discussed it and the Huichol talisman with Professor Amano, who said that similar artifacts frequently emerged in his excavations at Chancay, a pre-Columbian site north of Lima settled perhaps around 300 B.C. He thought my linking the two was of importance.

Another archaeologist, Seiichi Izumi, has also excavated at Chancay. In his *Inka Teikoku* (The Inca Empire), he writes: "Ten o'clock at night. The wind, and with it the unbelievable sandslide, has stopped. Looking under a leaf on which a two-handled jug had rested, I found some vicuña hair. And beneath it five cross-shaped objects made of bamboo wrapped with string and similar in shape to old-fashioned radio loop antennas. In the Chancay River valley, if one of these ornaments of no specific purpose is found, a mummy is usually underneath it."*

As I have noted, in the Huichol territory the Eye of God is a talisman for the welfare of children. It is connected with food, hence with the gods of the sun and the rain. The riddle posed by its presence all along the Pacific coast of the Americas is inexhaustibly interesting. I was still further fascinated when visits to New York's Museum of Natural History and American Indian Museum confirmed that similar objects occur throughout Mexico and Peru. Later I was able to see for myself that they are made by people living in the remote mountainous areas of the Amazon region in Brazil, in the lowlands of Colombia, and in the Isthmus of Panama. Much research will be needed and many puzzling problems must be solved before we will understand fully the religious and anthropological significance of the riddle of the Eye of God.

GUERRERO

Holy Week in Taxco. Mexico is a land of festivals: one takes place in some town or village almost every day of the year. Throughout whole nights people will sing and dance. Once the sun has set, villagers gather in the plazas in front of local churches. Small shops and stalls are set up. Music fills the air, and blue-white shafts of fireworks arc high into the night sky to explode and shower down in countless points of brilliance. Festival excitement is an indispensable accent to the normally placid and monotonous lives of the Mexican people. But the festival joy, the pleasure taken in sound and light, conceals a deep fear of the unknown and of the all-engulfing night that death brings to man. It seems as if the greater this fear the more intense must be the celebrations, the wilder the rhythms of the dances, and the louder the noises of the fireworks displays. The festivals are truly affirmations of life against death.

Unlike most festivals, the one to celebrate Holy Week—*Semana Santa*—in Taxco is more subdued and disciplined in tone. Pleasure-seeking tourists quickly fill the hotels at the time of this festival, but the people of Taxco maintain strict self-control and the atmosphere of the town is imbued with an air of piety. All music— even that of radios and jukeboxes—is silenced. Billiard parlors, cantinas, and other shops are closed, and the town is enveloped in quiet.

Although the Semana Santa festival originated in Seville, it has by now taken on a distinctly Mexican character. The town of Taxco with its range after range of orange-roofed, white houses, its cobbled streets, and its

* *Inka Teikoku,* Seiichi Izumi (Iwanami Shoten, Tokyo, 1969): p. 104.

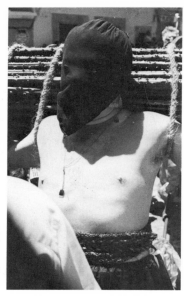

Penitent in Holy Week procession. Taxco.

roving burros reminds one of Toledo in Spain. But the fiery red of the bougainvilleas establishes its mood as Mexican.

On the day of the Holy Week procession, the plaza in front of the celebrated Church of Santa Prisca is crowded with tourists and children who dart in and out among the spectators. On the streets Indians sell pottery from Guerrero and imaginative paintings (Figs. 46–51) done on a rough-textured paper made from the boiled and beaten bark of the amate tree. Below the cathedral is a market where objects made of silver, fruits, flowers, sombreros, sarapes, and tin masks are sold (Fig. 36).

Inside the church the high altar blazes with gold ornaments made more brilliant by the lights of many candles. In a glass case in the center stands a representation of the merciful Virgin Mary. On her left stands a figure of Santa Prisca, and on her right a figure of San Sebastián. After bowing reverently to these figures, lines of faithful pilgrims pass quietly to a room on the left where on the wall hangs a vivid, bloody figure of Christ, crucified and crowned with thorns. From the wounds on His brow flows blood that spots the waxlike body. The marble floor beneath the effigy is cold.

For three long centuries of Spanish colonial rule, the Indians of Mexico were heedlessly pressed to the bloody Cross of Christ. But they have survived to learn to feel fellowship with the bleeding Saviour and to believe that suffering as He suffered is the one way to salvation. The medieval atmosphere of Taxco may well be the result of the fact that the exploitation experienced by the Indians has left them as bloodstained as the figure of Christ. The Holy Week celebration at Taxco amounts to a prayer to allow the people to come closer to God by shedding their blood as Christ shed His. Once the celebration begins, the cobbled streets of this old silver-mining town are transformed into the stage of a medieval drama, as back and forth through the streets threads a procession headed by a man dressed as a priest. In his hands he holds a document. It is the death sentence of Christ, and he reads it aloud as he walks. Following the reader come men impersonating Roman soldiers. They bear spears and wear gorgeous medieval European costumes. Next appears a long line of thorn bearers. Black-hooded, clothed in long skirts, these men bear on their naked shoulders bundles of thorny branches weighing as much as twenty-six kilograms. The black ropes that bind the bundles to their shoulders continue to their waists where they are wrapped in several layers and tied. The men, arms fixed firmly against their spiky burdens, become living crosses. In their apparently lifeless hands, the men hold candles, and as they walk slowly along, the thorns of the branches scrape and pierce their bare flesh. Blood streams down their backs.

After the thorn bearers comes a group of men clad as priests. They carry a large wooden cross in a horizontal position. Then follow others with a flower-decked figure of Christ carrying the Cross, and statues of the Virgin Mary, Adam and Eve, and high-ranking clerical figures. Finally a group of aged women, barefoot and carrying candles, comes dragging heavy iron chains. They are so weary that they seem unable to take another step without falling to the ground.

The procession takes place in the afternoon, in the evening, and again in the dark of midnight. As the marchers wind their ways up and down the hills of the town, the pious faces of the spectators are softly illuminated by candles. The people call upon the Holy Mother, and their faces glow with the appeal of deep faith. The women, with black mantillas on their heads, are more than usually lovely.

The bleeding, waxy-fleshed statue of Christ borne aloft against the stars of night. The sound of dragging chains. The clouds of incense and the occasional thread of music floating on the air. All of this is a re-creation of the worlds of Brueghel, Hieronymus Bosch, the grotesqueries of Daumier and Goya, and the emotions of El Greco and Rubens.

Visit to Olinalá. An exhibition of works from the states of Guerrero, Michoacán, and Chiapas was held in August, 1969, at the Museo Nacional de Artes e Industrias Populares, the national folk-arts museum in Mexico City. As I examined the pieces being shown, I was struck afresh with the excellence of lacquered dishes, jewelry

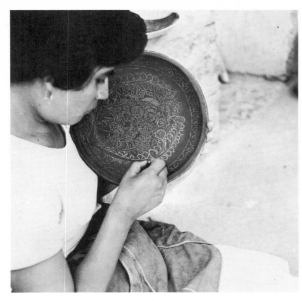

Decorating lacquer bowl. Olinalá.

boxes, and chests from the village of Olinalá, Guerrero. Though Olinalá lacquerware is said to have been at its most popular in the eighteenth and nineteenth centuries, it is still so greatly in demand that the small jewelry boxes made there are sold as quickly as they can be produced. Chests with four legs are especially dignified and impressive. Their colors are usually white on white or black on red, though one of the most handsome examples has a black jaguar pattern in relief on a black ground; the bright red eyes of the beasts gleam from the surfaces of the wood. When I saw this chest, I knew that I wanted it. Although I am usually able to purchase only small, inexpensive articles, in this instance I made up my mind to be extravagant. Approaching the man in charge of the exhibit, I told him that I would like to buy the chest. Its price was 5,000 pesos or about 500 dollars. Unfortunately it had already been sold to the Canadian ambassador. Once I learned this, I wanted the chest all the more. But I suppose that is only human nature.

As it happened, this all took place on the day of the opening of the exhibit and Damaso Ayalá, who had made the chest, was present. This tall, fierce-looking man explained that the special techniques used in Olinalá lacquerware were inherited from the Aztecs, and he invited me to visit the village if I was interested in learning more. A few days later, Carlos Espejel, Director of the Museo Nacional de Artes e Industrias Populares, and I decided to make the trip to Olinalá. Sr. Espejel drove our car. As we left Mexico City the neon lights were just beginning to flicker on. Our plan was to drive straight to Cuautla, where we would spend the night. We would then board a plane to fly to Olinalá. But as we reached a pass in the mountains, a violent electrical storm struck. Forced to stop, we could do no more than watch as the slashing rain pummeled our car and a white mist reduced visibility to zero. The sky darkened to the color of black lacquer; zigzag flashes of lightning were all that we could see. But later the storm subsided, and we descended part of the way down the mountain to the city of Cuernavaca. Late at night, after refueling at a gasoline station, we turned right into Tepoztlán Pass and completed our descent. Stopping at a hotel in Cuautla we arose at five the following morning and proceeded to the airfield, which was close to our lodgings. We paid our fare of 100 pesos and waited until our pilot, a hefty man, arrived.

I took the seat next to the pilot—which is where I like to sit—and we took off into the dim light of morning. All around us stretched range after range of mountains. White, threadlike rivers gleamed beneath us; then, at last, the burning light of dawn pierced the clouds.

Olinalá—the name of the town means "place of earthquakes"—is a small cluster of red-roofed houses nestling close against red-brown earth. Enclosed by mountains, it reminds one of a Spanish town (Fig. 52). Our small aircraft descended under a blue sky and above a field of waving corn to land on the runway in a spatter of flying mud. Beginning to walk across the path through the cornfield to the village, we met by chance the same Damaso who had discussed Olinalá craftsmanship with me at the exhibit in Mexico City. He immediately led us to his house and introduced us to his family, leading members of the local group of lacquerware makers.

The Olinalá decorative technique begins with the carving of the desired form from wood. Axe cuts are made in the trunks of linaloa trees in August or September. In April or May of the following year, when the trees are cut down for use, their fragrance is greatly enhanced thanks to this treatment (Fig. 60).

Traditionally even small Olinalá works require about twenty days for completion. After a base paint has been applied, another coat is prepared by kneading together oil and a claylike substance called *tecoxtle*. At least two layers of this are applied by hand evenly over the entire surface of the vessel or box. In a way similar to that used in applying layers of oil paint to a canvas, these layers of tecoxtle are gradually built up. Each layer is polished with a piece of stone.

The dried and polished surface is then bordered with a continuous pattern around the edge. The space inside the border is then filled with traditional plant, bird, and animal motifs. Men generally draw the patterns, using a quill pen with a point made of thorn. Women then carefully scrape away one layer of the coating from among the lines and patterns the men have engraved. The design thus raised from the background is polished with a

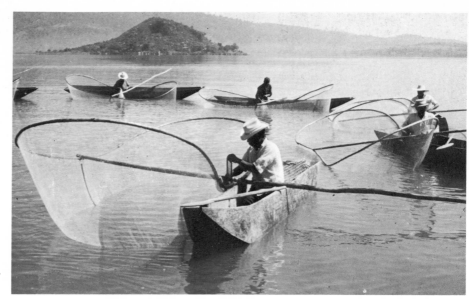

Fishermen. Lake Pátzcuaro.

white powder called *tecicalte*. The vessels or boxes are then dried for a day and polished with oil-impregnated cotton.

Not forgetting about my desire to make a purchase, I placed a special order for a black-on-black chest with gleaming red jaguar eyes, like the one I had wanted to buy at the museum in Mexico City. It was finally completed and sent to me in Japan about a year later (Figs. 56 and 57).

Sr. Espejel and I were in Damaso's workshop mainly to observe Olinalá craftsmen, but soon we became so fascinated that we started to do our own designs on bowls the people were kind enough to give us. I used a church, animals, and other Mexican motifs that I had earlier employed in copper engravings. At first the Olinalá workers looked on in surprise, then one of them said, "Listen, you could teach us something new besides the plants, birds, and animals that we have always used in our work. Why not live here for a year and introduce some different designs into Olinalá? We'd pay you forty pesos a day."

I did not know what to say out loud, but I knew what answer I made in my heart, "Olinalá patterns are good because they are traditional. I don't want you to start using all kinds of new things and losing the good things that you already have." Still I must admit that the prospect of living in that peaceful village, where there was not a single automobile, and of studying Olinalá craft as I struggled to get along with my broken Spanish was inviting. In my spare time I could have done oil paintings. And paying absolutely no attention to the ideas and perplexities upsetting the modern world of art, I would have been able to examine myself and to do my own work. Then after the year was up, I could load my finished pictures on a plane and fly back to Mexico City, where I could show them. "If I only could . . ." I thought. Sr. Espejel, who was sitting beside me, seemed to have guessed what I was thinking. He murmured, as if to himself, *"Muy bien."*

MICHOACÁN

All Souls' Eve on the Island of Janitzio. Leaving Morelia, capital of Michoacán, for Lake Pátzcuaro, one's bus soon enters a world of red-clay hills and mountains. The bus passes through Quiroga, and from there travels south to the village of Pátzcuaro. The houses in the vicinity of the large lake, where rainfall is heavy, have orange-tiled roofs with long eaves. The walls of the houses are white and the eave supports are painted red. The colorful contrast of these architectural members reminds one less of Spain than of China or Korea. In this peaceful rustic village, the people seem to be always standing about chatting, but the products of their handiwork are evident on the very roadsides. Wooden masks are lined up for sale, and mules bearing heavy loads of folk-art objects amble over the cobbled streets. Early every Friday morning, an outdoor market opens under the luxuriant boughs of the trees in the village park. Sarapes of brilliant colors and fresh designs, white fish (*pescado blanco*) caught in the nearby lake, flowers, vegetables, dried meats, folk-art woodcarvings, and various farm products are sold. Women carry their babies slung in rebozos and cradled in their arms. It is noteworthy that the many Indian salesmen, who sit on the ground beside their merchandise, are the last descendants of the Tarascans, once rulers of a kingdom that, in its heyday, was centered in Tzintzuntzán, about halfway between modern Pátzcuaro and Quiroga.

The folk-art museum in Pátzcuaro is a Spanish-style building with a courtyard; it stands at the top of a sloping street. In a model farmhouse-kitchen are displayed regional dishes and other pottery vessels decorated with primitive line drawings of fish and fishermen. These patterns tell much about the way of life of the local people, who are largely dependent on the lake for food. The same aspect of their world is represented in silver jewelry. For instance, some necklaces represent a canoe rowed by man and wife. Beneath the canoe are suspended a number of small silver fish, and between the fish hang bright red paste beads. The design of ornaments of this kind is simple but lovely. The collection of wooden carnival masks in the museum is especially handsome. The land on which the village of Pátzcuaro is located slopes gently to the broad waters of the lake, where fishermen use large paddles to row small craft called *mariposa* (butterfly) because of the distinctive winglike nets on bowed

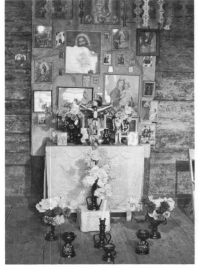

House altar. Janitzio.

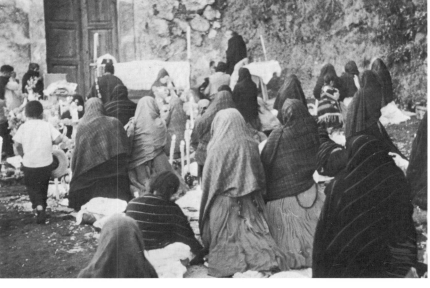

All Souls' Eve. Janitzio.

wooden frames with which the people catch fish. In the middle of the lake is an island called Janitzio. Scheduled ferryboats make round trips between the village and the island. In the local Indian dialect, the name Janitzio means "where the rain is." This island and the many others that dot the broad surface of Lake Pátzcuaro evoke a general scenic mood reminiscent of Oriental monochrome ink paintings. (One of the islands is called *Taza de Chino,* or Chinese teacup.) The numberless waterfowl living in and around the lake sometimes rise from the surface in cloudlike flocks.

As autumn deepens, in plots beside the small village park, masses of bright orange flowers burst into bloom. At this time, the women of the village may be seen bearing huge bundles of these blossoms. The color of the flowers contrasting with the purple of the women's long skirts—appliquéd with floral patterns for younger women—is a picture in itself. The older women, with their heads covered in shawls called *rebozos,* are less colorful, but decidedly strong of face.

Without doubt the greatest yearly attraction of the Pátzcuaro region is the Feast of All Souls' Eve, called the *Noche de Muertos* in Spanish (Figs. 83–85). It is celebrated on Janitzio on November first and second, and it reminds me of the Japanese Bon Festival, the Feast of Lanterns, held in the summer to greet the spirits of the dead.

As the time for the Noche de Muertos approaches, Janitzio is thronged with journalists, cameramen, and tourists. The mainland villages too become so full that it is not unheard of to come quite unexpectedly upon an old acquaintance whom one has not met for years among the visitors to the festival. To reach the island, one takes a ferryboat. As it draws near Janitzio, the tile roofs of the fishermen's houses, the nets hung out on the beach to dry, and an ugly monument on the island mountaintop come into clear view. From time to time, snakes swim by the boat. Energetic young men leap from canoes to swim in the lake waters; on the shore, in the shade of the hanging fishnets, young women comb their long black hair.

The boats are met by swarms of children dancing about in delight at seeing so many strange people. After disembarking, one usually eats fish in a dockside restaurant. The fish is deep-fat fried much in the fashion of Japanese tempura.

As one slowly mounts the sloping street towards the place where the festival is held, one sees through the open doors of houses altars adorned with flickering candles, flowers, bananas, paper cutouts, human figures made from bread, and sugar confections in angel, lamb, and bird shapes. Smoke rises from the chimneys of the houses, for the women are busy with preparations for the festival.

Among other things being prepared are ducks, bagged during a hunt held each October 31. On the day of the hunt, about two thousand hunters from seventeen villages in the lake region gather and board nearly one thousand hollowed-log canoes. Setting out on the waters of the lake, they kill ducks with gafflike weapons. Well thrown, a gaff will travel 185 meters, and a skillful hunter is sometimes able to bring down as many as ten ducks in a day. Since this hunt is both very popular and significant for the local people, for months in advance the men assiduously care for their weapons and practice to improve their aim. The roughly 20,000 ducks captured on that day—allowing approximately ten ducks per hunter—are prepared as carefully and beautifully as if for a banquet. They are then carried to the flower-covered cemetery, where they become offerings to the spirits of the dead.

Boat after boat of tourists and specially invited guests arrive. In the evening, music and dancing begin in a plaza about halfway up the island's mountain and not far from the cemetery. The important thing to see at the festival is the candlelight service that takes place in the cemetery from about midnight until dawn. The cemetery is no more than a level area midway up a hill and separated from its surroundings by a simple stone wall. The local people believe that on the Noche de Muertos the souls of the departed come first to their homes, then join the women and children, who, bearing armloads of flowers, offerings, and candles, walk in an almost unbroken procession to the cemetery. Only women and children tend to the needs of the departed spirits. Perhaps

Consuelo Sardeval. Tzintzuntzán.

the men remain at home and drink; at any rate, they do not enter the cemetery, which, after midnight, gradually brightens with the lights of hundreds of candles.

On the ground the women spread cloths on which they arrange offerings and candles. In addition to the orange flowers scattered about, there are the same sugar and bread figures one sees on the home altars. The cloths on which the offerings are arranged are embroidered with floral patterns, and the bread figures are exactly like pre-Columbian idols. As the number of women and children increases, the cemetery becomes a virtual forest of flickering candles. The children, determined to enjoy this once-a-year festival, sit wide-eyed among the lights and refuse to think of going to sleep. Even dogs join in the solemn celebration. All the women wear similar clothes: indigo shawls over their heads and shoulders, blouses, and pleated, red woolen skirts. Though blackness spreads over the surface of the lake below, with the lengthening of night, the number of lighted candles in the cemetery grows until, just before dawn, the space becomes a mass of flickering—almost breathing—flames forming a link between joy and sorrow, between the living and the dead. Chanted greetings to the dead rise into the sky.

Throughout the night, the women make offerings to the dead, approach them in their memories, and offer reverent prayers for the sorrow that the spirits feel because, when the festival is over, they must return to the land of death. It becomes very cold. The children who had been determined to remain awake grow drowsy; and dogs, rolled up like balls against the chill night, sleep. At last a table is brought out and placed before the crumbling purplish-indigo walls of the cemetery church. A priest arrives to say Mass in this outdoor sanctuary, as layers of darkness fall one by one from the sky, and a whiteness appears in the air over the lake. The cold is intense and a low, crying voice begins to sing. An old woman intones a phrase, and the rest of the women follow her. Wailing and low, the mournful melody to the dead spreads out over the lake waters. On the cliff above the cemetery women take part in the Mass. In the cold light of morning, the red and blue of their sarapes are beautiful. Here there is no discord between Catholic and Tarascan traditions.

During my first visit to the festival, in 1959, I sat all night near the women, sometimes sketching their faces. When a great bell nearby boomed into the night, I felt a kind of security that I had never experienced before, an emotion that is difficult to describe except as a kind of security rooted in the very ground of the island. In some parts of Mexico, the sense of deep relation with the land has been lost, but for the women sitting and kneeling in this cemetery, the ground under them was the earth to which their fathers and mothers had returned and to which they too would return. As long as such a link with the land remains unbroken, no matter how they suffer, no matter what persecution they bear, and no matter how dire their poverty, these people will remain united. They will never forsake their island. The yearly ceremony for the dead is a link with eternity.

Impressions of Tzintzuntzán. I spent nearly a month in Tzintzuntzán in October, 1972. Though it is now only a small village, the place was once a great city of the Tarascan kingdom. I had long thought to live there for a while and do paintings on the various pottery vessels made in the village. Although there was no hotel, letters of introduction brought me to the house of Sra. Consuelo Sardeval, who accepted me as a guest.

I breakfasted the next morning on basic Mexican foods: maize tortillas, beans, chilies. Afterwards, I visited a nearby pyramid, at the top of which yellow, white, and purple flowers were blooming. In the field below me, two cows were grazing, and the farmer-landowner was sowing wheat. A guard, who lived in a small hut on top of the pyramid, asked me to sign the visitors' register in Japanese. Chatting with the guard, I was once more impressed with the fact that the modern descendants of the Tarascan kingdom bore strong resemblances to certain groups in Japan, especially those to be found in the southern island of Kyushu. I recalled the words of a

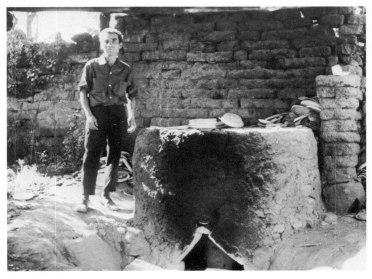

Faustino Peña. Tzintzuntzán.

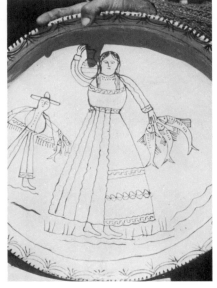

Dish by Faustino Peña.
Tzintzuntzán.

young doctor who sat next to me during the bus trip to Tzintzuntzán. When I asked him where the Tarascan people might have originated, he answered, without smiling, "Perhaps in Japan." This may have been a pleasantry, but the origins of the Tarascan people are obscure. They have even been linked to the Incas of Peru.

A few days later, after waking, I went into the courtyard to wash my face. Hummingbirds darted among the white blossoms of a lemon tree, as one might have expected, since Tzintzuntzán itself means "place of the hummingbirds."

My hostess, dressed to go to Pátzcuaro on a shopping expedition, came out of the house. Consuelo was a stout lady of sunny disposition, who owned a folk-art shop in the village. She sold clay works of her own as well as straw work and woodcarvings of eagles and tortoises made by other local residents. Sra. Sardeval was the mother of four sons and two daughters, the elder of whom was married.

At the beginning of the next week, I visited Bernardo Sardeval. Though they are both of the same family, my hostess and he did not like each other much. As I was leaving for my appointment, Consuelo's eldest son asked for ten pesos, which he planned to use to make a trip to see his girlfriend. Mexico is something of a lovers' paradise.

Once at Bernardo's kiln, I spent the day painting designs on various pottery objects. I used black paint on white pottery as well as white paint on black pottery, but, because I was not accustomed to the dog-hair brush provided, I did poorly. I resolved to bring my own brushes for the next session.

As I watched the members of the Sardeval family painting deer and fish with the primitive brushes, I was once more convinced that the essence of painting is not realism. An artist must not attempt to duplicate something exactly: he should instead record his impression of an object, and the final image he creates should be allowed to evolve naturally and not be created in accordance with strict rules.

For the last two or three days, my knee has been giving me trouble. I fell and wrenched it while returning from a short visit to Pátzcuaro. This morning a bee stung me on the left hand while I was sitting under an orange tree in front of Consuelo's house. Unpleasant events have a way of clustering together. The family's children told me that sulfur from a match head was good for the sting, but my hostess applied a piece of onion to the inflamed place.

Preparations were going ahead for a festival to be held at the end of October. It was to take place in the plaza in front of Consuelo's house. At night I could hear the sounds of stakes being driven into the ground and the assembly of wooden frameworks, destined to be temporary shops when covered with cloths.

I went to the workshop of Faustino Peña, who was skillful in executing naive designs on dishes with white backgrounds. According to his wife, he loved to hunt deer and rabbit. Faustino himself brought out the disassembled parts of a rifle and put them together for me. He was proud of his weapon.

In Faustino's garden, ducks, chickens, and cats were playing around the rather old kiln. The local people had told me that this year there had been a great deal of rain, but, of late, the sky had been so blue that I had been wishing for clouds to give it variety. However, we were in the dry season.

Faustino's drawings were of women holding fish and of views of Janitzio Island, all done in wavy lines. I tried the homemade squirrel-hair brush he used. Obviously, this primitive tool has much to do with the way his

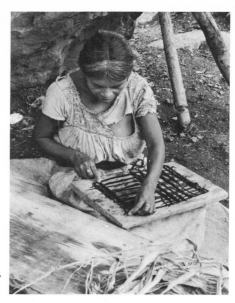

Laying out strips of amate bark. San Pablito.

designs turned out. At the end of the visit, I left accompanied by the entire family, who, arms loaded with flowers, were going to hear Mass.

The local priest called on Consuelo to discuss the coming festival. He told me that this was his first parish, and that in the church garden was a handsome olive tree planted by the famous Dominican Vasco de Quiroga, who encouraged the development in Michoacán of folk arts and crafts based on traditional skills. He lived in the sixteenth century, but the results of his labors are well seen in the excellent handicraft objects made today in Michoacán's towns and villages. The names of many villages are based upon their specializations. For example, Santa Clara de los Cobres denotes that village's tradition of working in copper (*cobre*), and San Felipe de los Herreros indicates that the village is noted for blacksmiths (*herreros*). One could list many well-known craft centers, but among the most interesting are: Patambán and San José de Gracia, both noted for distinctive red and green pottery; Tocuaro, which makes rough-carved wooden figures; and Uruapan, which produces carved wooden masks. Michoacán is, unquestionably, a region of varied and interesting folk-art objects.

At last, the long-awaited festival began. Since morning, Consuelo and some women she had hired had been busy making special foods for the event. The plaza had been decorated with colored paper flags and illuminated with electric lights. Some forty temporary shops surrounded the square.

At eight o'clock in the evening, the event was formally opened when the sister of Mexico's president arrived. She visited each shop, shook hands with the proprietors, and eventually accumulated a huge amount of ceramics given to her by the makers. High above the festive scene, the white moon shone and the stars glittered. A fire built on top of one of the village's pyramids added a primitive touch to the proceedings. My plump hostess, with woolen yarn woven into her hair, bustled about here and there.

Against a background of sky and ancient pyramid, folk songs accompanied by a brass band began on the stage erected for the festival. In the square, people danced to the steps of the Pescado Blanco and the Mariposa. As everyone accompanied the movements and sounds with clapping, a raw life force seemed to flood through the crowd. It was a fitting last-night impression of Tzintzuntzán.

MEXICO CITY

Holy Week in Mexico City. As Holy Week approaches, grotesque papier-mâché figures begin to appear for sale on the streets of Mexico City. These figures are called Judas dolls, named, of course, for the betrayer of Christ. To them are attached fireworks, which are exploded on Holy Saturday as a symbolic way of banishing evil spirits. The dolls occur in many forms, including skeletons, horned devils, unpopular generals from the time of the Mexican Revolution (1910), and even Mickey Mouse (Figs. 101–105). In many of these Judas dolls, as well as in confectionery skulls and a whole range of humorous skeleton figures, Mexicans treat the fact of death rather lightly. In their folk art, they often skillfully transmute the odor of what might be called a conspiracy between life and death into an aroma of humor. Judas dolls particularly capture the distinctive Mexican view of the relationship between life and death.

The painter Rufino Tamayo used Judas doll-motifs in some of his works. Generally, it is not the professional artists but the poor people living in row houses on side streets who make the dolls. Old newspapers are the basic materials, and a fish-glue that must be melted in hot water is the adhesive used in binding the layers of paper together. Once painted, the dolls are put outside the houses to dry, and they can often be seen from the main boulevards of the city. Children in ragged clothes play in the doll-lined alleys, and from time to time a

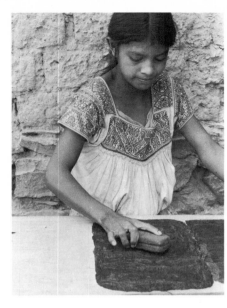

Final step in making amate paper. San Pablito.

thin mother with brow wrinkled in vexation hurries from a house to scold a child for some misdemeanor. The faces of these women remind one of women's faces seen in the paintings of Ben Shahn. Should a few drops of rain begin to fall on days when the Judas dolls are drying, the alleys become battlefields of scrambling adults and children hurrying to get the figures inside to prevent their being spoiled.

One of the most talented and famous makers of Judas dolls—though she herself probably has no idea of her renown—is elderly Sra. Carmen Caballero, whose works the painter Diego Rivera collected with great enthusiasm. He hung them in his study and used them as material for some of his wonderful paintings that interweave illusion and fear. In one of his pictures, a number of Judas dolls are leaning against a woman who is sleeping in a chair in the painter's studio. All of the dolls he used were purchased from Sra. Caballero, who lives, like most of the other makers of Judas dolls, in a back-street row house. After the death of Rivera, she went to the studios of a number of other artists, selling her works. When I visit Mexico, I always look forward with pleasure to buying some myself. Of course, they are never sold in the more elegant folk-art shops on the main streets. Recently her son has been bringing some of his Judas dolls for my inspection, but they do not approach his mother's work in either color or form.

Owing to the many people injured when the explosives attached to the Judas dolls were set off, the fireworks have been banned by law, thus eliminating a colorful and exciting custom.

PUEBLA

Visit to San Pablito. Attractive, rough-textured paper made from the bark of the amate tree has been produced in Middle America since ancient times. Originally used to make wearing apparel, it later came to be utilized as a writing paper on which hieroglyphs and drawings were set down. The sheets of amate paper were put together in the form of sacred books (*tonalamatl*) and were placed in special rooms within temples. The Maya, Toltecs, Totonacs, Zapotecs, and Aztecs all employed amate paper in this way to preserve calendars and their national histories. Today the people of the villages of Ameyaltepec and Xalitla in Guerrero use it as a base for painting vividly colored pictures (Figs. 46–51).

But the villages where today's paper is actually made are located in the mountainous region known as the Sierra of Puebla, lying between the central highlands and the Gulf of Mexico in the northwest part of the state of Puebla. The Sierra is high and remote and the inhabitants of its villages are members of the Tepehua, Otomí, Totonac, and Nahua Indian groups.

The sawback range of mountainous territory was not sufficiently attractive to catch the eyes of Europeans invading Mexico from Veracruz in the sixteenth century. Even today it remains undeveloped, cursed with a bad climate, and tightly shut off from the rest of the world. Though land is plentiful, water is frequently lacking. But when clouds rolling in from the Gulf of Mexico strike the mountains they cause great downpours of rain, enabling the people to raise corn, beans, peanuts, chilies, pineapples, sugar, and coffee.

The village of San Pablito in the Sierra of Puebla still employs pre-Conquest techniques in making amate paper. The village is remote, and not easy to get to, but in September, 1971, I persuaded Miguelángel Tenoco, a designer at the Museo Nacional de Artes e Industrias Populares, to join me in an expedition to San Pablito. Since a large automobile would have rough going—if any going at all—on mountain roads, we borrowed a pure-white Volkswagen and, armed against the cold with sarapes, started our journey.

After traveling ninety-two kilometers from Mexico City to Pachuca, the capital of Hidalgo, we turned to the east on the Poza Rica Highway until we arrived at Tulancingo, where we spent the night. Getting an early start the following morning, we turned off the road just before reaching Acaxochitlán and cut through a field of riotously blooming cosmos. Gradually we entered mountainous territory. At a small village we stopped and stocked up on beer and soft drinks and then set out for Pahuatlán. Along the way we saw a tractor, apparently being used in the building of a road but at that time fighting desperately with mud and mire. Our road was

now impassable. When we asked how we ought to proceed, a laborer told us that we might make it through if we took a lower, older road. Although the road he indicated was barely large enough for one vehicle, the scenery around us was splendid with pine trees and ferns much larger than the ones we had seen so far. We stopped at a house along the way and there learned that from that point on the road was too bad to continue in a small car. To our question whether we could walk the rest of the way, we received the answer yes. But when we inquired what conditions farther along the road were like, we were told *"Quién sabe?"* or "Who knows?" Just as we had completed arrangements to leave our Volkswagen with the man who had volunteered this information, a bus came down the road. Grabbing our sarapes, we jumped aboard. The bus, packed with Indians, made explosive sounds as it bumped along a road just to the side of which was an apparently bottomless ravine. Chills of fear ran through me from head to foot, but the bus driver was unperturbed. He continued chatting with the assistant at his side as he kept one ear open to the roaring of a football game being broadcast on a small radio placed just above his head. I was petrified, especially when, as the bus made a sharp turn, the road in front seemed to disappear. The chasm at our side grew deeper and deeper.

Then suddenly the bus halted on a downgrade. A landslide had turned the road ahead into a muddy river. On the other side of the newly made obstacle, passengers from a bus—coming from the opposite direction—were wading, hip deep in mire, towards us. As I sat thinking what a fine mess we were in, some of the men from our bus climbed up the mountainside, broke limbs from trees, and laid them on the mud to form a makeshift bridge. Others made staffs from branches with which they helped women and children to cross. Everyone was caked with mud by the time both busloads had exchanged sides. Then, a sudden shout announced that stones were falling from the mountainside. Following the slide, a waterfall of muddy water washed our entire temporary bridge away.

The bus drivers simply exchanged buses, and at about twelve o'clock we arrived at Pahuatlán, where we learned that to reach San Pablito, which is on top of a mountain visible from the town, we must either walk or ride horses. We elected to rent horses—mine was white and my companion's chestnut—and tied our muddy sarapes and suitcases to the saddles. The next problem arose from the horses' reluctance to budge, but this was solved when a boy handed us a stick and gave us the advice, "Hit the horse on the rump." The advice was effective, and the horses started. "Which is the way to San Pablito?" we called out. And a man in the distance, who had been enjoying our plight, laughingly replied, "Don't worry; the horse knows the road."

Our horses first climbed and then descended mountainous roads, and since we grew slightly apprehensive about relying entirely on their sense of direction, we asked a young boy to guide us. Soon, after our road had snaked its way among rough terrain for some time, we came upon fields of peanuts and, in the distance, a white church. As we drew nearer the village, we heard an ever-increasing clacking sound that our guide explained was produced by women at work making amate paper. Indeed when we arrived in the village we found that under the eaves of each of the tree-enclosed houses sat a woman, or women, busy at this occupation (Fig. 211).

The raw material for the paper is the bark of the amate tree. It is cut in the spring and left to dry for a time. In the yards of most of the houses in San Pablito stand large cauldrons in which this bark, water in which corn has been cooked, and ashes are boiled until the fibers of the bark are soft. The fibers are washed in wooden buckets and arranged on wooden boards in overlapping horizontal and vertical strips to form rectangles. They are then pounded to a smooth cohesive sheet by means of a stone called *metlapili*. In one day a single workwoman can produce about eight sheets of amate paper, which in hot weather will dry in about two hours. The women who make the paper are poor, but lovely.

At first, the women and girls, surprised by unexpected visitors, hid in the houses, but after becoming accustomed to the idea of our presence, they came out to show us *quexquemetls,* garments characteristic of the Sierra. The quexquemetl (Figs. 213–216), a simple but striking capelike garment, is thought to have been in use among Indian women since the fifth century. Today it is still worn by people of the villages in the Sierra

Madre east of the central Mexican highlands, by people living along the Gulf of Mexico, and by the Huichol in the west. It is very simple to make.

The width of material used today is generally under sixty centimeters, though it is thought that quexquemetls of the past were larger. Wool is prized for cold weather, but since it is expensive, the garments are more often made of cotton cloth. Some of the most attractive ones we saw in the market of Acaxochitlán were embroidered with many-colored threads on white, black, or indigo grounds. The embroidery motifs are outstandingly handsome: animals, plants, and geometric patterns. Perhaps the most elegant are the quexquemetls worn by the Totonac women. They are embroidered in white thread on a white, gauzelike, material.

Returning to the topic of amate paper, it is also used to make undecorated cutouts (Fig. 212). Depending upon the fibers used, amate paper can be either dark brown or white. In cutouts, the dark paper represents bad spirits; the white, good spirits. Therefore, a cutout may be used for beneficent or malignant purposes.

We had to leave San Pablito before dark, since there was no place to eat or to lodge. We left at about five o'clock, and as we got some distance away from the village, the sounds made by the women pounding amate bark into paper suggested to me that similar sounds must have been heard in the days when men and women worked cloth over fulling blocks.

Cuetzalán. St. Francis of Assisi is one of the most highly regarded of the saints among Mexican Indians, and there are many festivals throughout the country in his honor. One of the most attractive takes place in Cuetzalán, a village in the mountains of the state of Puebla. Held on October 4, the festival includes performances of the quetzal dance. Totonac men, wearing circular headdresses adorned with colored ribbons and bordered with lovely bird feathers, do the dance to the accompaniment of flutes and small drums. Their movements are said to represent the flight of the quetzal bird, once native to the region but no longer found there, since it was hunted into extinction ruthlessly for its highly prized feathers. (It can be found in Guatemala, where it is the national bird.) The quetzal is considered a symbol of freedom, for, if caught, the bird will choose to starve itself to death rather than remain in captivity.

OAXACA
The City of Oaxaca. When one's plane lands at Oaxaca Municipal Airport on an unclouded day, the startling clarity of the sky is splendid. A never-ending stream of tourists pours into the city, principally to visit the pre-Columbian ruins of Monte Albán and Mitla. But they also find that the city and the state form a treasure house of folk art.

Although every morning the streets of the city are lined with vendors of fruits, vegetables, flowers, and other merchandise, the most arresting event of the week for me is the Saturday market. There, gathered together, are folk-art objects from all over the state: black pottery from Coyotepec, green-glaze ware from Atzompa, fanciful incense burners and clay figurines from Ocotlán, wearing apparel, and metal and wood objects. The wares displayed in the market invite one to visit the towns and villages where they are made.

Coyotepec, Village of Black Pottery. I was so taken with the black pottery from Coyotepec that I made a trip to this village, located south of the city of Oaxaca. The extremely handsome metallic-black color of the pottery of Coyotepec results from a quantity of lead oxide in the clay (Figs. 255–258). The polishing techniques that produce the lovely luster are said to date from pre-Columbian times. Though the potters shape their vessels without the aid of a wheel, the small mouths and gently bulging bodies of the jugs and bottles are very beautiful. Some figures—for instance those of the goddess Soledad, horses, deer, mermaids, and bells—are cast in molds. In addition to these, the village produces cooking utensils, water jugs, bottles for mescal (a liquor made from an agave), and small ceramic lamps pierced with holes (Fig. 255).

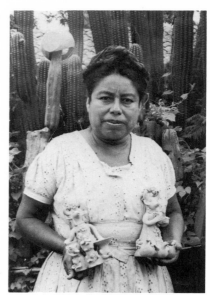

Teodora Blanco. Atzompa.

Pottery of Atzompa. At the market in Oaxaca I saw some large pottery pots in which vegetables and other foods were displayed for sale. The insides of these lovely vessels were glazed green. Inquiries about the place where they are produced led me immediately to the village of Atzompa, located about ten kilometers from the city.

Kilns are visible the moment one enters the village. For many years Atzompa has been famous for brightly colored ceramics with a distinctive green glaze, but the village also makes small pottery lambs and other animals with grooved backs. *Chía* seeds, which sprout from surface moisture, are set in the grooves.

Aside from wanting to buy some green-glaze ware, I had a second purpose in visiting Atzompa. At the Museo Nacional de Artes e Industrias Populares in Mexico City I had seen some terra-cotta figures made by Teodora Blanco. Her technique seemed charmingly imaginative, and I very much wanted to meet her and see more of her work. Vividly recalling ancient pre-Columbian idols, Sra. Blanco's figurines are covered with pigs, birds, flowers, and fish that emerge at unexpected places all over the bodies (Fig. 254). The image I formed of her from seeing her works was entirely unlike the real person. She is a bright-spirited, untroubled, ordinary woman of middle years. At our initial meeting, she started an animated conversation at once.

Inside her small house, under a naked light bulb, many of her figures stood in rows on some darkish shelves. She said she had been manipulating clay since she was nine years old. As she sat on the earthen floor of her house chattering merrily, her hands were making a figurine. When it was finished, she covered its head with a clay shawl, took a small clay pot that she had already made, and put it in the figure's hand. Then, taking up a stylus, she limned in eyebrows and eyelashes. In her garden in front of a cactus hedge stood two primitive kilns in which she fired her works: terra cotta took three hours, glazed pieces required an additional six.

Sra. Blanco's art is completely removed from the elaborate and difficult theories of modern painting and sculpture; it is instead a world where artisans' fingers instinctively know what to do. In place of a modern, well-equipped atelier, she has only a poor, small house with a dirt floor, simple dishes and clothing, her altar, her hearth, her dog, and her chickens. Is true folk art only to be found in premodern, primitive circumstances? If so, how are we to resolve the perplexing contradiction inherent in a desire to improve the living standards of the folk artists while realizing that to do so may cause them to lose the soul of their art?

For a number of years, Sra. Blanco's works have been becoming increasingly famous. They are featured in newspaper and magazine articles. Her prices too have gone up: works that once sold for eight pesos now fetch twenty times that much. But her life was not comfortable. She had children in secondary school and said she needed money.

The proprietor of a folk-art shop in the city of Oaxaca told me that a certain Frenchman gave Sra. Blanco the ideas that her fingers skillfully execute. But in her figurines (Fig. 254) I see the indisputable stamp of the Zapotec people of Oaxaca, not of foreign influences.

Ocotlán. In Ocotlán, south of Coyotepec, the Aguilar family is engaged in producing ceramic objects of a very fanciful kind. For instance, terra-cotta incense burners (Fig. 249) used on All Souls' Day are crowned with groups of blue and white figures representing the spirits of the dead. Clay images of this village are all associated with major human events, such as weddings, baptisms, or funerals. Another interesting product of the village is a clay bell topped with fantastic human and animal heads in brilliant colors (Fig. 251). In addition to these, baskets and cages of a bamboolike water reed reveal delicate workmanship.

Woodcarvings. Of the woodcarvings done in Oaxaca, among my favorites are those of Manuel Jiménez of Arrazola and Isidoro Cruz of San Martín Tilcajete. They carve human beings, animals, and birds in forms that are extraordinarily natural, and then paint them in brilliant reds, yellows, blues, greens, and magentas. The vivacity of their work is perhaps best seen in merry-go-rounds that children can turn by hand (Figs. 260 and 261). The carvings of these two men evoke a world that has a strong sense of actuality. Looking at them, one can

recall vividly bulls grazing under cloud-filled skies in Oaxaca Valley, or one imagines that he is hearing the violent threats of a bandit set in one of the merry-go-rounds. Something of the placid, but profoundly human, way of life of the people of Oaxaca is captured in these carvings.

Juchitán. One soon discovers that train service in Mexico is erratic, and that, if one wants to arrive at some destination more or less on time, it is preferable to travel by bus or plane. In September, 1960, I boarded a bus in Mexico City bound for Juchitán, a town in the Oaxacan portion of the Isthmus of Tehuantepec. This trip takes one from highland to lowland, past the famous volcanoes of Popocatepetl (the smoking mountain) and Ixtaccíhuatl (the white woman), through Cholula, with its many domed churches, into Oaxaca, where one eats dinner, and on farther and farther south with the air growing warmer by the minute. As the bus hurries through the night, black cactus shadows dart past the bus's windows while most of the passengers sleep until the city of Tehuantepec is reached. The air is hot and one refreshes himself with a glass of coconut milk. The bus then proceeds to Juchitán.

When I arrived in Juchitán in that particular September, I found that I was extremely tired and somewhat shaky. My body seemed unable to make the adjustment from the cooler highland temperatures to the hotter ones of the coast. About me, a steady burning wind swirled the dead white dust from the road, along which walked a barefoot woman wearing a long skirt and carrying a basket on her head. Juchitán is truly a town of winds and heat—and women.

The women are big, with exotic and often beautiful faces, and they are noted for their festival costumes, which are combinations of violent reds, yellows, purples, and blacks, ornamented with large embroidered flowers. The women rule the town, for on the Isthmus a matriarchy reigns. They gather at dawn in the marketplace and there, probably informally, arrange the town's affairs. They all have their say: the vast fat woman in the butcher shop, the female proprietor of the restaurant, the woman drawing water from the well, and the women selling fruit, cloth, ceramic vessels, or iguanas. Men are rarely seen in the marketplace. Most of them put out daily in boats to catch fish, though a few may be seen lolling in chairs and drinking beer in front of the restaurant.

My mouth was grainy with sand and dust as I walked the streets in a fruitless search for suitable lodgings. Finally I settled on the Hotel León on the market square. It was cheap enough, but my blue-painted room contained nothing but a bed. A man named Hiroyuki Shibayama, a lone Japanese living in Juchitán, runs a pharmacy directly behind the hotel.

After checking into my room, my throat got sore and I began to feel feverish. I resolved to take some steps quickly to protect my body, which is often a human being's sole ally. Wrapping a sweater around my trembling shoulders, I went to buy cold medicine. At first, the pharmacist recommended penicillin, but I refused because I am allergic to it, and bought some cold tablets instead. After returning to my room and taking the medicine, I began to have chills. My uneasiness and impatience were not allayed by the hot wind that blew ceaselessly throughout the night. Ultimately my chills passed, but I was next treated to some tiresome music—like the sounds of a tinkling music box—rising from the park outside the hotel. Together with the wind, it continued till dawn. Nothing could have better suited my conception of a long sleepless night in a hot country.

On the following morning, however, I felt much better. A local widow named María (I never learned her last name) was kind enough to guide me to places of interest. I went to a pottery factory where vessels are turned on hand wheels. I saw kilns and visited a young man who paints primitive pictures. Because of the heat, nobody wore much clothing. Some children with nothing on found me so curious that they followed me about everywhere, as did the eternal winds carrying the billowing white dust through the streets.

The people of Juchitán believe in magic. For instance, should a young woman fall in love with a man, she will resort to a *bruja* or a *brujo*—female or male sorcerer—to cast spells to make the object of her fancy receptive.

In other cases, the same magically skilled people are consulted to break spells cast by others. The sorcerers make effigies of straw, primitive tree-bark paper, and cloth from a shirt or garment of the person on whom the counter-spell is to be cast. To achieve the desired effect, a needle is thrust into the place on the doll corresponding to the human heart. Often potions are compounded and covertly introduced into the food or drink of the victim, who then becomes powerless and wanders away from home. For such potions, nuts, various roots and barks, dried bats, cactuses, squirrels' tails, reproductive organs of snakes, and many other things are pounded and blended in mortars as need requires.

The important festival days occur in Juchitán during the last two weeks in May. I had been in the town in May on an earlier visit. Bulls and bull wagons were gaily caparisoned. Young girls wore the famous festival costumes and tossed fruit from the wagons in which they were riding (Fig. 266). Men playfully cast nets to capture the girls and children and, sometimes, tourists as well (Fig. 269).

When night fell, large women dressed in brightly colored garments and wearing golden necklaces and bracelets gathered in the dancing area prepared in front of the church. Food was served, and young and old drank beer as if it were water. The music began and the women danced in a slow, stately fashion. Soon the young men joined in to dance with the young girls, and the plaza became a confused mass of dancers. Music flowed on through the night; and the dancing and beer drinking continued until six o'clock in the morning.

At one point, I turned to a man sitting next to me. He had a large mustache and was consuming a seemingly endless number of bottles of beer. I asked him why the women of Juchitán were so big and the men so short and thin. Laughingly, he answered, "There are four women to each man in this town. Each man must work four hours a day, spend four hours in eating, and take care of four women at night. Because of those twelve hours of labor the men can't gain any weight."

CHIAPAS

San Cristóbal de las Casas. San Cristóbal de las Casas, the former capital of the state of Chiapas, has many beautiful colonial-style buildings, including the Church of Santo Domingo. On festival days it becomes a virtual display case for the many Indian peoples living in the surrounding region. Especially notable are the men who, with machetes suspended from sashes around their waists, stride into the town with jugs of *pulque* (like mescal, a fermented liquor made from an agave) or *chicha* (a maize-cane brandy) on their backs. Some have unpainted handmade musical instruments slung on their shoulders in the fashion of troubadors of long ago.

Part of a large colonial-style mansion in San Cristóbal is now a museum devoted to Lacandón life. These long-haired people of Maya descent lived in the dense forests of Chiapas in complete isolation from the outer world until traders invaded their territory in search of mahogany and chicle. Today their numbers are diminishing, and they make a poor living by raising corn, tomatoes, beans, and squash, by hunting birds, and by fishing.

In the central plaza of San Cristóbal is a folk-craft shop, operated by a man of Spanish descent, filled with Indian craft articles, hats, shoulder bags, blouses, and skirts. Some of the costumes are displayed on cardboard dummies. All of the work is done by hand, and perhaps because of the proximity to Guatemala, many of the patterns contain quetzal and deer motifs.

The abundance, variety, and low prices of the folk-craft items produced by the Indian peoples of Mexico are amazing. Yet the lives of these Indians are poor and simple. It may be their premodern way of life that gives to Mexican folk art its great interest. Even today, women in mountain villages use primitive looms to make beautifully designed, richly colored cloth that takes so long to produce that the modern urban dweller, already having been baptized in the ideas of an industrial society, has to be astonished at the immense patience of the weavers. For example, one lovely piece of cloth may take from two to three months—or maybe as much as six months or a year—to complete. Folk crafts in post-Revolutionary Mexico have not only inspired the artists of the country; they have also contributed greatly to the growth of Mexican nationalism.

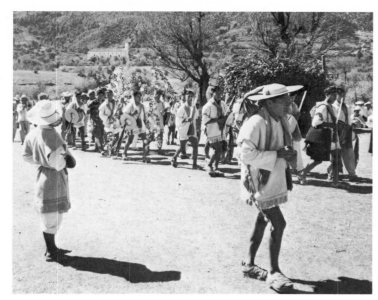

Festival procession. Zinacantán.

One day, while I sat in the San Cristóbal marketplace sketching and taking photographs, I noticed that, as morning drew on, many women with flowers on their heads came into the square, leading pigs and horses. Suddenly the whole scene took on the air of a fiesta. Poor, but sturdy, women with copper-colored, Asiatic faces were selling corn, dried fish, vegetables, fruit, cheese, meat, salt, cloth, and many other things. Both men and women were drinking chicha or pulque, and when noon arrived many of them sat down beside the road to have lunch. They ate tortillas and beans, and some women from Chamula also ate raw green beans.

The amount of money gained in a day's transactions by an Indian seller at a market may be a shockingly low twenty centavos or one peso, but at evening, the Indian fist tightly clenches the few coins. What has pushed these people, whose forefathers created brilliant cultures, to such an extremity? Will the day never come when the Indians will cut themselves free from the net of poverty and bring to new life another age of glory?

For the Indians of Mexico, coming to the marketplace to walk about, sell, buy, talk, and eat is one of the most important functions in their lives. Here they meet and bring each other up to date on events outside their own villages. The marketplace is a hub of communications. Although an air of informality is to be found in most Indian marketplaces, there is still no relaxation of the barrier between "white" and Indian.

One afternoon, when I was sketching in San Cristóbal's main plaza, a group of children gathered around me. I drew in my sketchbook the face of one boy and this made us fast friends. He happily guided me through the town and led me to a church on a hilltop from which all of San Cristóbal could be seen. Noticing fireworks in the distance, I asked my young friend what was going on. "A fiesta," was his reply. As we descended the hill, the sound of music grew louder; and when we at last entered the marketplace I saw that a large group of people had gathered for the breaking of a piñata, a clay jar covered with a papier-mâché figure and filled with candies and toys. At Christmas and on other occasions, piñatas are hung from ceilings or other high places, and blind-folded persons must break them. Usually, the task is done by a child, who is heartily cheered by all the on-lookers when he succeeds. In the marketplace that day, a child managed to break the piñata on his second try and was highly praised.

The next day I wakened at eight-thirty in the morning to white sunlight slipping through the cracks in my door. Opening my blinds, I looked out to a dazzling sky, the orange roofs of the village, and the brilliant white church on the hill. Later, at morning market, I met the mother of the child whose face I had sketched the day before. I had given the drawing to the boy, and his mother was delighted with the likeness. Although proud enough to show it to her acquaintances in the marketplace, she did so with an air of reserve that is part of a formal etiquette often encountered among Mexican Indians. I noted earlier (p. 20) that among the Huichol of Nayarit a young man removes his hat and bows his head when encountering an elder of his village. The older man responds by placing his hand on the bowed head. In San Cristóbal the same custom is found.

Later in the morning, I kept an appointment with a man who, on a previous visit, had rented his car to me and acted as driver. Today he was to take me to Chamula, a village northwest of San Cristóbal.

As we approached Chamula, we came upon a wooden cross on a hilltop. Next a large white church came into view, and beyond it the cluster of thatched-roof houses that make up the village. In front of the church a few sheep grazed, and several women sat spinning woolen yarn. Everything was very quiet.

In contrast to the blinding whiteness of its exterior, the interior of the church was dimly lighted. Pine needles were spread on the floor and flickering candles lit the faces of women and children, who, kneeling, were reciting prayers. Thinking that this would make a good photograph, I took my camera from my shoulder, but did not use it, since two elderly men doing some repair work in the front of the church gave me hard looks that made me uneasy.

Zinacantán. Every day in Zinacantán, a village just beyond Chamula, is quiet to an almost inconceivable degree, but at festival times everything changes. Music blares, fireworks flash, and men wearing bull headdresses and

red-cloth masks leap and dance about like demons. Strolling men play musical instruments and women sit on the ground munching sugar cane. Men drunk on chicha and pulque begin quarrels. And soon, with the village elders in the lead, the band arrives. (Even on ordinary occasions, these people dislike being photographed, but they are especially touchy about it at festival times. A person foolish enough to point his camera at them then runs the risk of serious trouble.) The village elders, clothed in black cloaks and red head-cloths, sit at a special table where they are served a handsome feast. The drinking, the music, and the general mood of the festival reminded me of many festivals I have seen in Japan and elsewhere in Asia.

Just as at Chamula, the people gather in the church to pray. Fresh pine needles are strewn on the floor, and thick leaves of the century plant are used as holders to support candles by whose soft light the faces of the devout villagers gleam.

These festivities are probably the only times during the year when the restrained Indians have a chance to allow their pent-up emotions to break forth. And they take very good advantage of the chance. In Zinacantán, men with ink-painted faces shriek at each other and climb trees where they throw, exchange, and try to steal from each other stuffed squirrels and weasels. Sometimes their rough-and-tumble play spills over into the audience to disturb women and children sitting on the ground and watching the proceedings. But before long, the sun that was once so high drops into the west, and the white heat of the daytime plaza suddenly gives way to night chill.

Mitontic. About thirty kilometers from Chamula, in the shadow of great boulders, is the village of Mitontic. When I went there, men were tilling the fields and, in yards in front of thatched-roof houses, other men were tanning hides. Beans were ripening on the vines, and, though it was January, huge artichokes and fiery salvia were growing on both sides of all the roads. Out of a door appeared an old woman with thinning hair who might have stepped from the pages of an ancient Japanese romance.

While sketching some of the local people, I had an opportunity to make the acquaintance of a seventeen-year-old mother of two young sons. She wore a blouse with beautiful embroidered designs in red wool yarn. My attempts to communicate by means of the few words of her language that I knew brought smiles even to the habitually dour faces of the people about us.

San Bartolomé de los Llanos. One day during my stay in the mountaintop town of San Cristóbal, I boarded a battered bus which, churning up choking clouds of white dust, descended into the heat and sugar-cane fields of the lowlands. As the sun set in a glory of madder red, I wondered how far it might be to the Pacific Ocean. My next thought was of the hardships probably suffered by an early group of Japanese immigrants to Mexico. Thirty-six in number, these people crossed the Pacific in the late nineteenth century to settle finally in Chiapas. Idealists following the teachings of Kanzo Uchimura, a student of American missionary William S. Clark and the founder of a nonsectarian Christian movement, they were determined to produce results even in that remote, sultry, backward place. In a region where no one wore shoes, they attempted to open a shoe factory. Though this venture, as well as their projected coffee plantation, ended in frustration, the people of the local villages still remember these settlers.

Our bus trip was filled with events, in the face of which the passengers maintained an almost maddening calm. At one place we had a flat tire. At another, though there was no bridge, the bus drove straight across a shallow river. None of this, however, perturbed my fellow passengers.

At San Bartolomé de los Llanos, our terminal stop, I soon found that what my painter friends in Mexico City had told me about the women of the region is true: in their own coloring and in that of their costumes they resemble the women in Gauguin's Tahiti paintings. In another sense, however, their rich black hair and sarongs and blouses embroidered with colorful bird and flower patterns remind me of the work of Paul Klee. So fond

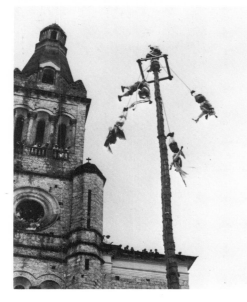

The volador, *or flying dance. Cuetzalán.*

are they of gay colors that even the small tortilla-containers they carry are covered with bright floral patterns. In the blazing sun, these women walk barefoot down the roads. Some of them wear no blouses; many of them carry large water jugs. The women and the white flowers blooming by the road contribute to a most exotic mood. But the people are very poor, and the weather is incredible. Once the sun mounts the sky, there is no relief from its merciless heat until night. The only thing one can do is remain indoors and hide from the blazing light. During the hot hours, the women make good use of their time: sitting on the earthen floors and using primitive equipment they weave colored cloth of great beauty. I could only wait and long for the night.

When darkness finally comes, there is the pleasure of dinner, which takes place at about eight. The meal is often highlighted by marimba players who gather in the hotel patio. After dinner, guests take their chairs into the cool garden and sit under the glittering star-crowded sky, while a group of musicians plays marimbas that look like monstrous, outsize xylophones. The ferocity of the sound of the instruments is unlike anything one is likely to hear in restaurants in Mexico City. In San Bartolomé, the marimba music matches the brilliance of the sky, which seems to be almost within touching distance. So infectious is the rhythm that it is impossible to sit quietly and do no more than listen. The marimbas bring relief from the heat of the long day. Without that heat, marimba music of this kind might never have come into being; and without the evening pleasures of marimba music, the heat might be intolerable.

I shall never forget the effect of marimba music in San Bartolomé, and I shall always remember one other musical event in the town. Across the street from my lodgings was the shop of an old shoemaker. In the shop were an old sewing machine and, hanging on the wall, a guitar and a cello. The old shoemaker seemed to find nothing as pleasant as playing the cello in the evening when his day's work had ended. Sometimes friends playing a violin and a guitar joined him in a concert of songs. People passing along the street at night stopped to listen to the music. One night I and some of my friends were invited to the shoemaker's house. After playing a few of his specialties, he performed a song he said he had written himself. His lovely daughter sang as the shoemaker played the cello. Our uninhibited applause for the performance of this local Pablo Casals resulted in an encore.

VERACRUZ

Papantla. In 1972, just after an exhibition of my works had closed in Mexico City, I went to Papantla, Veracruz, to see that town's renowned flying-pole dance (known as the *volador*). A very pleasant bus ride took me first to Tuxpan, on the Gulf Coast, and then on to Papantla. When I arrived, the Hotel Tajin, which faces the city's main plaza, was already packed with tourists come to see the annual event. In cool, shaded parks crowds were milling about, and dancers with large circular ornaments on their heads were passionately stamping their feet in time to the music filling the air. Purple and vermilion flowers gaudily emphasized the tropical setting of Papantla. Squirrels hopped from branch to branch in the wide-spreading trees, and, in one park, a merry-go-round and a Ferris wheel seemed to revolve in time to the rhythms of the music.

The Indians of Papantla are Totonacs, and for the festival the women wore white skirts and white shawls, and had decorated their long, black, plaited hair with flowers. The young girls seemed always to be in groups of four or five, or, if without friends, a girl was accompanied by her mother. The women invariably hid their faces if cameras were turned their way. Young men looked dashing in white shirts and trousers; they wore neckerchiefs and carried shoulder bags; and the turned-up brims of their sombreros gave a final jauntiness to their costumes.

While the people—eating, drinking, laughing, talking—are diverting in themselves, the main attraction of the festival takes place in the central plaza, where a pole has been set up for the volador. If the weather is good, the dance is performed both in the morning and in the afternoon. On the day I watched it, the roof of the white church and the upper floors and roofs of the other buildings around the square were crowded with spectators.

Four young men, the flyers, climbed the pole to their places on the frame; then a fifth man, the musician and leader, climbed up to take his place on a tiny platform atop the pole. The musician played a flute and drum and executed a number of dance steps. On the ground, masked men chased hysterically laughing children through the crowd. The other spectators seemed to be holding their breaths in a mixture of anticipation and delight. Suddenly, the dancing stopped, and the four flyers, secured to the pole by ropes, leaned over backwards and fell into space. Their bodies revolved downwards around the pole. A short distance from the ground, they turned somersaults and landed lightly on their feet. And, sadly, after they had landed, they turned to camera-clicking tourists with requests for money.

The flying dance is ancient and had at one time a symbolic religious meaning. But today, it is an exercise in acrobatics and only one part of a highly commercialized festival.

Western Mexico

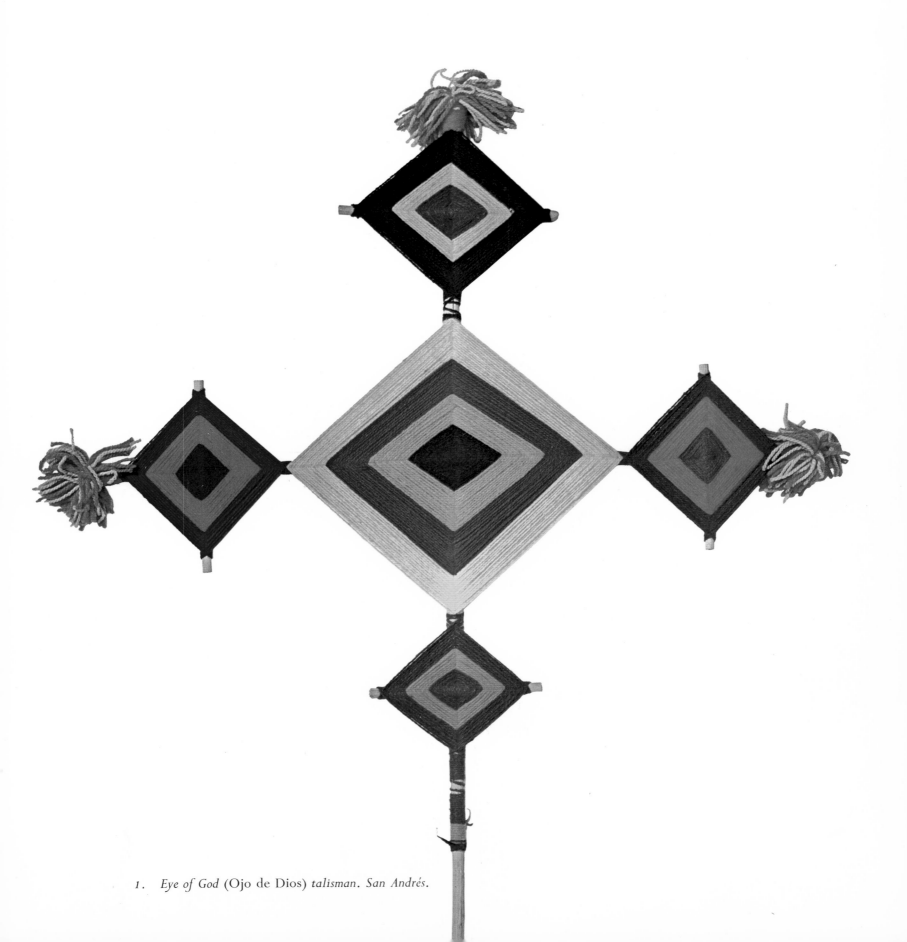

1. *Eye of God* (Ojo de Dios) *talisman. San Andrés.*

Nayarit

San Andrés. In five small villages deep in the mountains of Nayarit live the Huichol, a people who dislike contact with foreigners. They have long resisted the influences of outside cultures. In San Andrés, one of the five villages, the inhabitants produce pictures in woolen yarn and vessels decorated with beadwork in the brilliant colors they admire. Located at the edge of a large grassy plain in the mountains, San Andrés vividly reveals the contrast between indigenous and imported traditions, for in it there are both a small Catholic church and a reed-thatched temple where the Huichol worship their numerous local deities.

3. *Huichol man making a picture with woolen yarn. San Andrés. Sketch by author.*

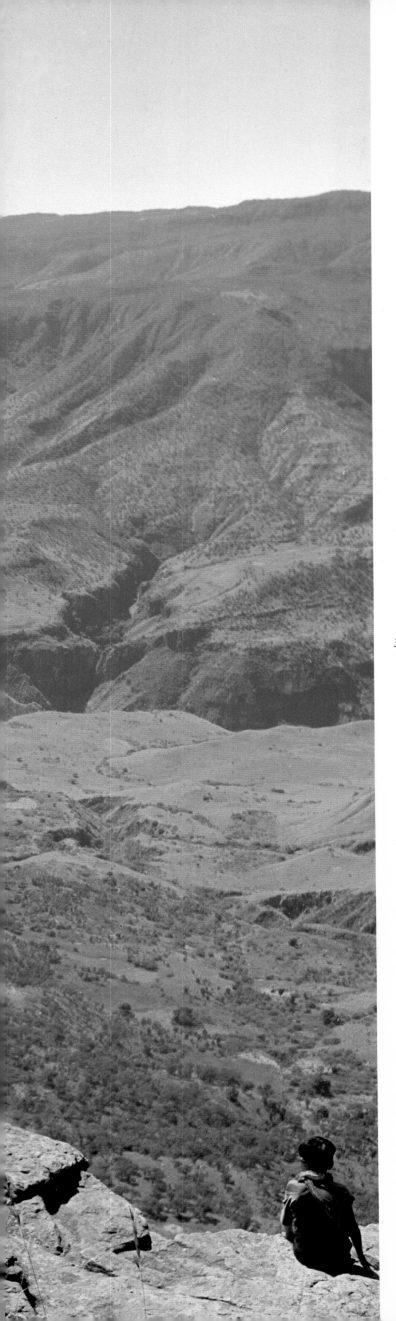

2. *Mountains near San Andrés.*

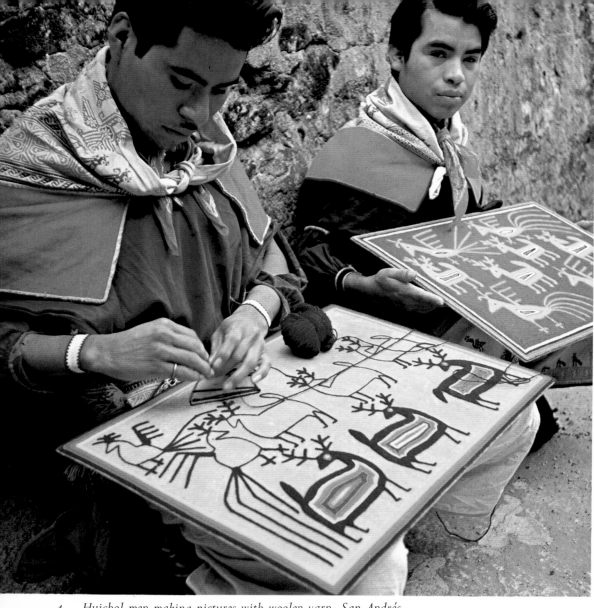

Woolen-yarn Pictures. The bright deer, birds, and butterflies embroidered on the garments of the Huichol people are more than mere ornaments: they are related to living gods. Similarly, the animals skillfully worked into dazzlingly colorful woolen-yarn pictures have religious significance as parts of the pictures which are used as votive offerings.

4. *Huichol men making pictures with woolen yarn. San Andrés.*

5. *Beeswax is spread on a wooden board, and wool applied with the fingers. The artist is sketching a volcano. San Andrés.*

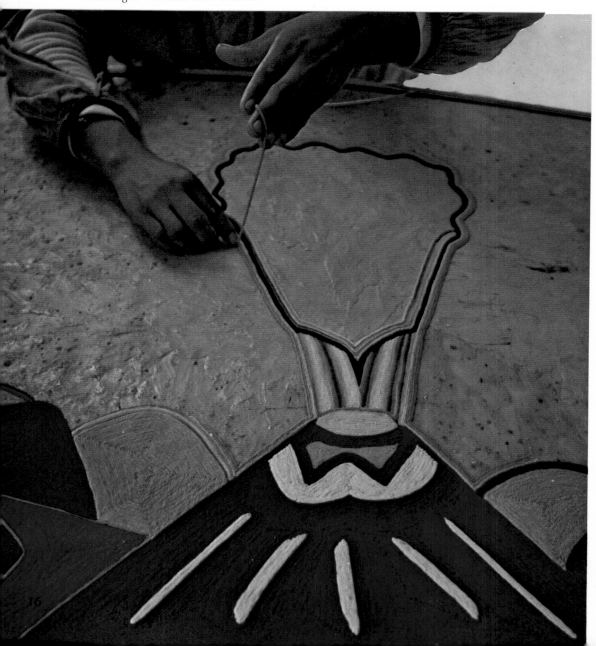

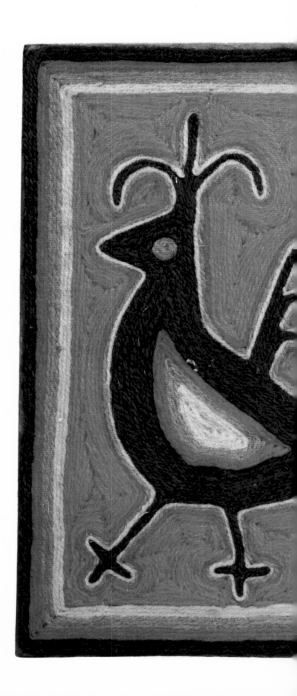

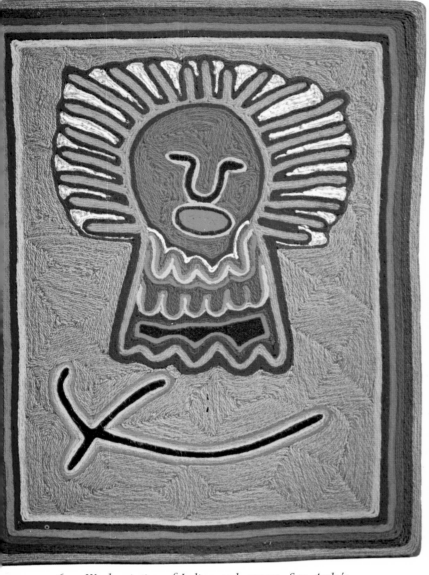

6. *Wool painting of Indian and serpent. San Andrés.*

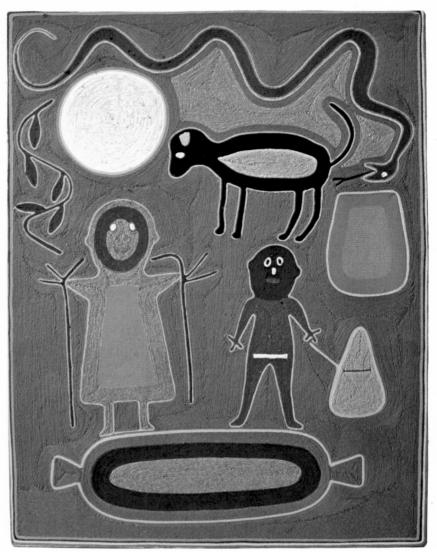

7. *Wool painting of Indian village. San Andrés.*

8. *Wool painting of birds. San Andrés.*

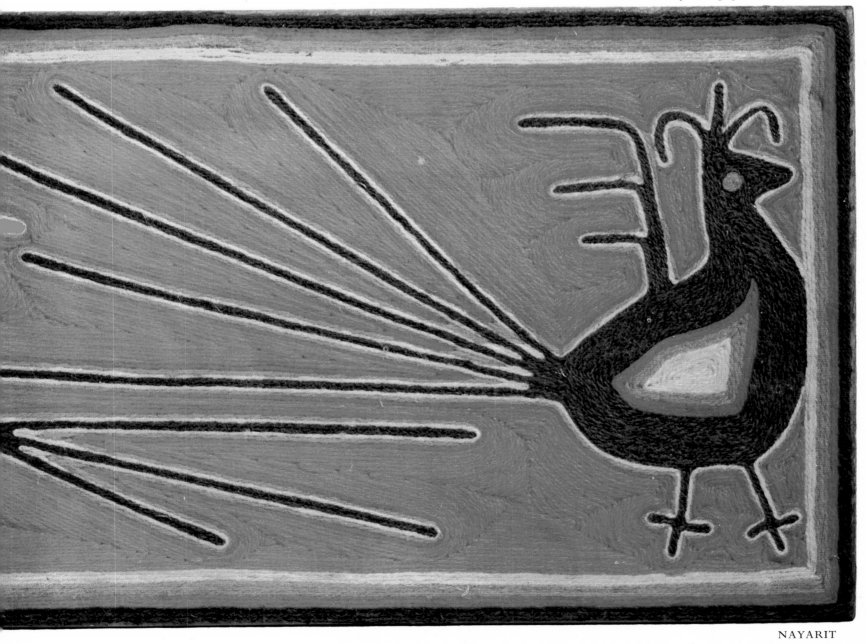

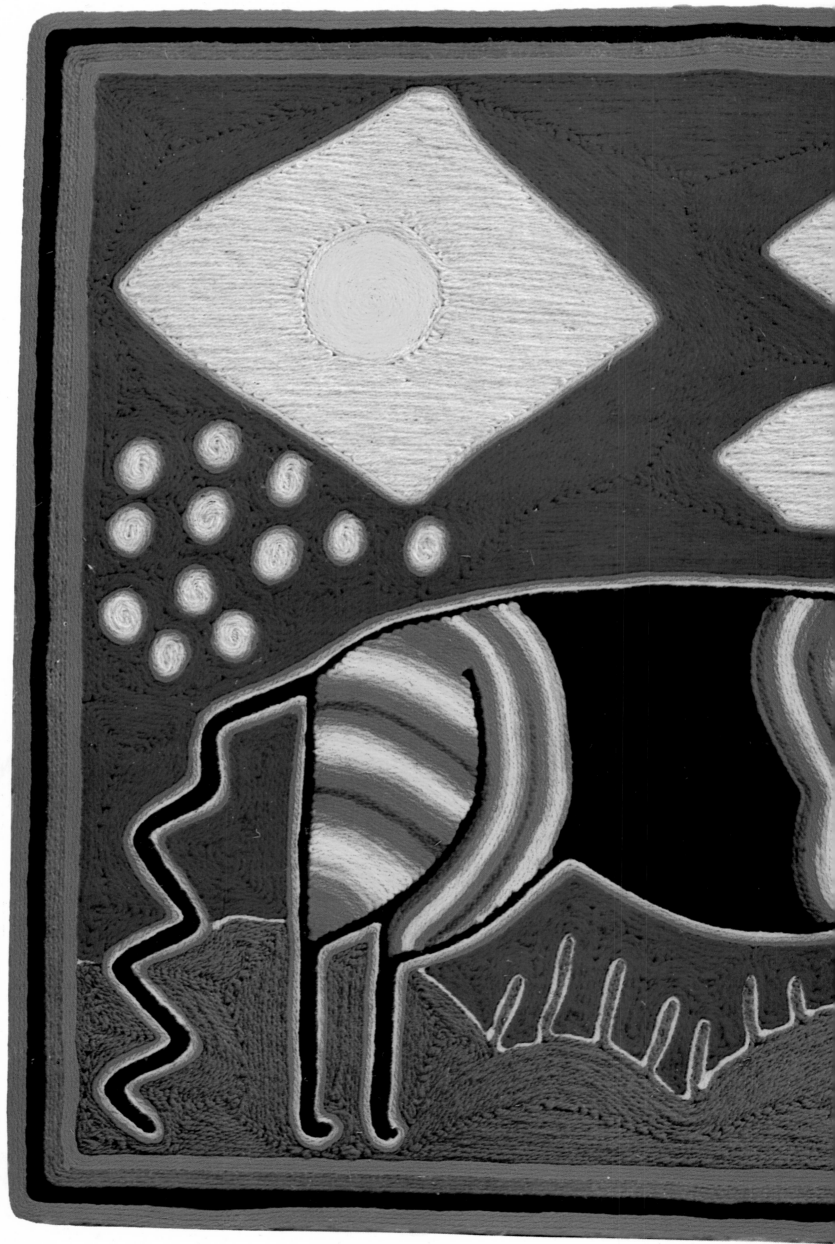

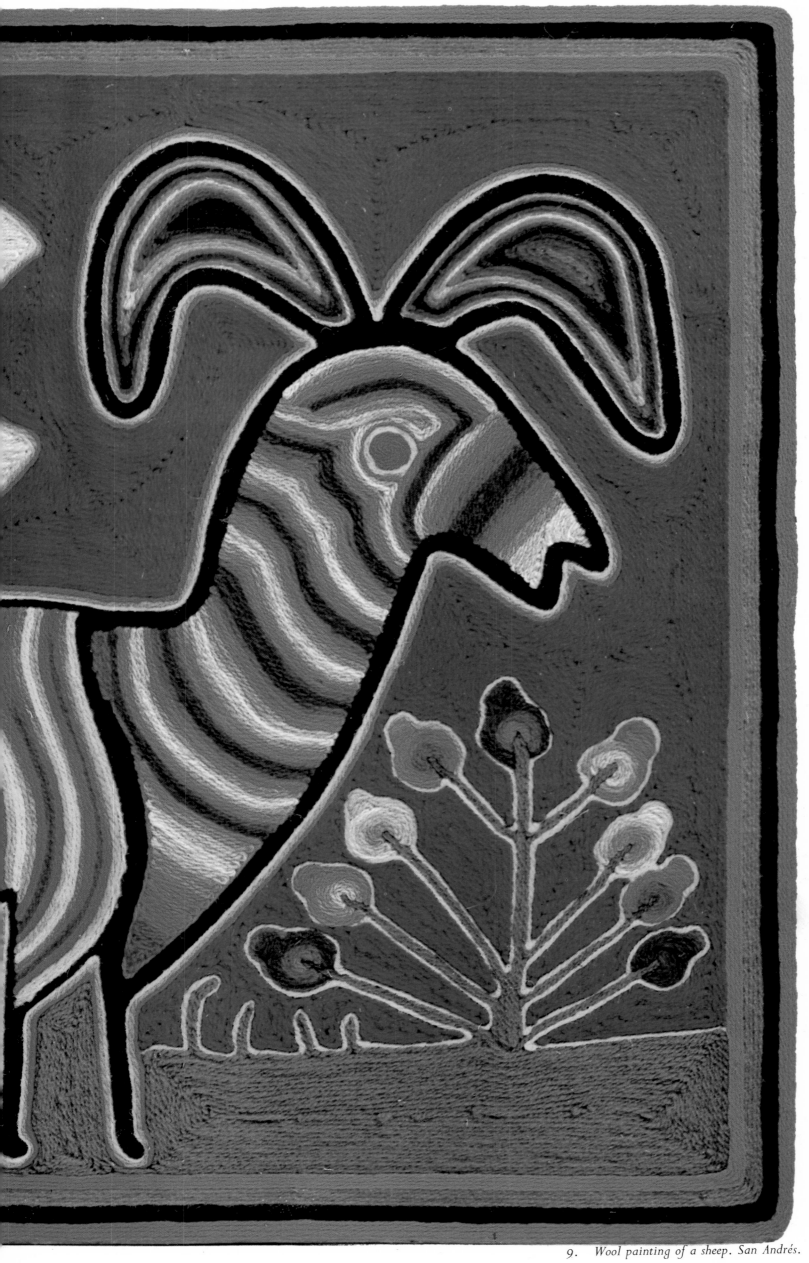

9. *Wool painting of a sheep. San Andrés.* 47

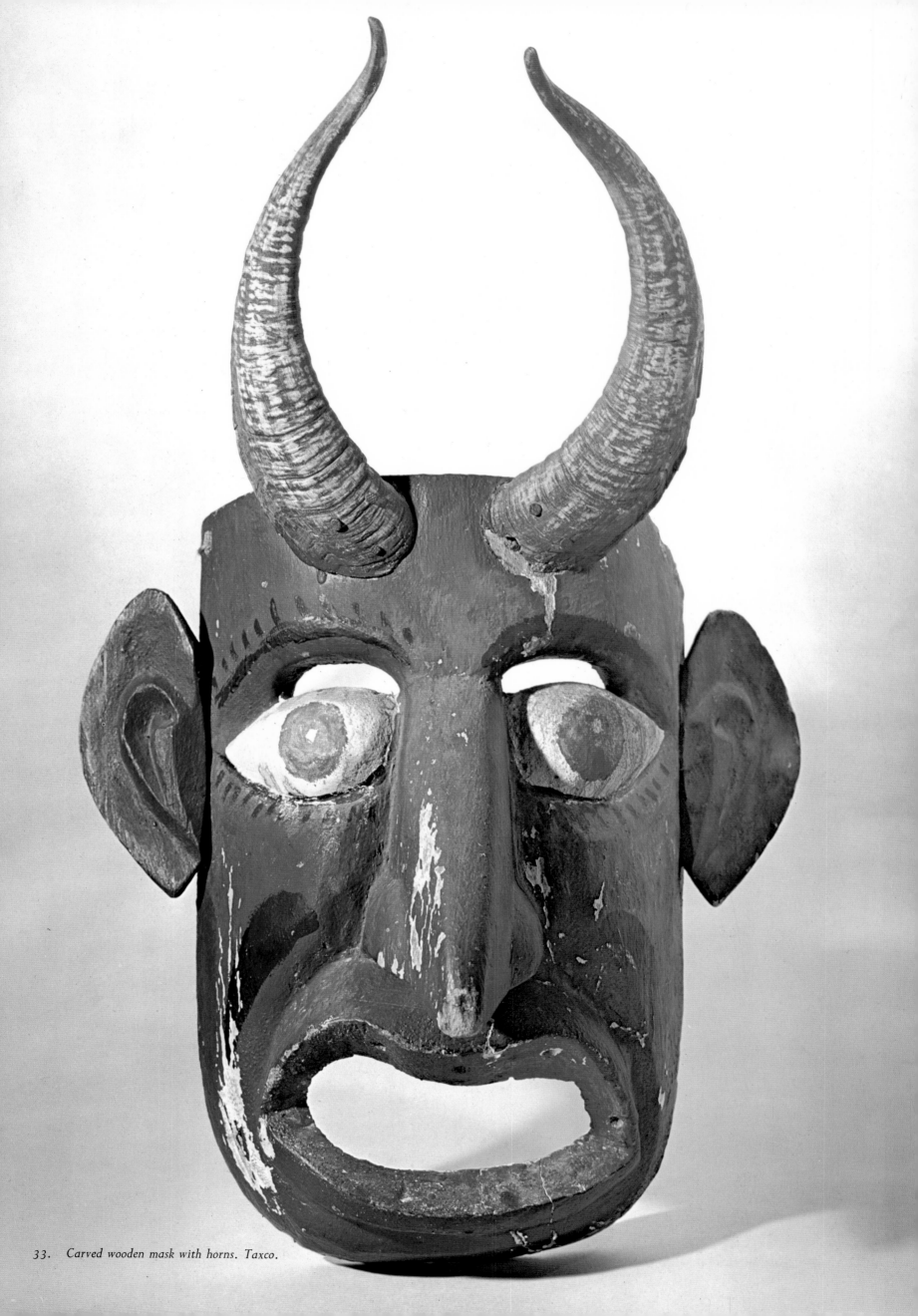

33. *Carved wooden mask with horns. Taxco.*

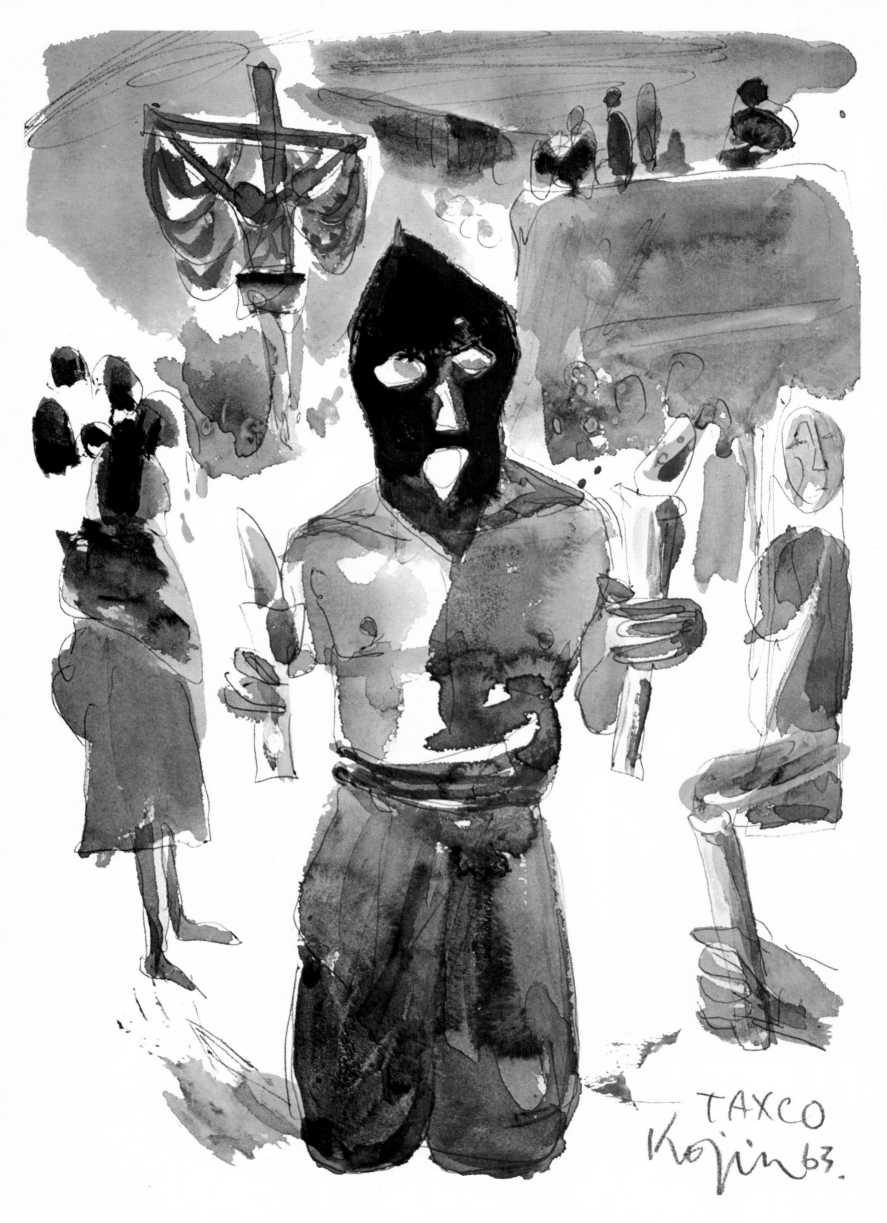

34. *Holy Week ceremonies in Taxco evoke a feeling of medieval times. Sketch by author.*

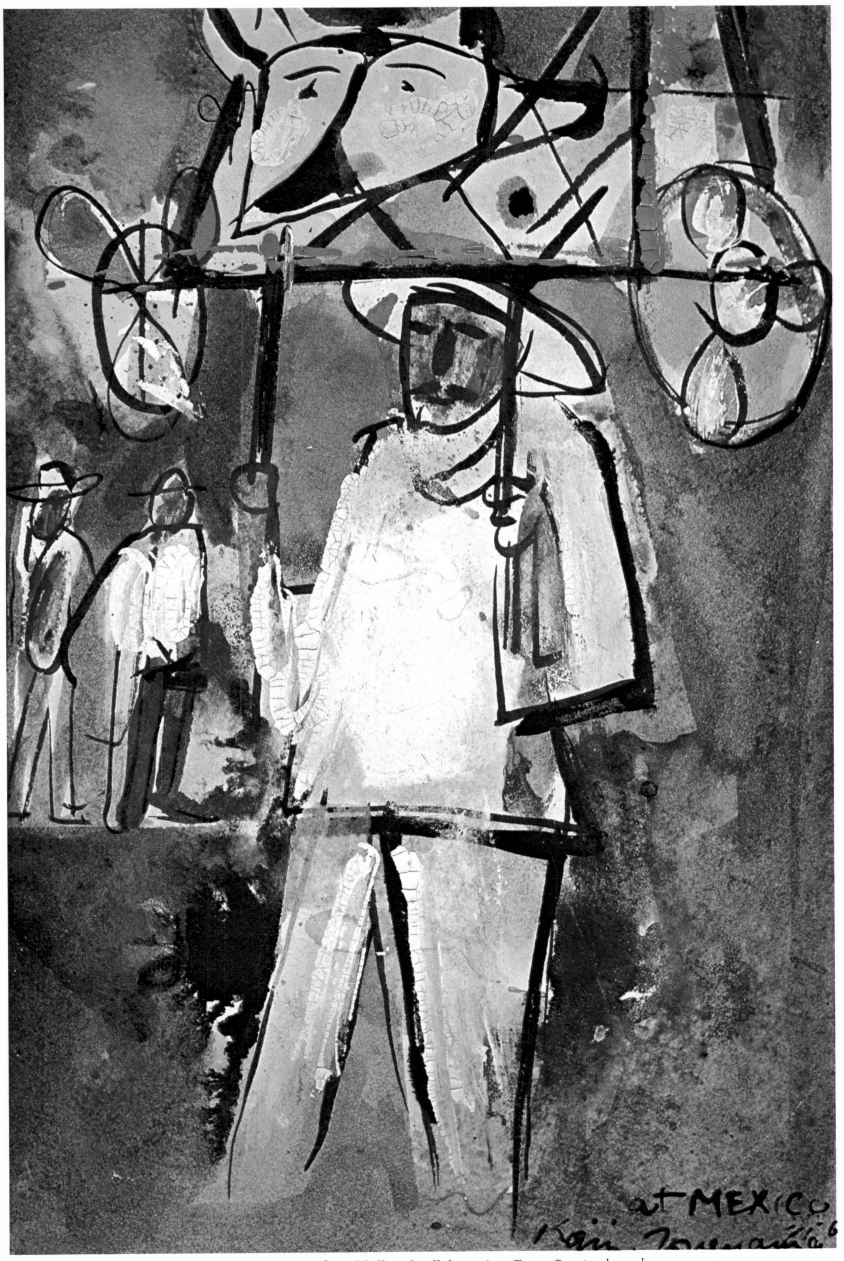

35. *Man carrying a festival bull mask called a torito. Taxco. Drawing by author.*

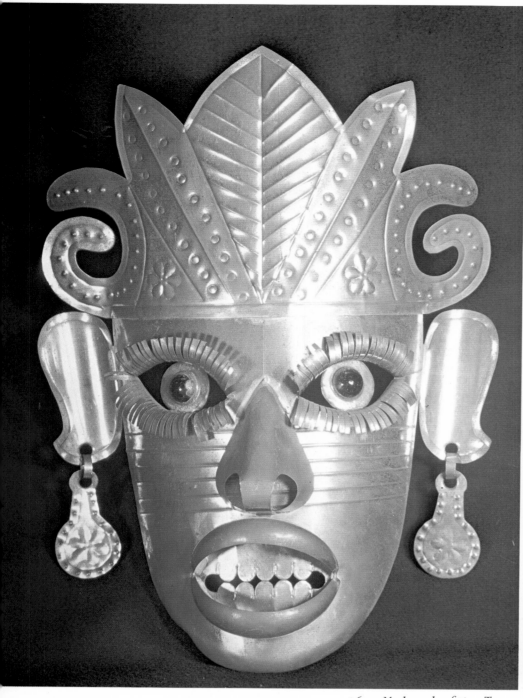

36. *Mask made of tin. Taxco.*

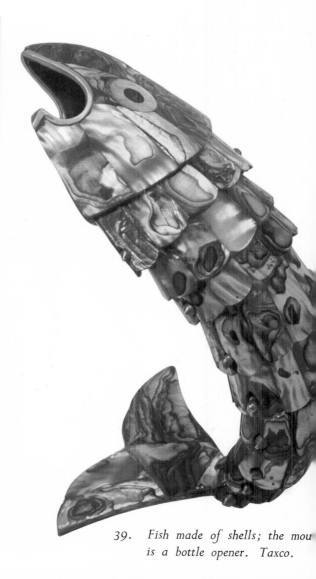

37. *Mask made of hemp. Ta:*

38. *Silver necklace and earrings. Taxco.*

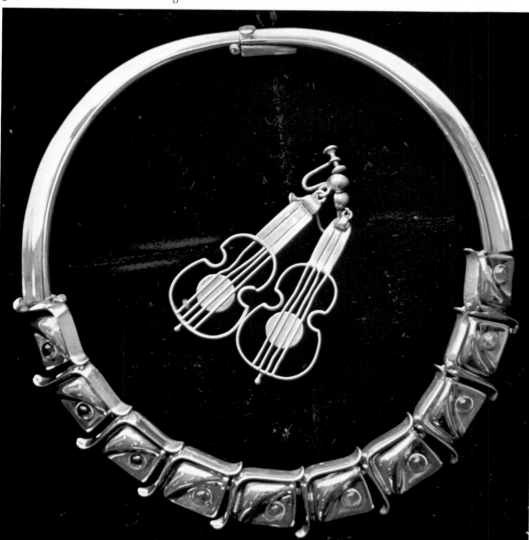

39. *Fish made of shells; the mou is a bottle opener. Taxco.*

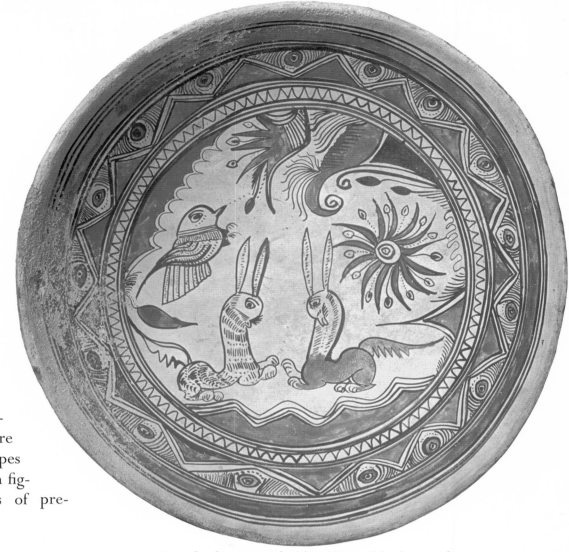

ia and Brown Pottery. The pottery
oduced by the people of Guerrero
mostly of a terra-cotta kind, decor-
d with lovely designs in sepia and
own. Most noted for pottery skills
e the towns of Tolimán, Ameyaltepec,
n Augustín Huapán, and Xalitla. They
n be reached from the road between
xco and Acapulco by horse or burro. Al-
ough the designs on Guerrero pottery are
luenced by Spanish art, the simple shapes
the vessels and of the birds and human fig-
ines made today recall ceramic forms of pre-
nquest times.

40. Large bowl ornamented with rabbits and bird. Ameyaltepec.

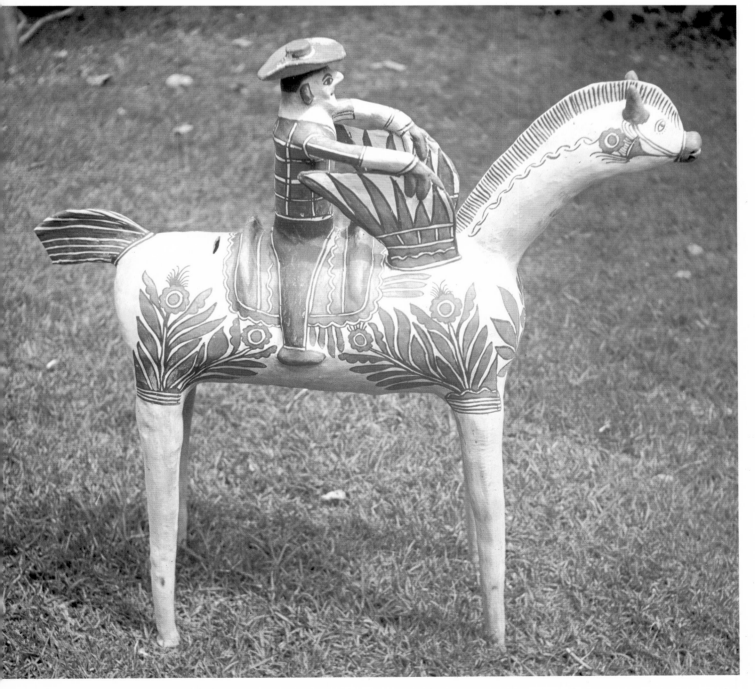

*41. Pottery man on
horseback. Ame-
yaltepec.*

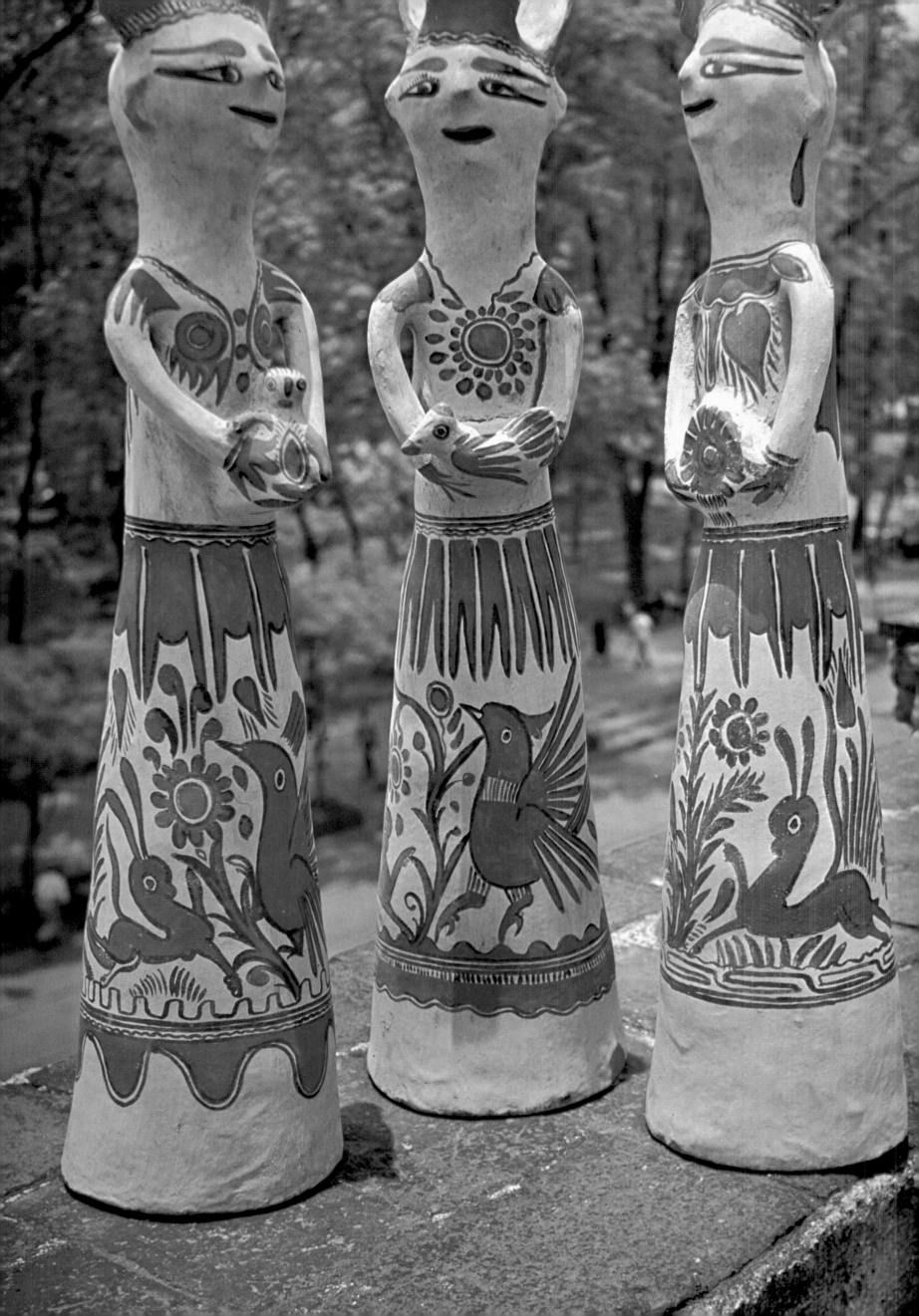

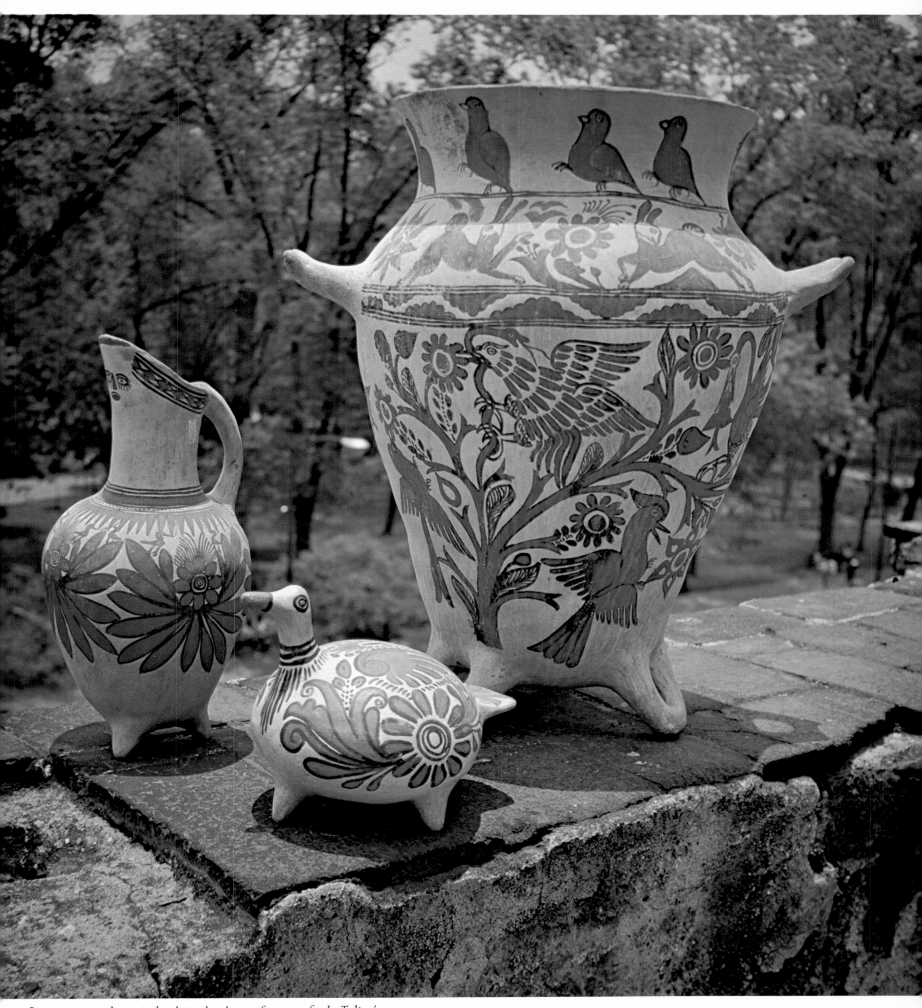

3. *Pottery jars and a coin bank in the shape of a waterfowl. Tolimán.*

Mixed Origins. The designs drawn on Guerrero pottery show many Spanish influences, but the simple shapes of the pots, dolls, and birds are reminiscent of pre-Conquest designs.

2. *Three pottery figurines. Tolimán.*

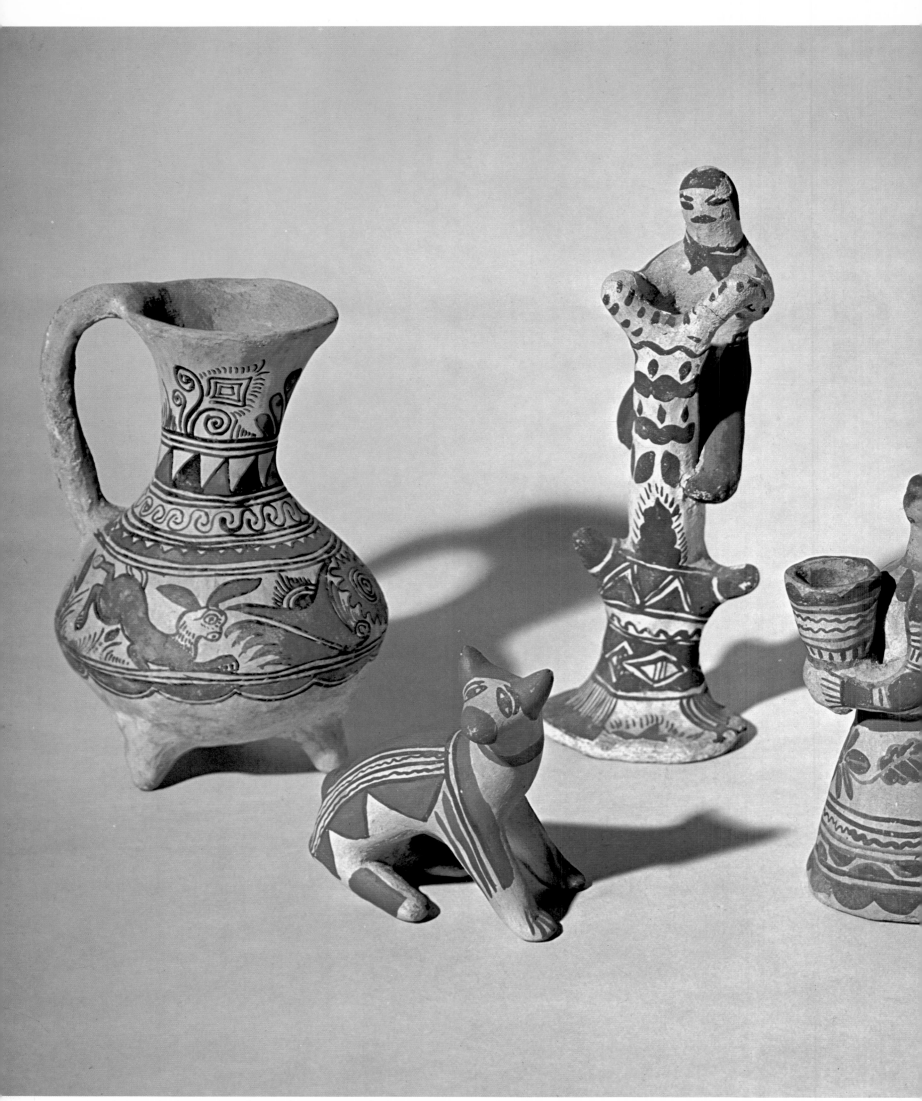

44. *Pottery objects: pitcher; figures of a dog, man climbing a tree, an angel; and coin bank shaped like a waterfowl. Tolimán.*

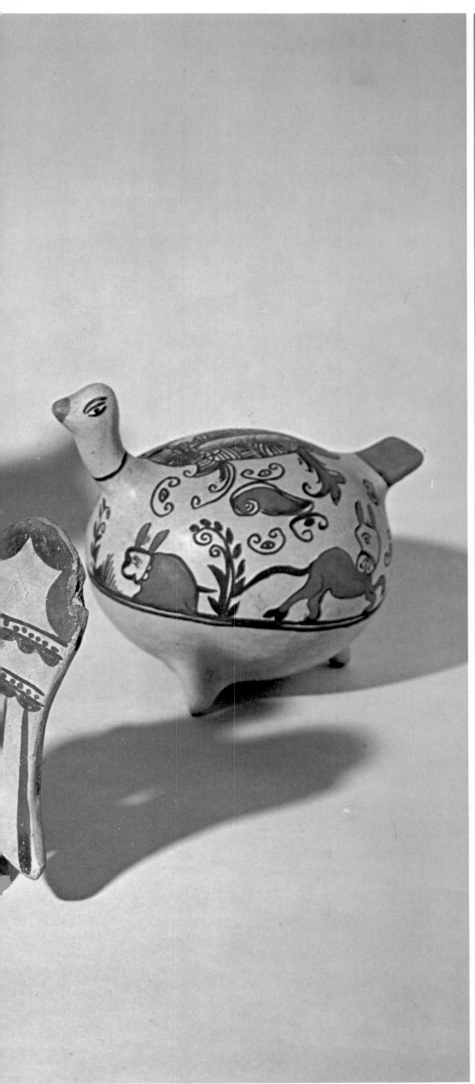

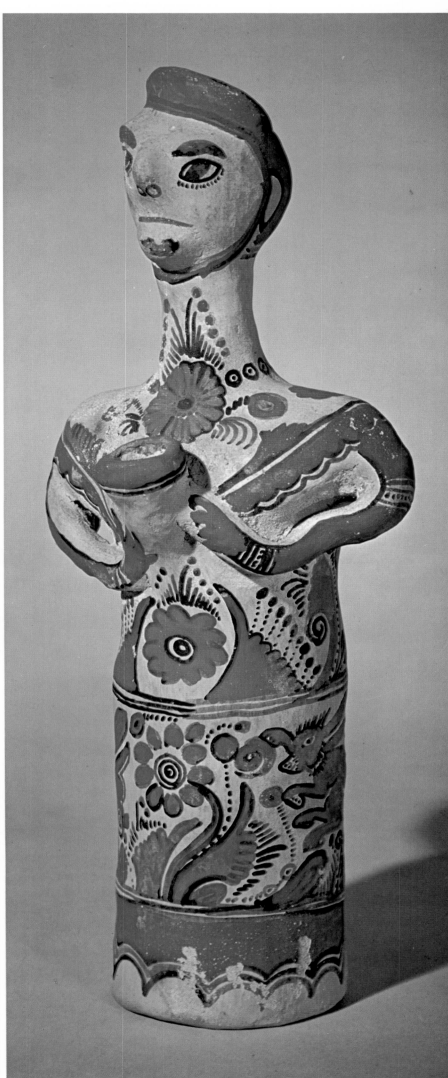

45. *Pottery figurine. Tolimán.*

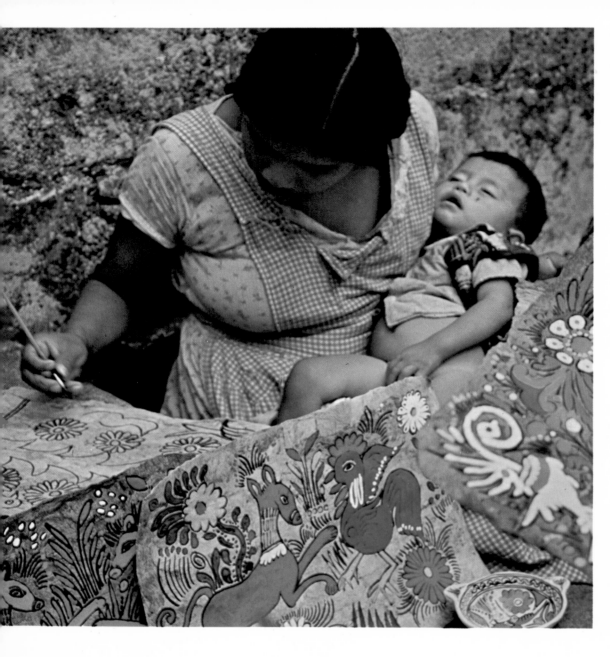

Amate Paper. A rough textured paper is made in San Pablito, Puebla, by boiling and then pounding with stones the bark of the amate tree. The paper is purchased by the people of Ameyaltepec and Xalitla who paint brilliantly colored pictures on it.

46. *Woman seated with her child in front of the Church of Santa Prisca in Taxco executes colorful drawings on amate paper.*

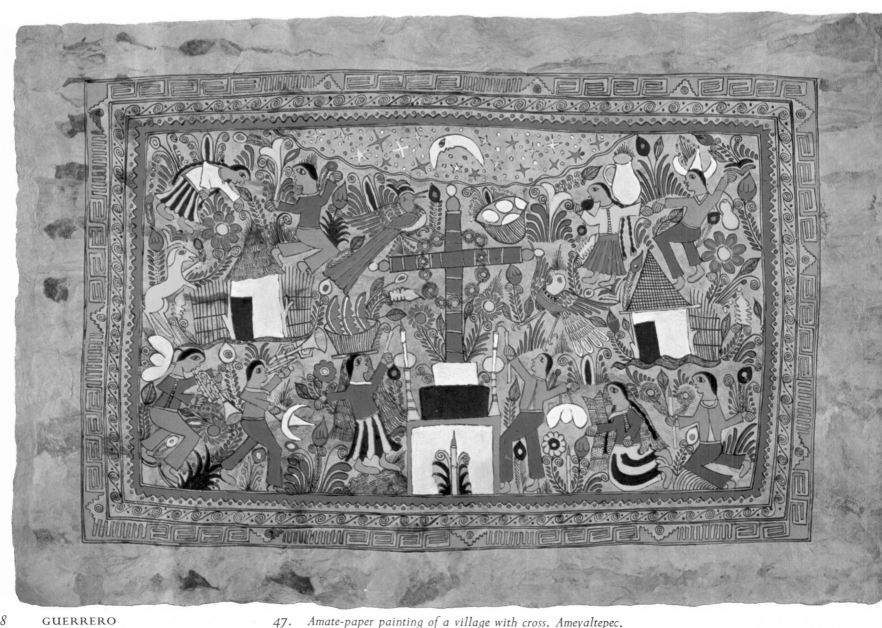

47. *Amate-paper painting of a village with cross. Ameyaltepec.*

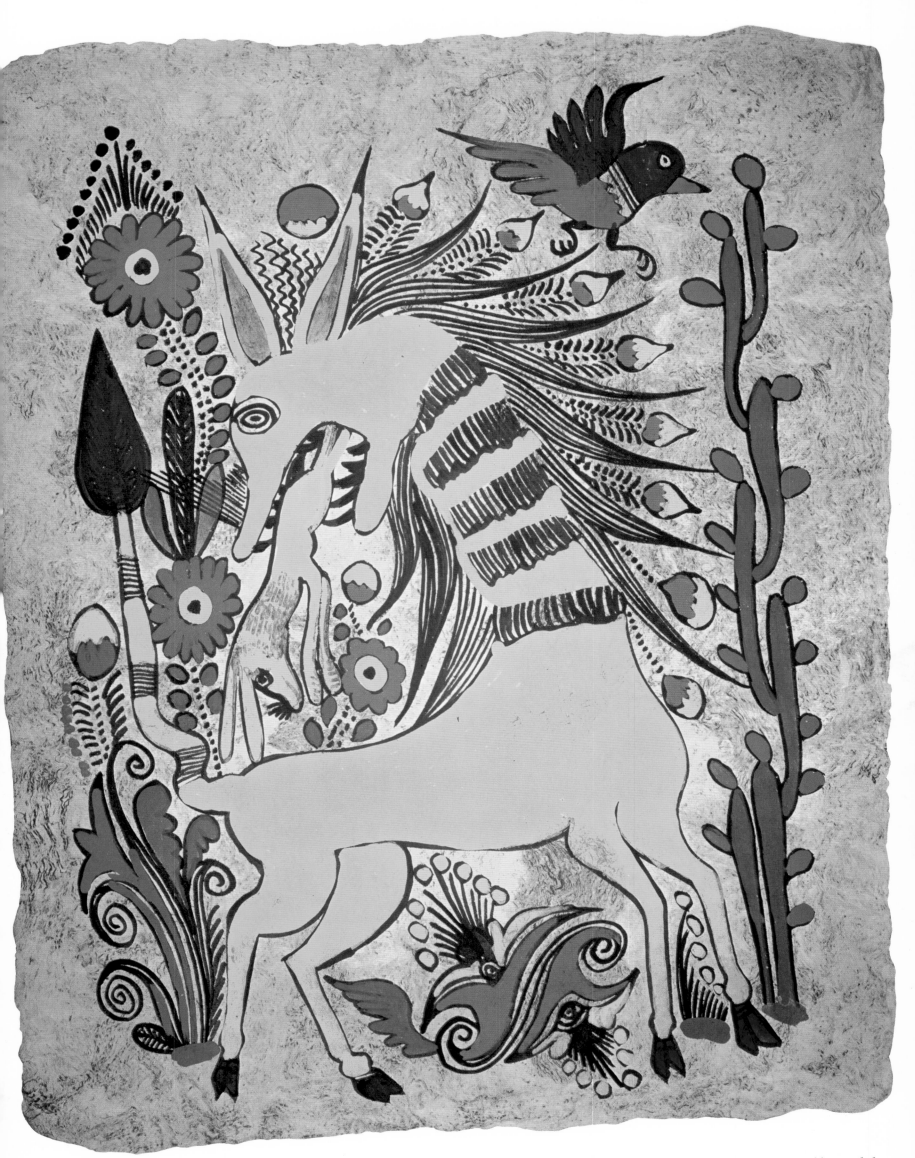

48. *Amate-paper painting of a lion eating a rabbit. Xalitla.*

49. *Amate-paper painting of a blue horse. Xalitla.*

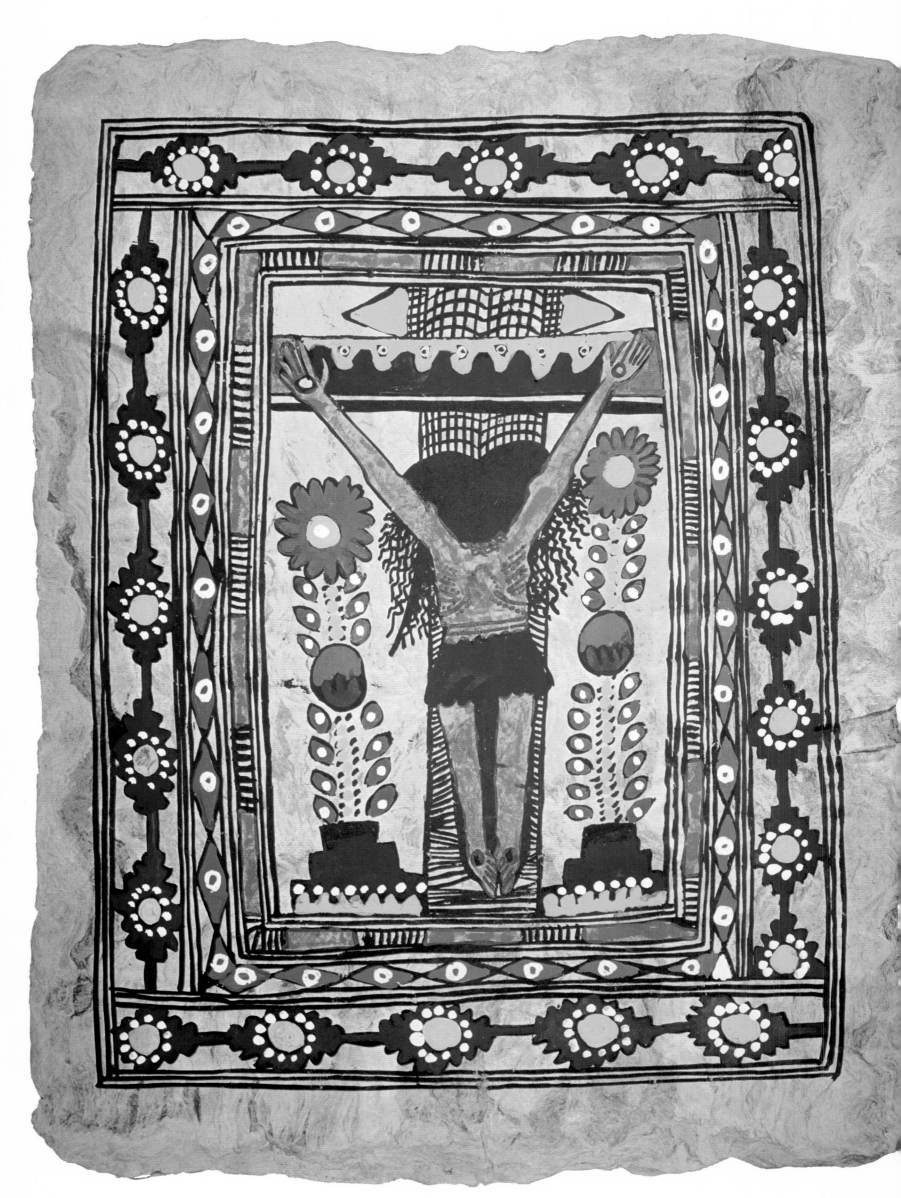

50. *Amate-paper painting of the Crucifixion. Xalitla.*

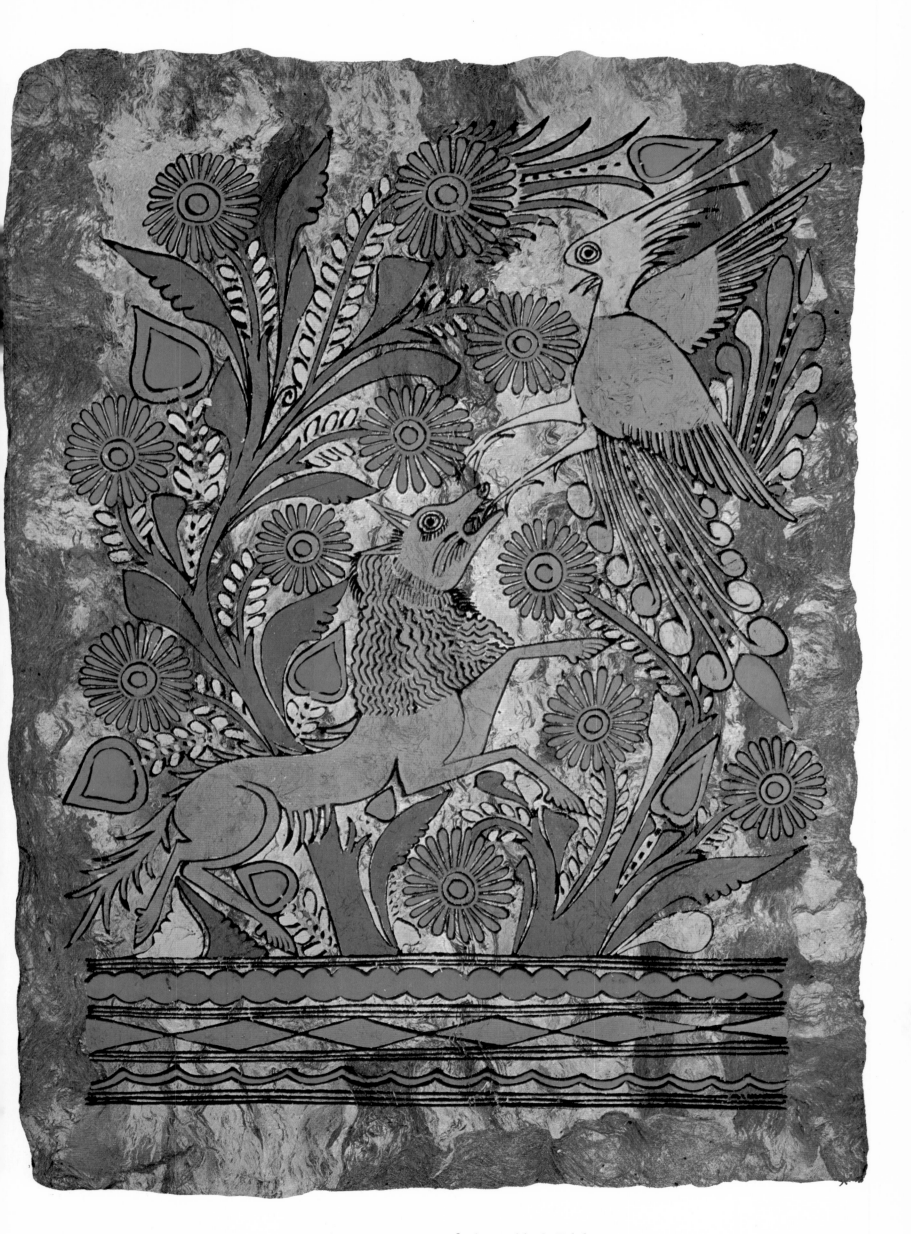

51. *Amate-paper painting of a lion and bird. Xalitla.*

53. *Votive picture. Olinalá.*

54. *Tiger's mask worn for festival of St. Francis of Assisi. Olinalá.*

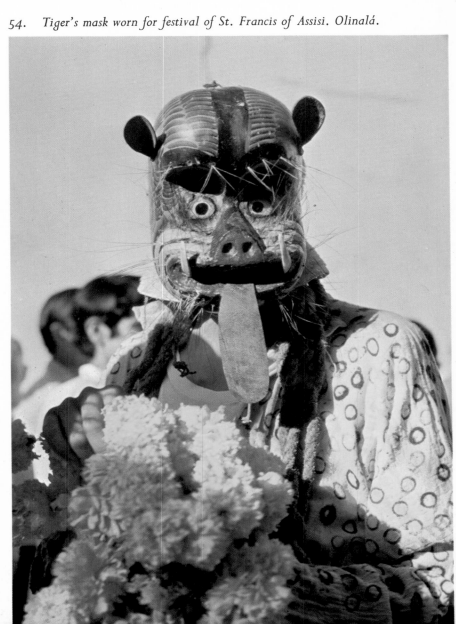

linalá. Nestled in the mountains of Guerrero, the luster of orange-roofed houses that is Olinalá resembles a small Spanish village set in rustling fields of corn. The people of Olinalá make handsome lacquerware objects decorated by means of a technique dating from re-Conquest times. First a mixture of oil and pigment is applied to a vessel and left to dry. Then a contrasting color is lacquered on. When the second coat has dried, the artisan engraves designs with a quill pen tipped with a thorn. This process may be repeated several times until the desired design is completed.

52. *Aerial view of the village of Olinalá.*

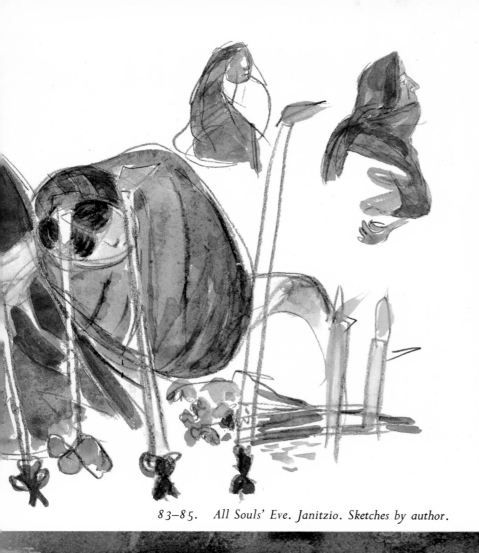
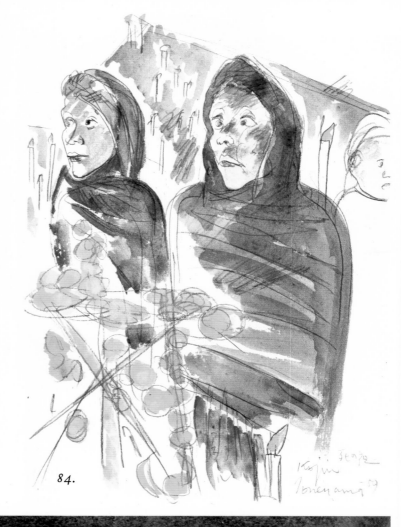

84.

83–85. *All Souls' Eve. Janitzio. Sketches by author.*

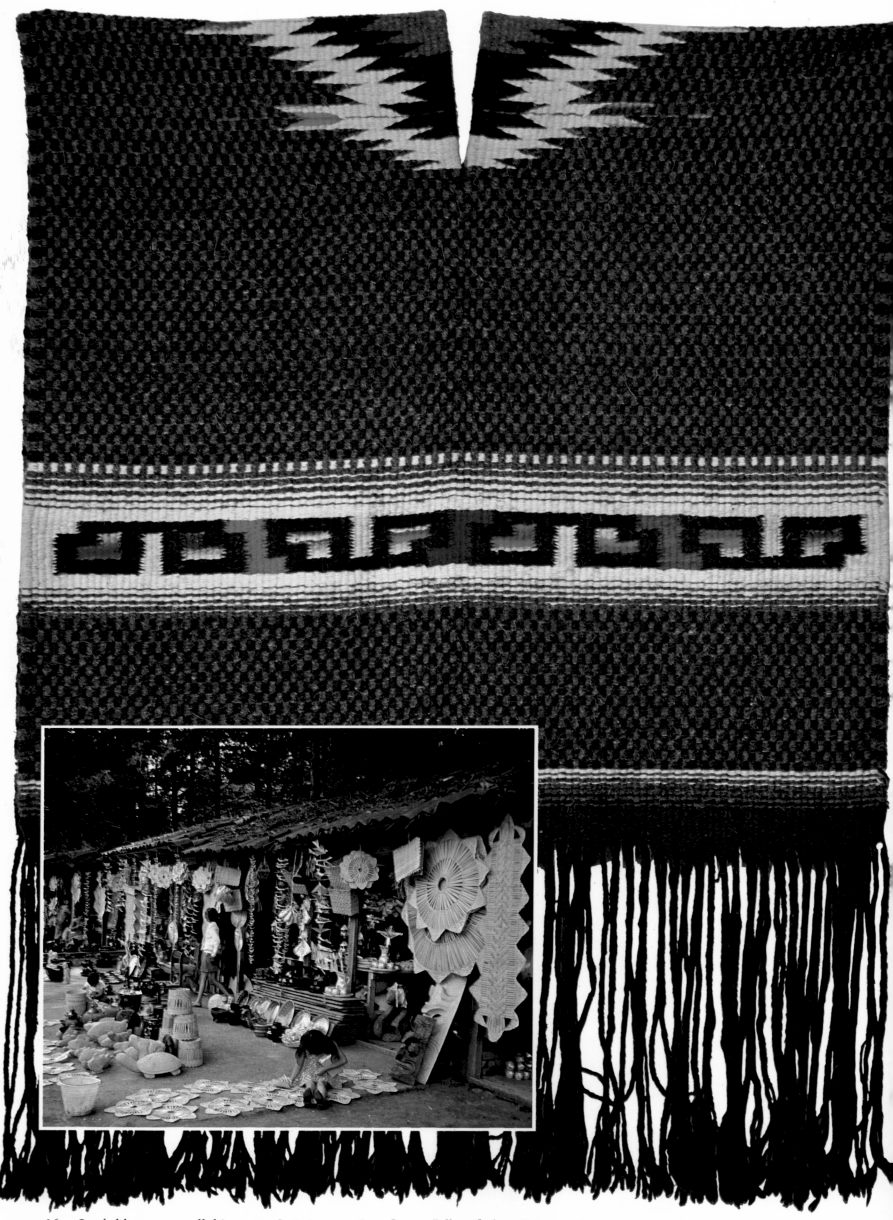

86. *Poncholike garment called* jorongo. *Janitzio.* 87. Inset: *Folk-craft shop. Tzintzuntzán.*

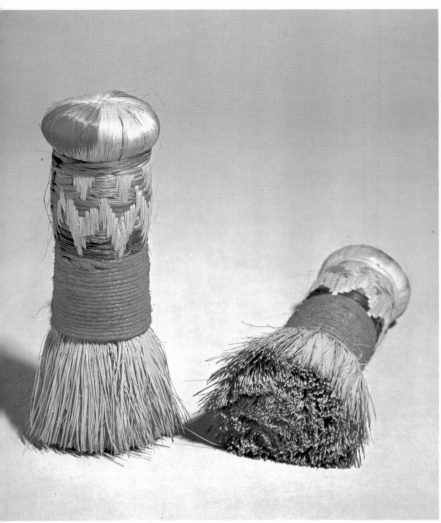

88. *Well-designed brushes. Janitzio.*

Pátzcuaro Market. Pátzcuaro is located on the shore of the lake of the same name. In its market the wares of the Tarascan Indians of Michoacán can be seen. The setting of mountains and water, and the displays of pottery, textiles, musical instruments, lacquerware, and metal work make for a very Oriental mood.

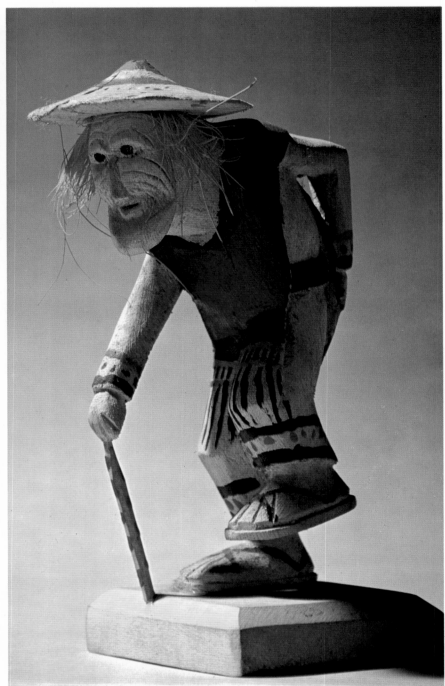

89. *Wooden figurine of old man dancing. Janitzio.*

90. *Wooden toys of a fishing boat called a* mariposa, *or butterfly, and a white fish. Janitzio.*

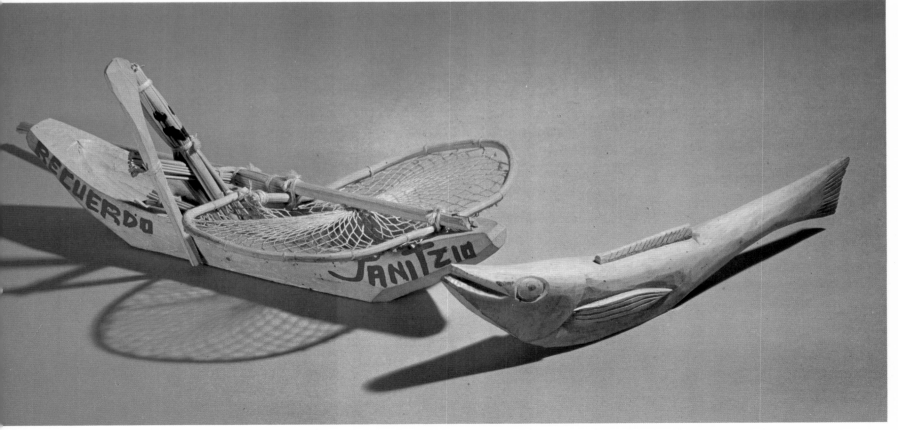

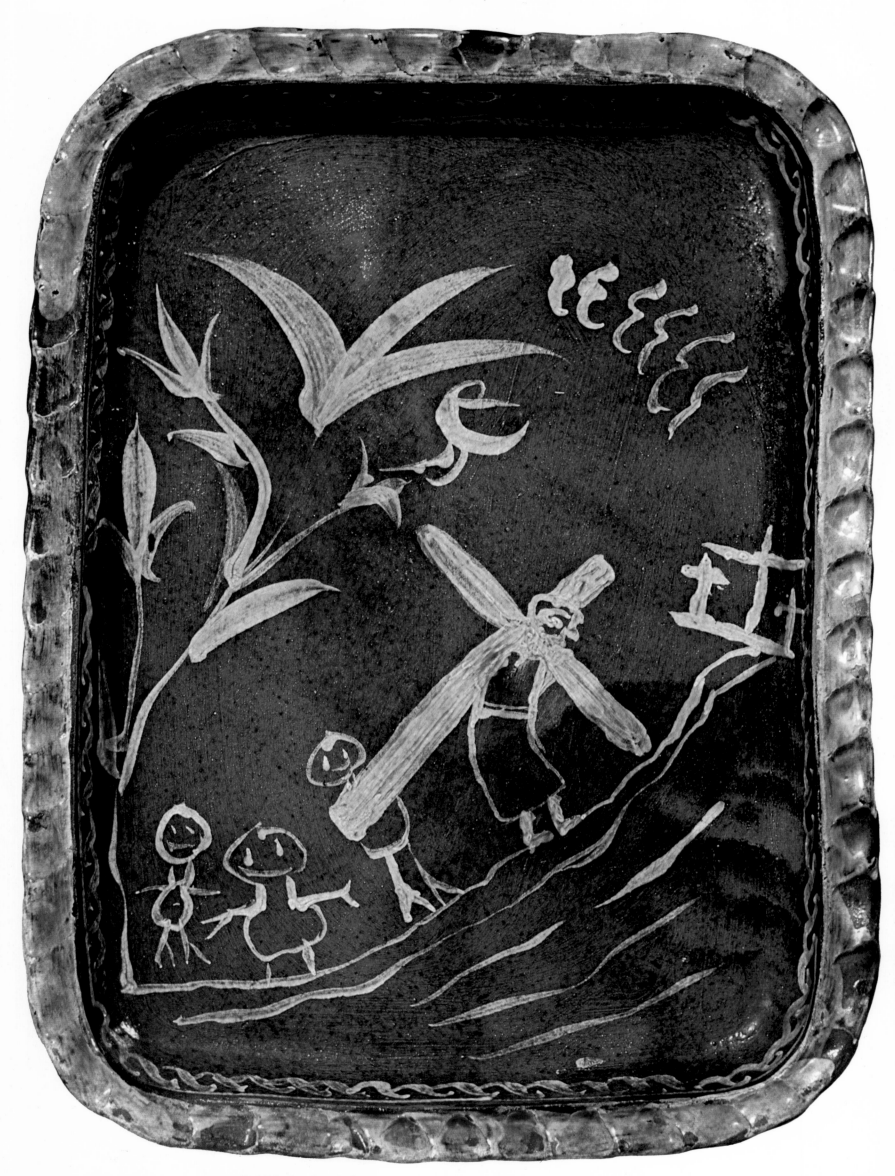

91. *Childlike brushwork depicting Golgotha on green-glaze pottery dish. Patambán.*

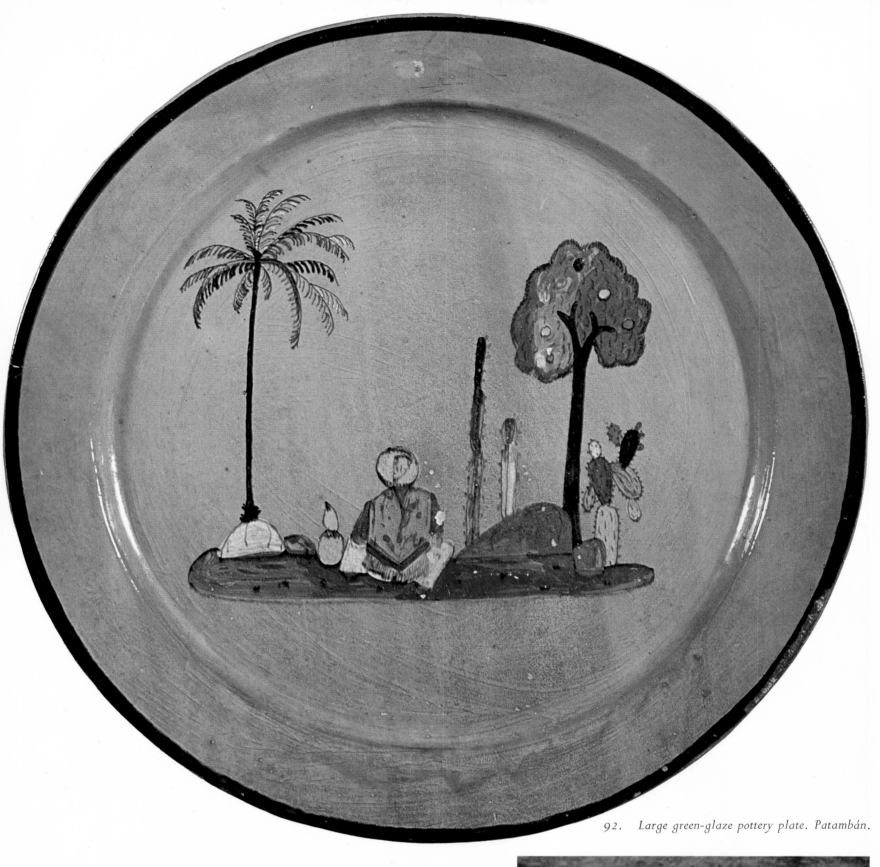

92. *Large green-glaze pottery plate. Patambán.*

Michoacán Pottery. Michoacán produces a surprisingly wide range of pottery that reveals much about the Tarascan people. Some of the pottery is ornamented with patterns in green or red glaze. Other varieties worth noting are those of San José de Gracia, Tzintzuntzán, and the "Eleven Villages" (*Once Pueblos*), each with a separate name but referred to by the collective term. The grotesque figurines from Ocumicho too are very interesting. All of this splendid pottery is surprisingly inexpensive.

93. *Green-glaze pottery water jug in the shape of a pineapple. San José de Gracia.*

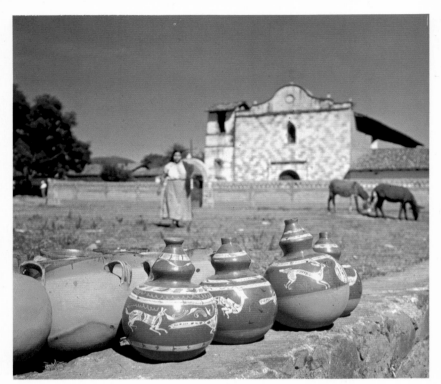

Pottery, Dolls, and Woodcarvings. The pottery, dolls, woodcarvings—especially the unusual chisel-carved figures of Tocuaro village—and the fine wooden furniture made by those who live around Lake Pátzcuaro are all interesting and attractive.

94. *Pottery jugs in the square at Ichán, one of the "Eleven Villages"* (Once Pueblos) *in the vicinity of Lake Pátzcuaro.*

95. *Cloth doll. Michoacán.*

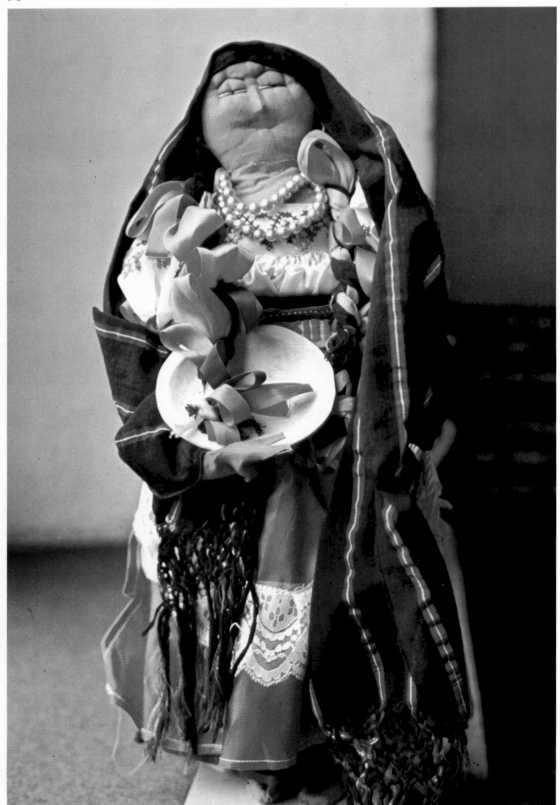

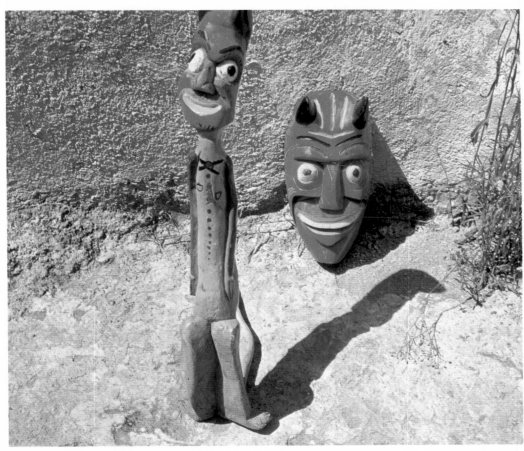

97. *Wooden figurine and mask. Zirahuén.*

98. *Woodcarvings. Tocuaro.*

6. *Man and pottery vessel. Patambán. Sketch by author.*

99 and 100. Hand-wrought copper vessels. Santa Clara.

Santa Clara de los Cobres. A town near Pátzcuaro, Santa Clara is noted for exquisite handwrought wares of copper and brass. The sound of artisans' hammering is usually heard throughout the day.

Mexico City

Judas Dolls for Holy Week. Holy Week is a very special festival time in Mexico City, and the so-called Judas dolls are an important part of the celebrations. On the day before Easter Sunday, fireworks are exploded throughout the city to chase away evil spirits. The fireworks are attached to Judas dolls, papier-mâché figures sold in the market places. The personages depicted are not limited to Judas: there are also skeletons, wicked generals from the time of the Mexican Revolution, and famous characters from popular cartoon strips. The dolls are demolished when fireworks attached to them are set off. The painter Diego Rivera collected Judas dolls as a hobby.

101. *Judas dolls, papier-mâché figures made for Holy Week. Mexico City.*

102. *Judas doll. Mexico City.*

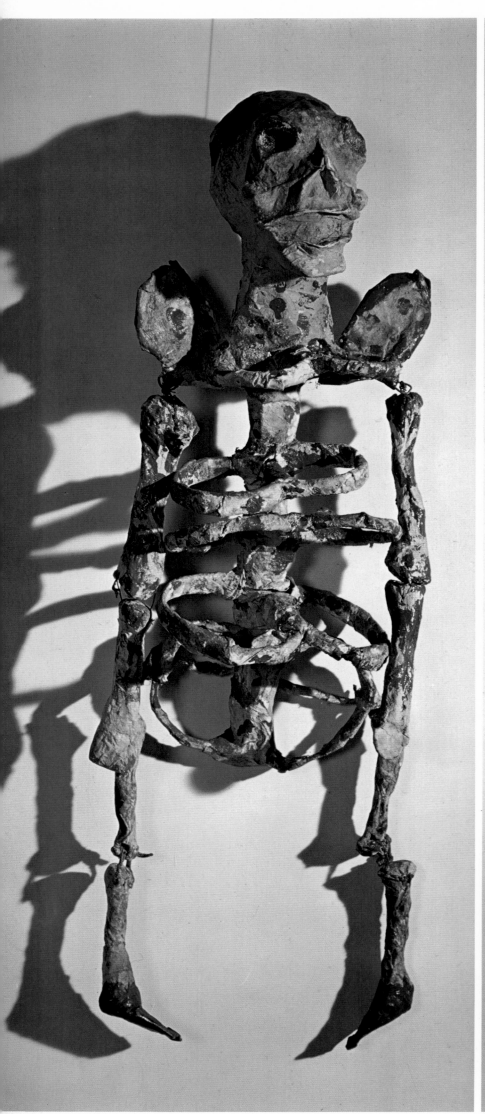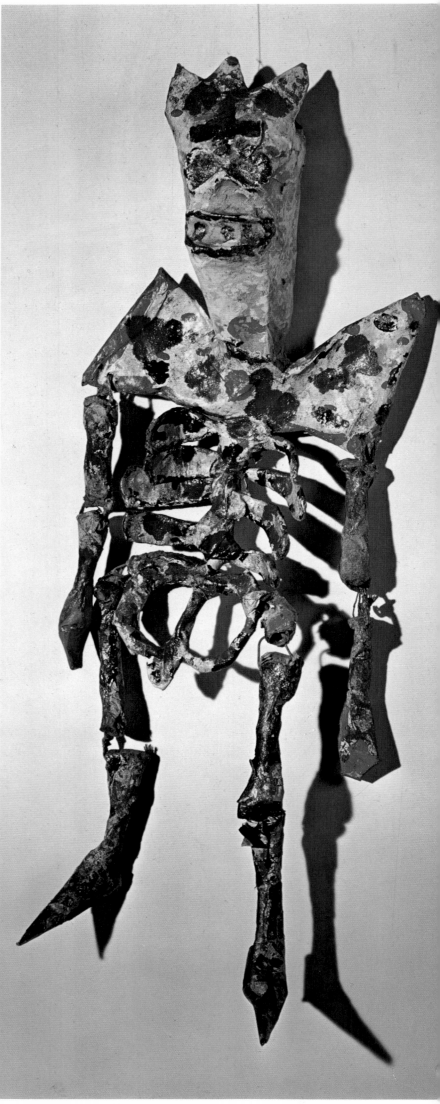

103, 104, and 105 (facing page). *Judas dolls in the shapes of skeletons. Mexico City.*

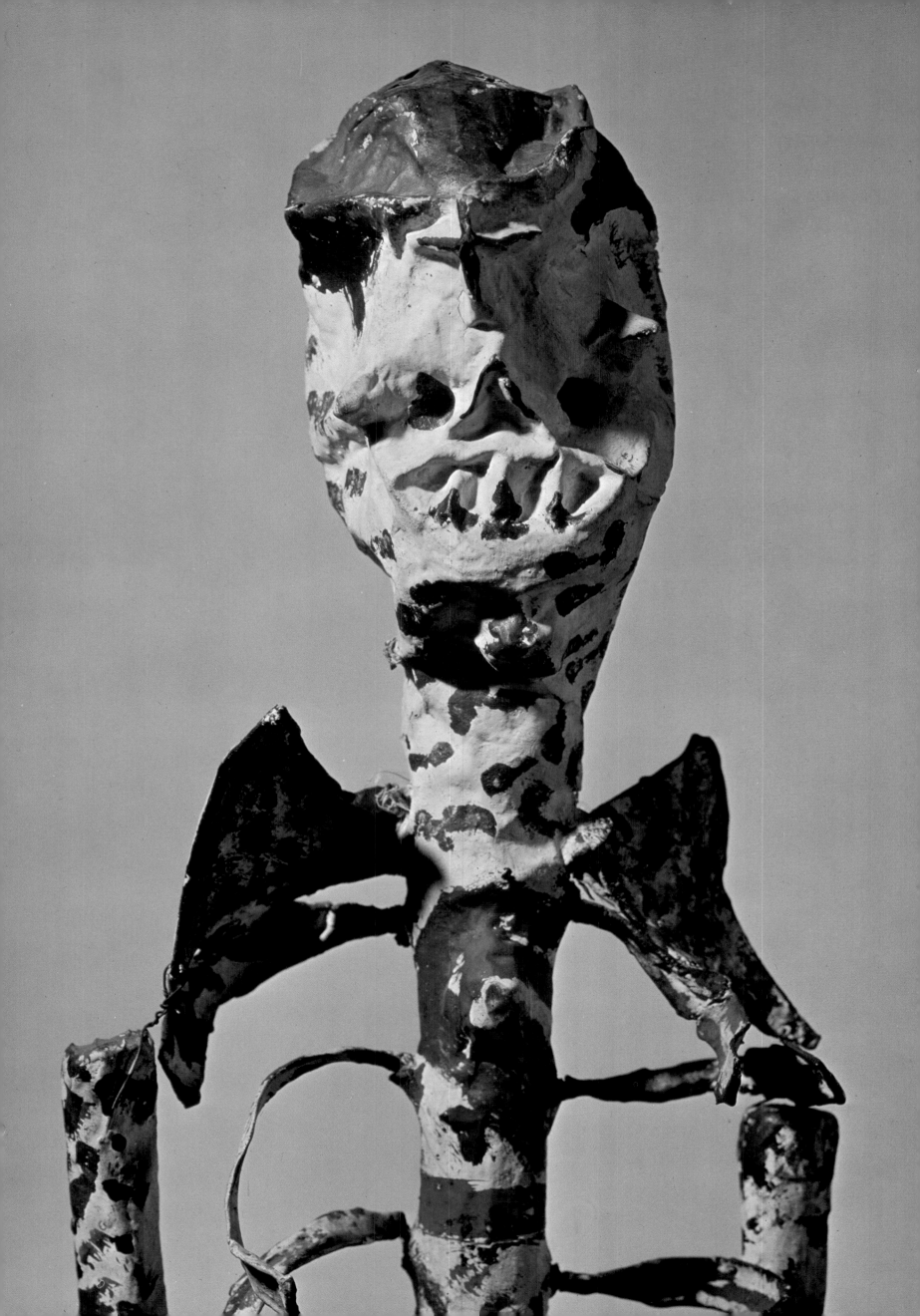

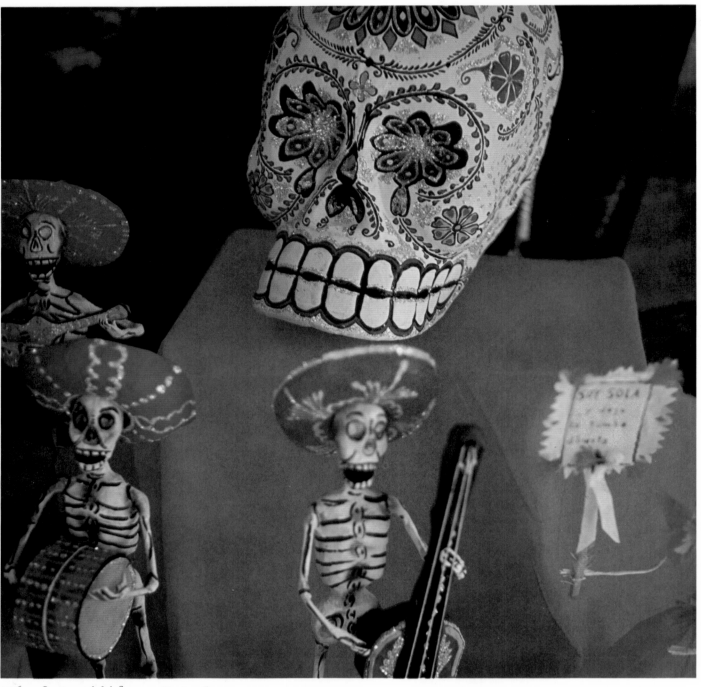

106. *Papier-mâché figures. Mexico City.*

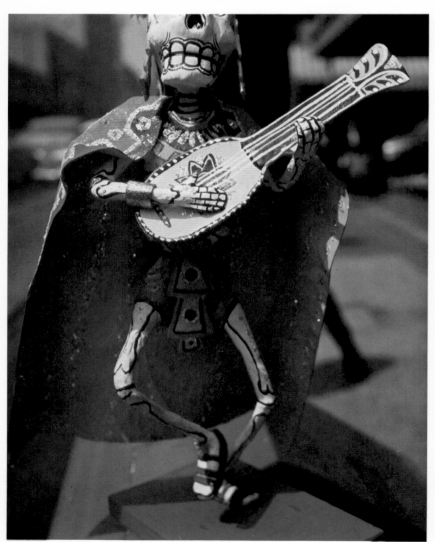

107. *Papier-mâché skeleton musician. Mexico City.*

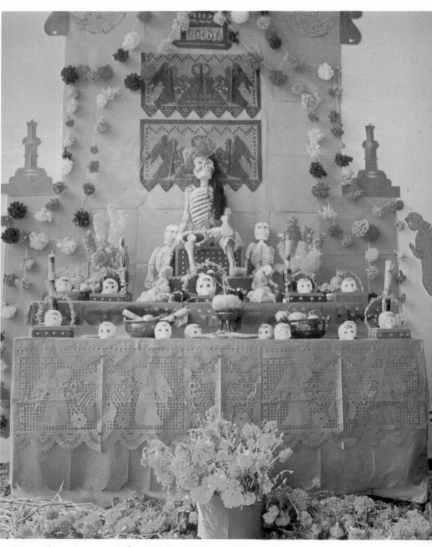

108. *Altar decorated for All Souls' Day. Mexico City.*

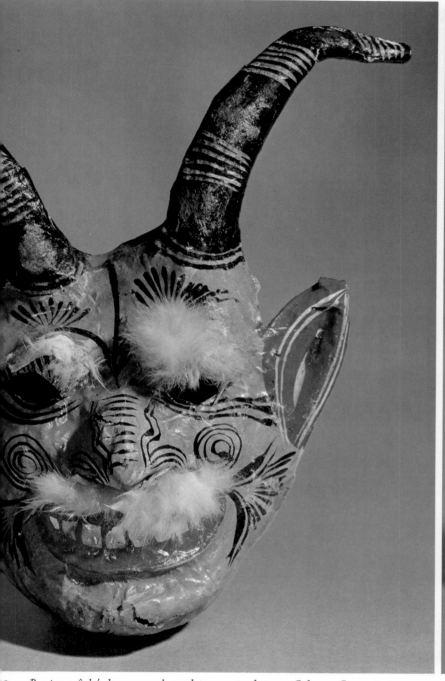

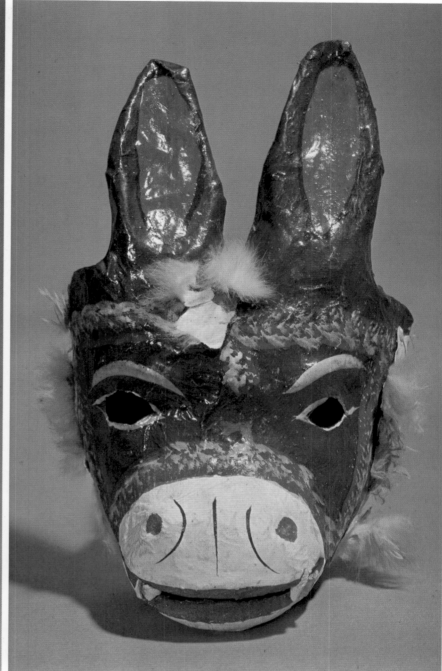

109. *Papier-mâché demon mask used in carnival time. Celaya, Guanajuato.* 110. *Papier-mâché donkey mask. Celaya, Guanajuato.*

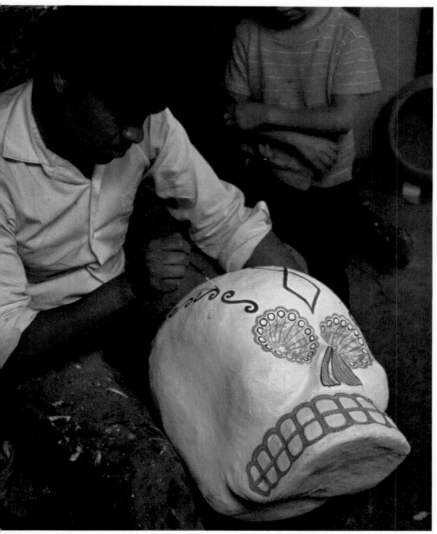

111. *Painting decorations on a papier-mâché skull. Mexico City.*

Death Treated with Humor. For All Souls' Day, the Mexican Day of the Dead, brightly colored and decorated skeletons and skulls in sugar, bread, and papier-mâché are seen all over Mexico City. Some of the skeleton figures are made to represent strolling guitar players, mariachi bands, or even newspaper delivery boys. This humorous approach to the fact of death is a Mexican national characteristic.

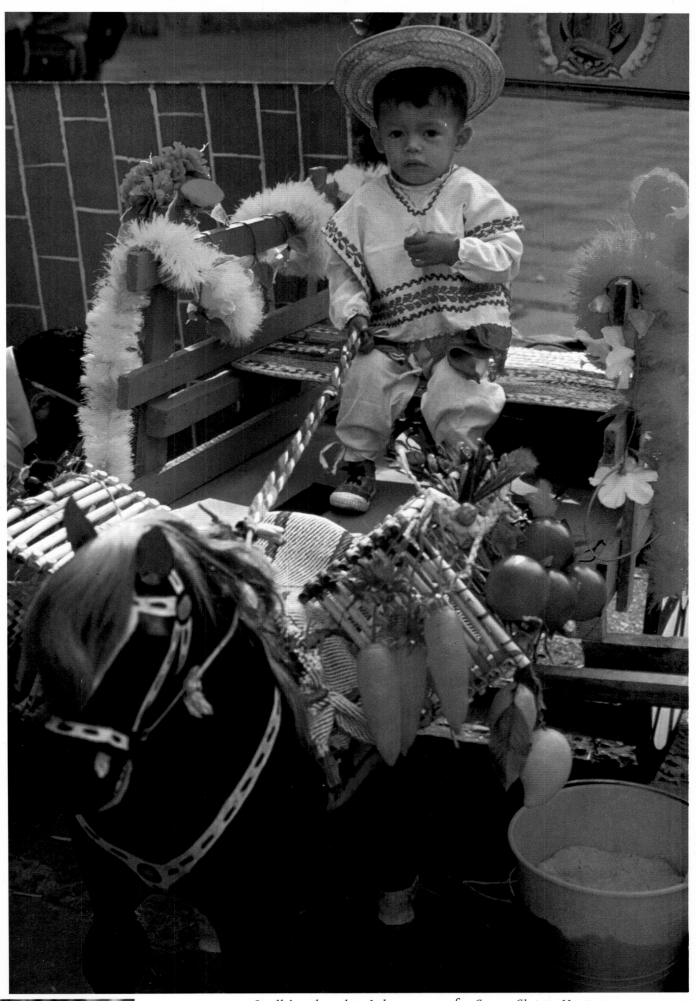

125. *Decoration for Corpus Christi. Parts of donkey's body are made of corn leaves. Mexico City.*

124. *Small boy dressed in Indian costume for Corpus Christi. He sits in toy pony cart before the Cathedral in Mexico City.*

Feast of Corpus Christi. On Corpus Christi, celebrated the Thursday after Trinity Sunday, parents in Mexico City dress their children in native Indian costumes and take them to the Cathedral. Gaily adorned adults and children and large numbers of burros throng the streets.

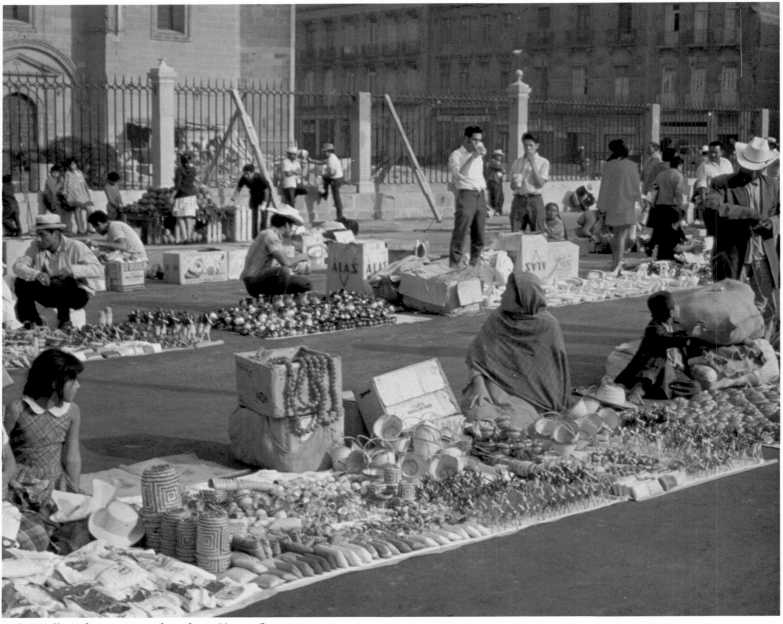

126. *Selling decorations and trinkets. Mexico City.*

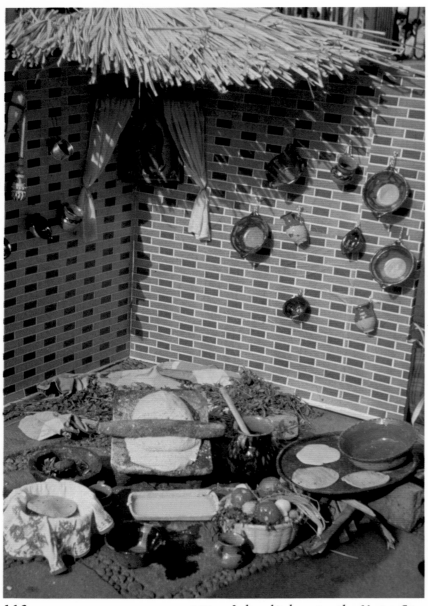

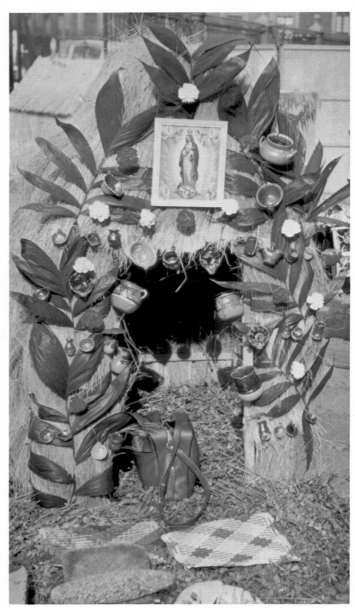

127. *Indian kitchen utensils. Mexico City.*

128. *Symbolic grass-hut ornamented with flowers, pottery, and picture of the Virgin Mary. Mexico City.*

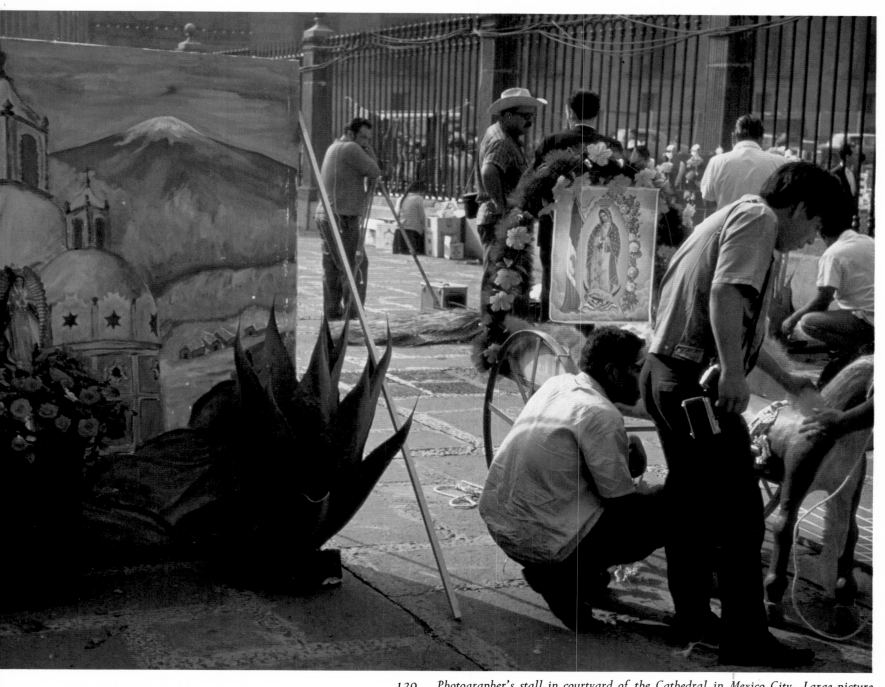

129. *Photographer's stall in courtyard of the Cathedral in Mexico City. Large picture on left is background for photographic portraits.*

131. *Small boy with festival toys tied to his back. Mexico City.*

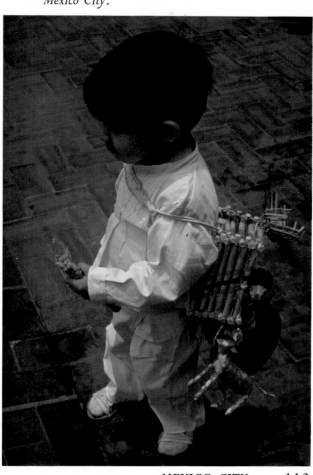

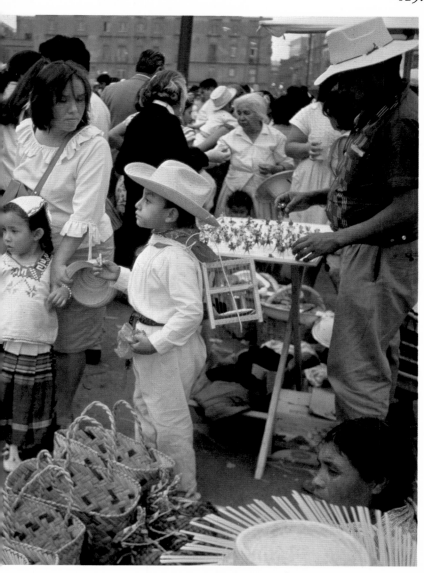

130. *Children on festival day. Mexico City.*

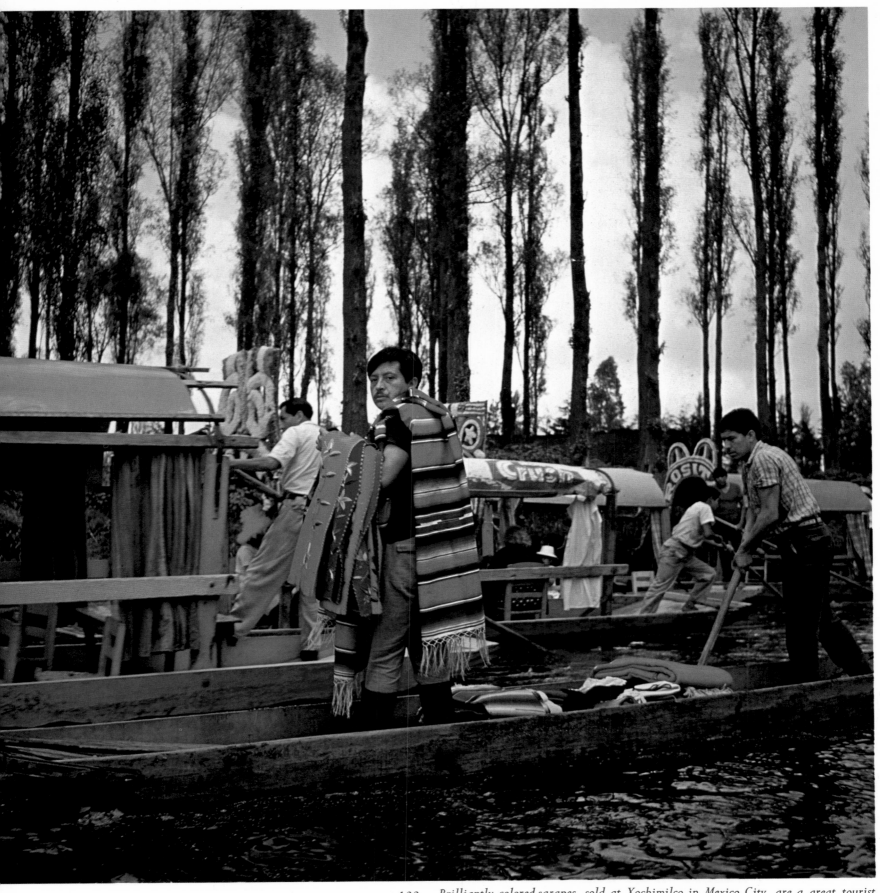

133. *Brilliantly colored sarapes, sold at Xochimilco in Mexico City, are a great tourist attraction.*

ting at Xochimilco. Riding in flower-decked boats, rists enjoy excursions among the famous "floating dens" of Xochimilco in the outskirts of Mexico y. Among the tourist craft float other boats bearing riachi bands and sellers of sarapes.

a Market. On Sunday mornings, people in Mexico ty flock to the famous flea market, where men in tered clothes shout the word "rubbish" as enthusiic bargain hunters rummage among the antiques and ds and ends offered for sale.

. Sunday flea market. Mexico City.

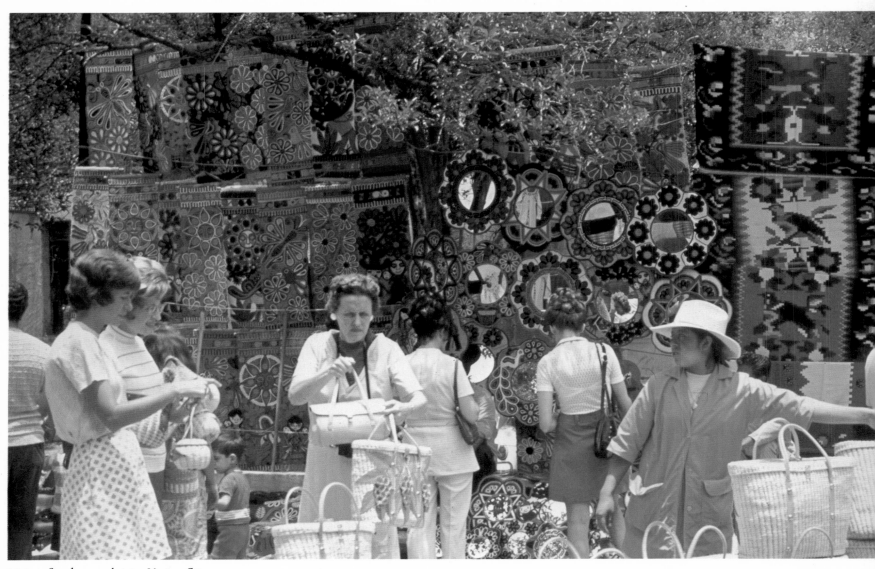

134. *Sunday market in Mexico City.*

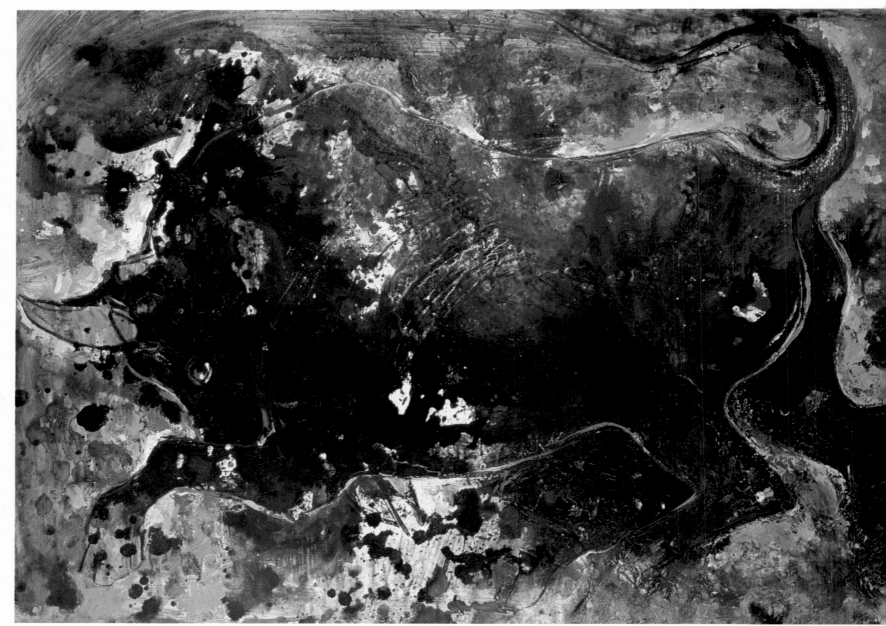

135. *Fighting bull. Painting by author.*

136. *Impressions of carnival. Mexico City. Painting by aut*

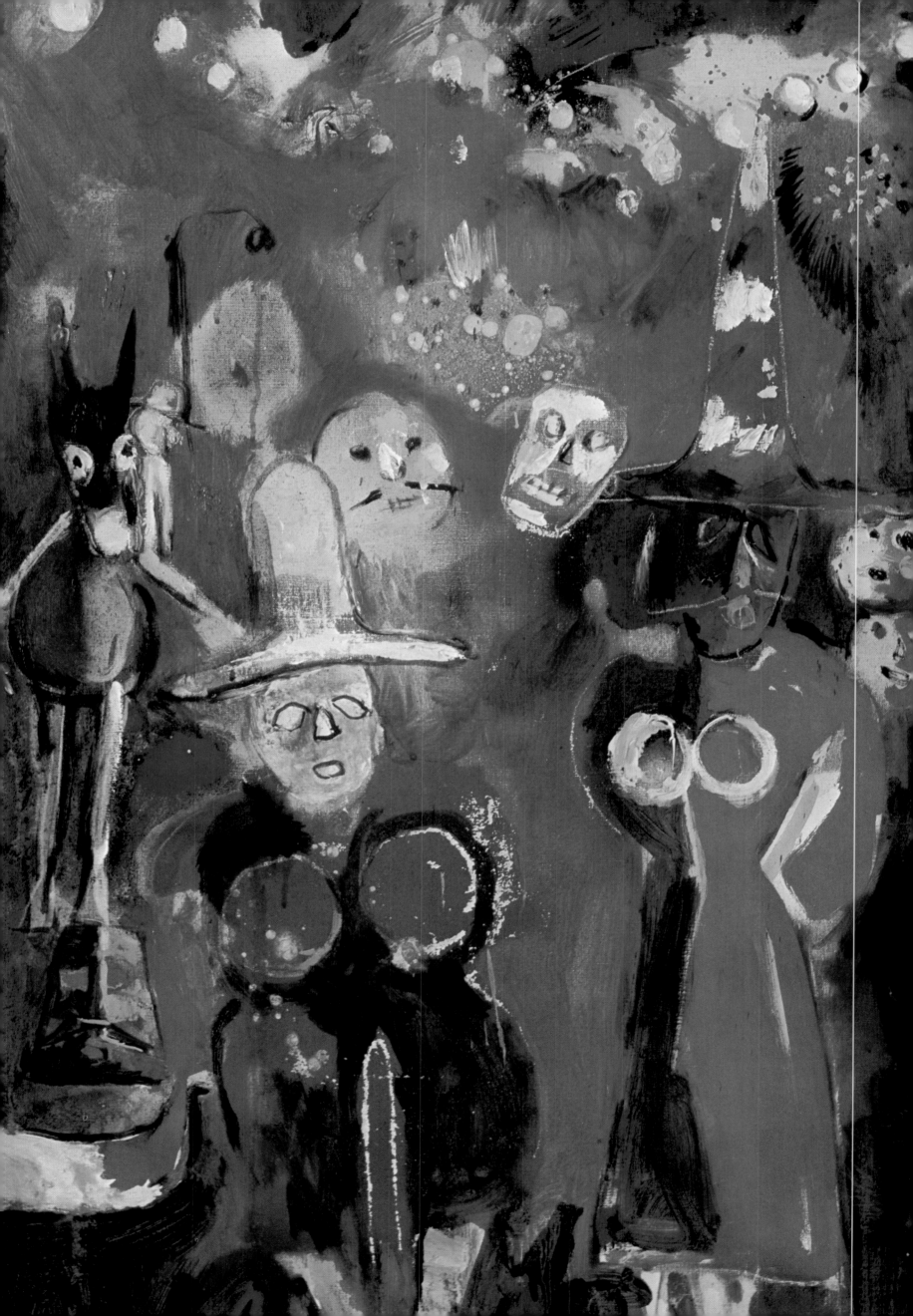

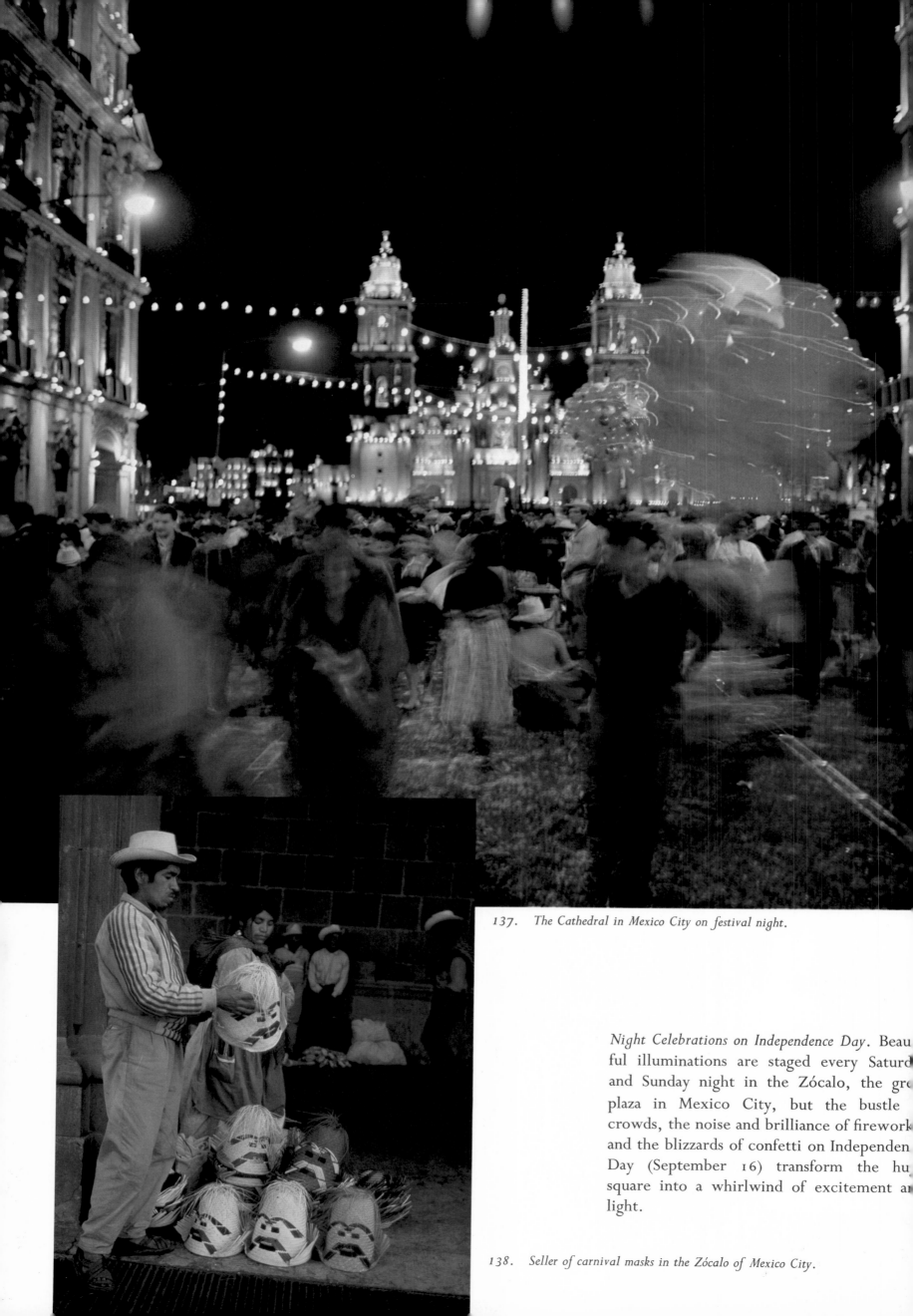

137. *The Cathedral in Mexico City on festival night.*

Night Celebrations on Independence Day. Beau
ful illuminations are staged every Saturd
and Sunday night in the Zócalo, the gre
plaza in Mexico City, but the bustle
crowds, the noise and brilliance of firework
and the blizzards of confetti on Independen
Day (September 16) transform the hu
square into a whirlwind of excitement ar
light.

138. *Seller of carnival masks in the Zócalo of Mexico City.*

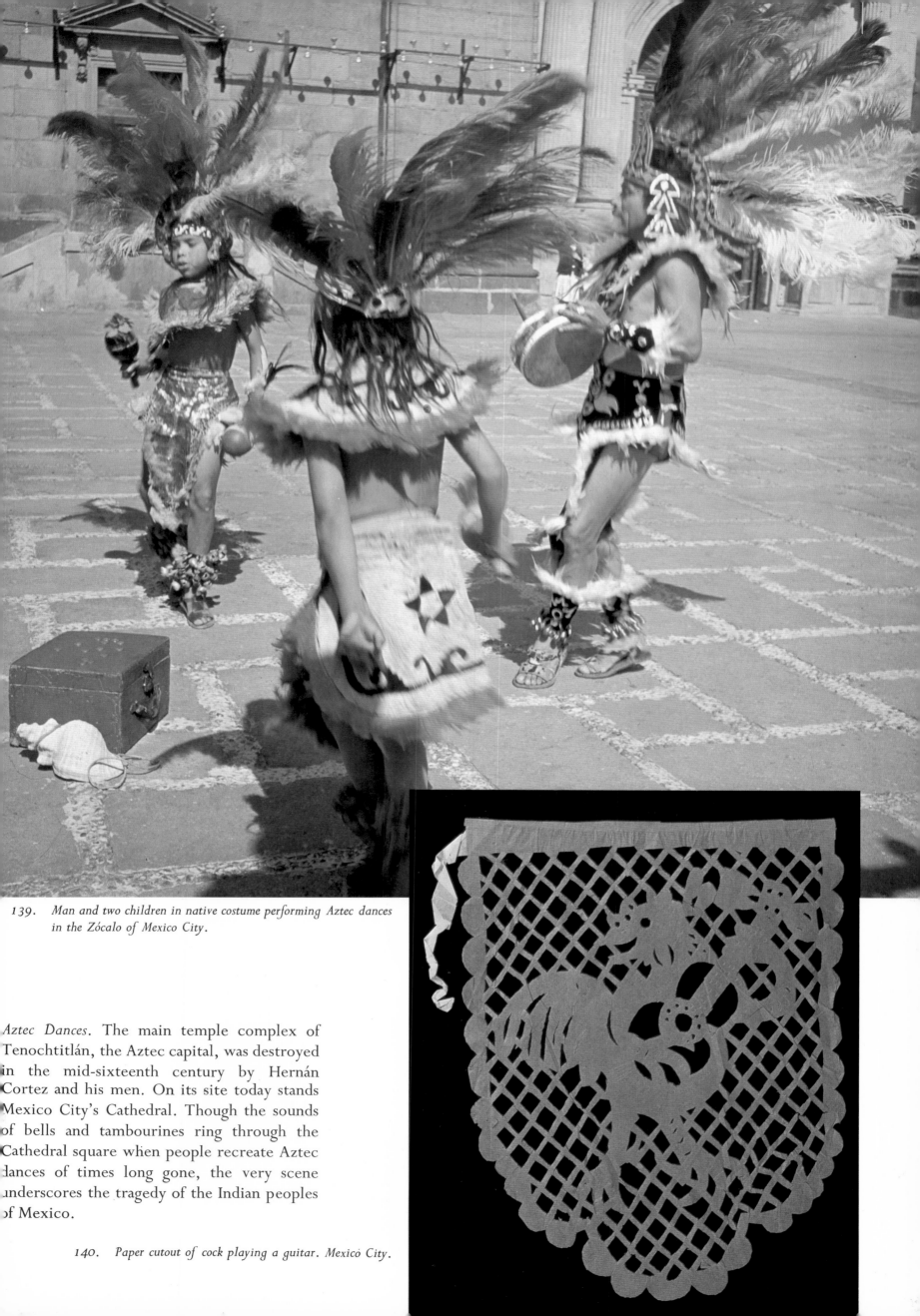

139. *Man and two children in native costume performing Aztec dances in the Zócalo of Mexico City.*

Aztec Dances. The main temple complex of Tenochtitlán, the Aztec capital, was destroyed in the mid-sixteenth century by Hernán Cortez and his men. On its site today stands Mexico City's Cathedral. Though the sounds of bells and tambourines ring through the Cathedral square when people recreate Aztec dances of times long gone, the very scene underscores the tragedy of the Indian peoples of Mexico.

140. *Paper cutout of cock playing a guitar. Mexico City.*

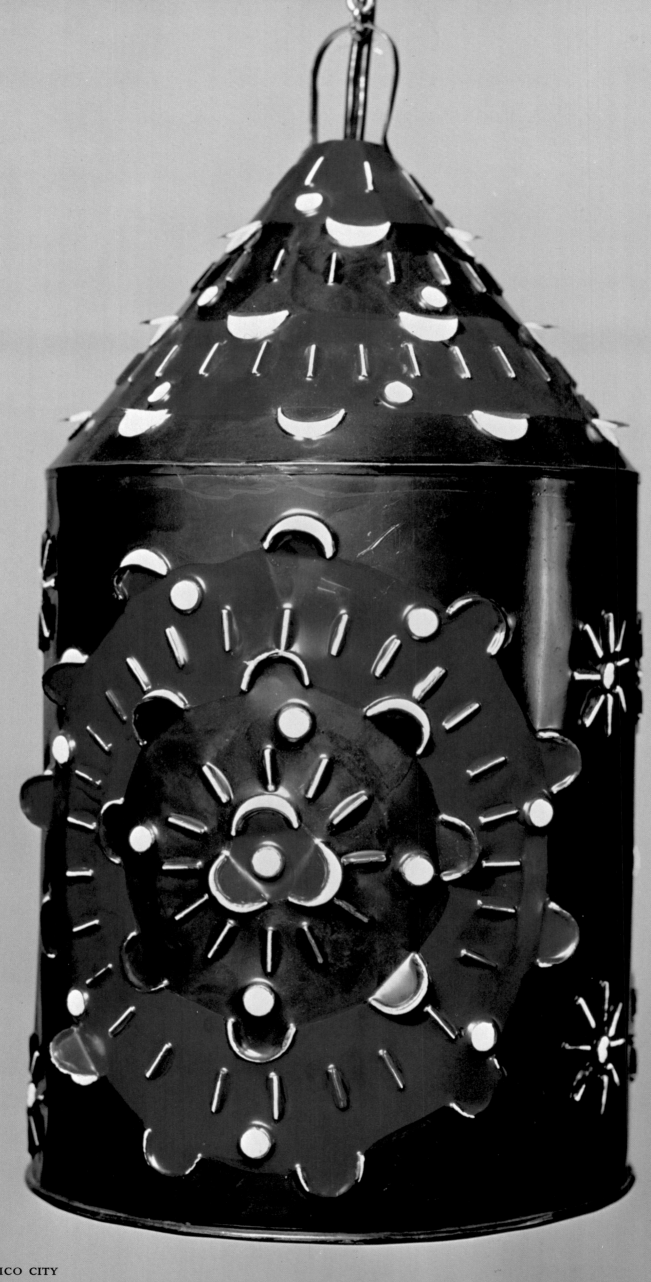

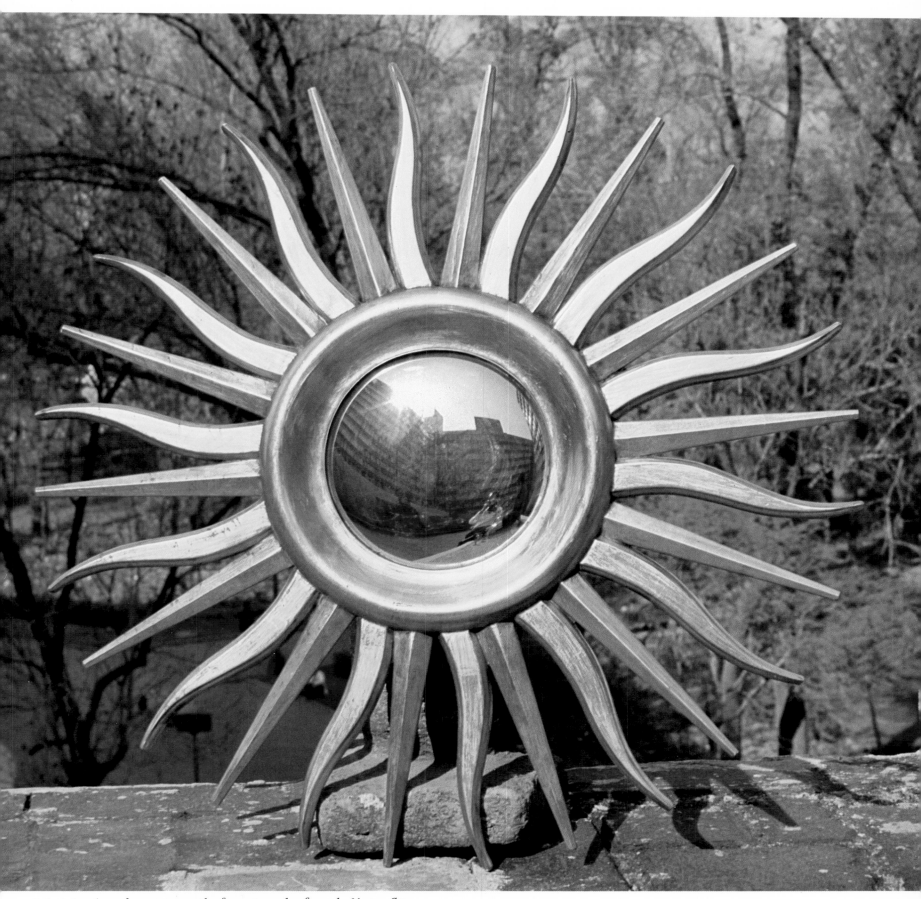

42. *Colonial-style sunburst mirror; the frame is made of wood. Mexico City.*

1. *Hanging lantern made of tin. Mexico City.*

164. *Doves at the entrance to potter's workshop. Metepec.*

State of Mexico

Colored Unglazed Pottery. Whether used to depict sun masks, representations of Adam and Eve called "trees of life," saints, or animals, the unglazed pottery of the village of Metepec is unusual and powerful in form and color.

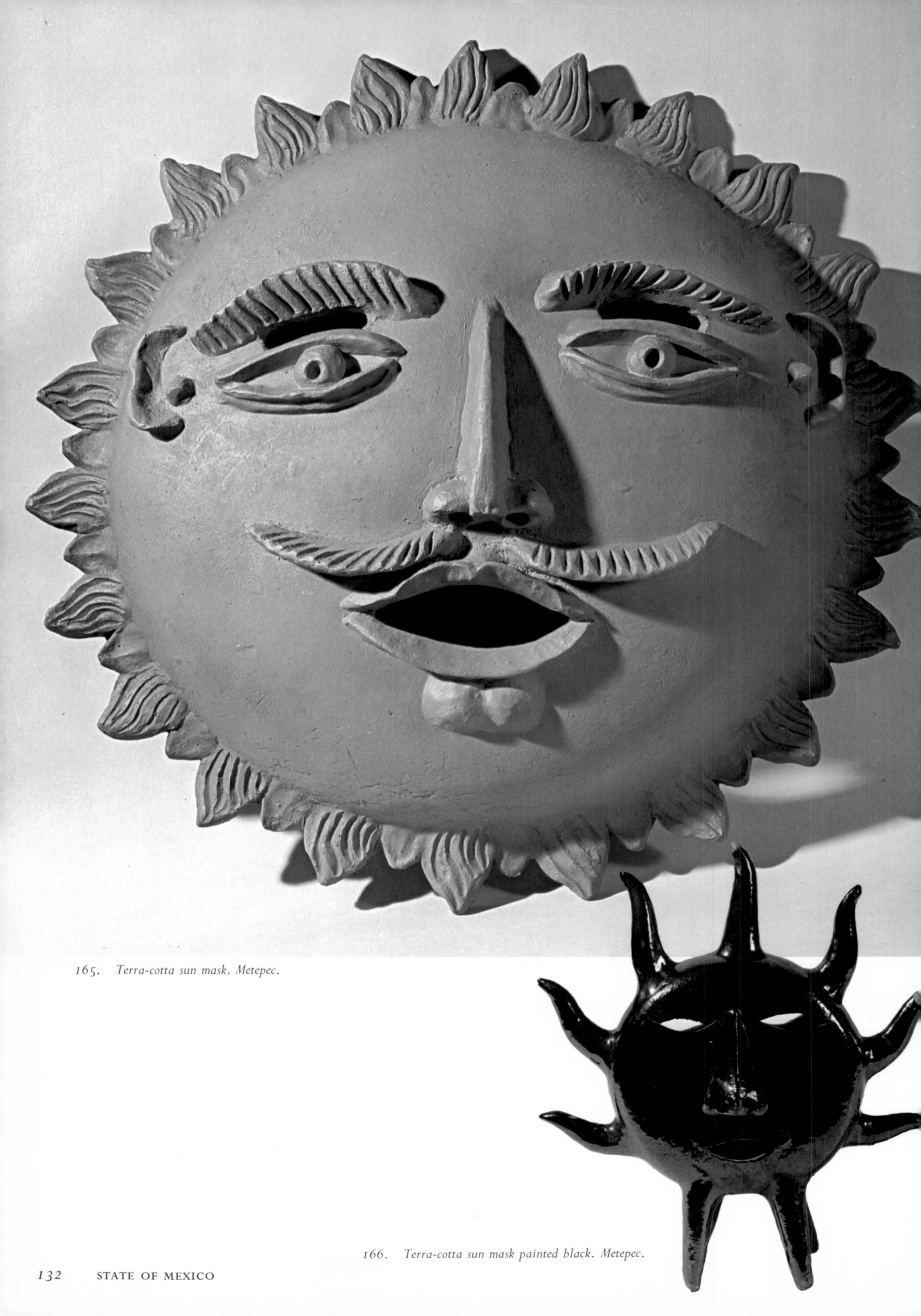

165. *Terra-cotta sun mask. Metepec.*

166. *Terra-cotta sun mask painted black. Metepec.*

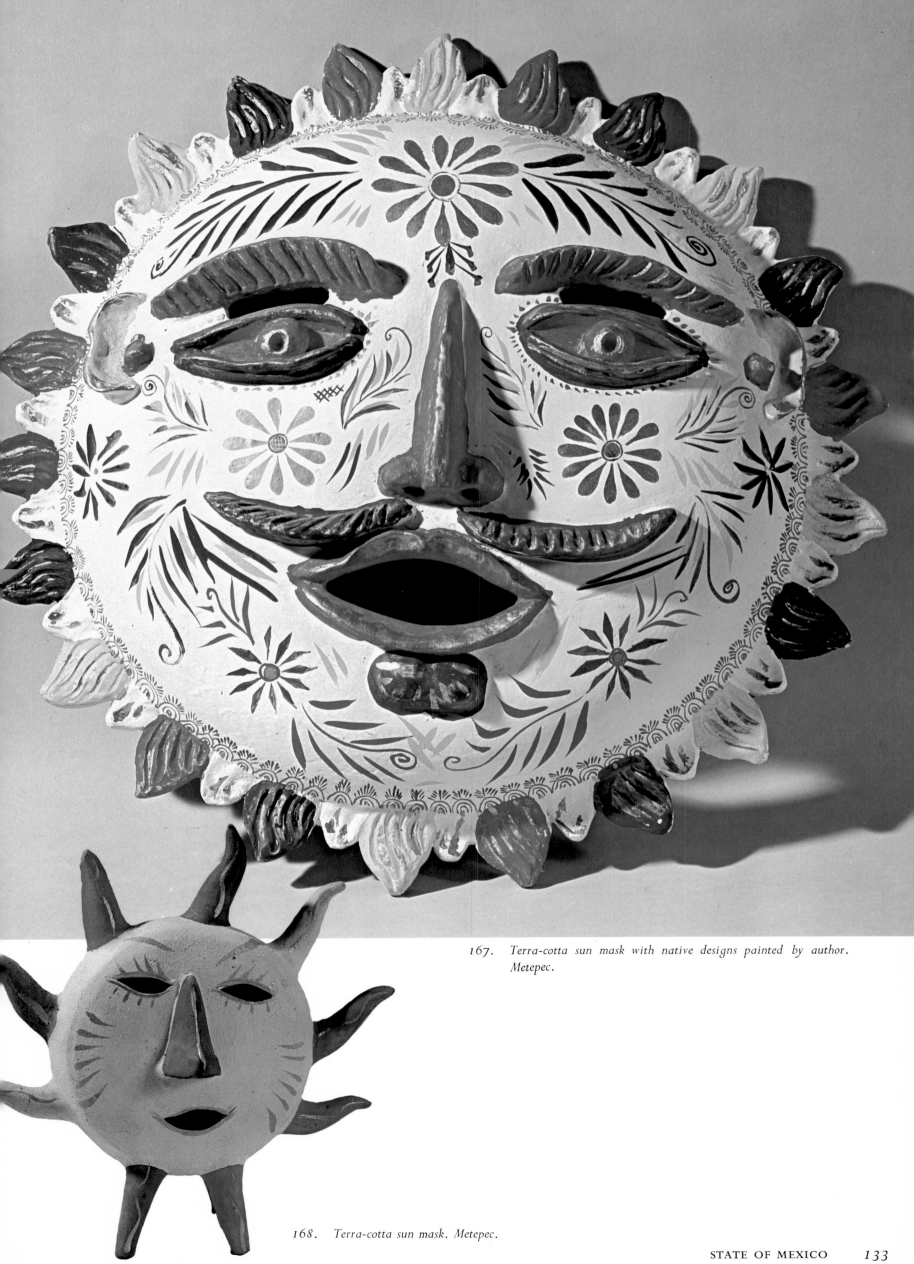

167. *Terra-cotta sun mask with native designs painted by author. Metepec.*

168. *Terra-cotta sun mask. Metepec.*

169. *The famous potter Timoteo, in front of his kiln. Metepec.*

Metepec Kiln. One of the most outstanding sources of Mexican folk pottery, Metepec is located near Toluca, capital of the state of Mexico. The kiln of Timoteo, a famous Metepec potter, rises conspicuously at the entrance to the village. In the distinctive front court-yard of his factory, sun masks, candlesticks, and other pieces stand drying in the sun as flocks of white doves wheel overhead. After the pottery is dried, it is fired in a standing kiln. Later it is usually painted with a white base coat and then decorated in brilliant colors and gold paint. Some of the masks and "trees of life" produced in this factory are of great size.

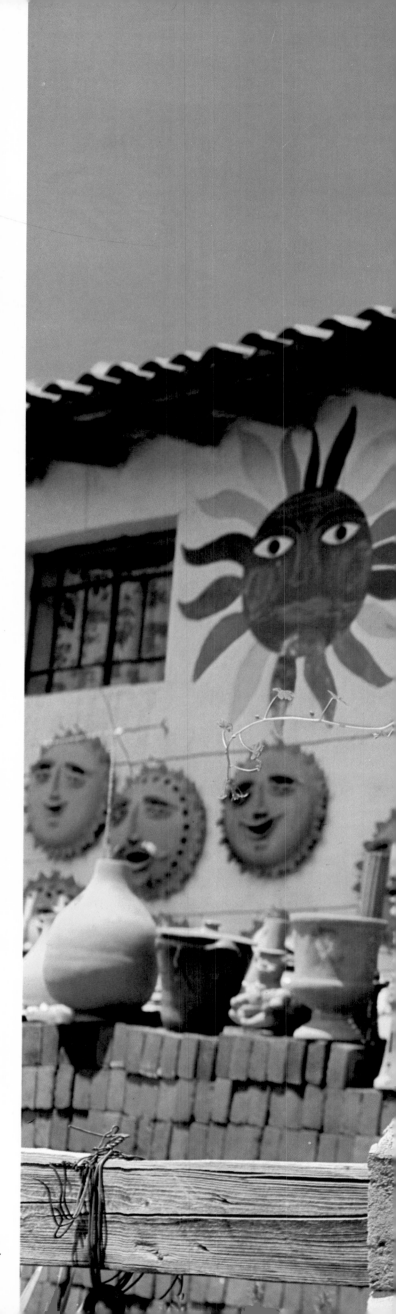

170. *Timoteo's workshop displaying a number of terra-cotta works. Metepec.*

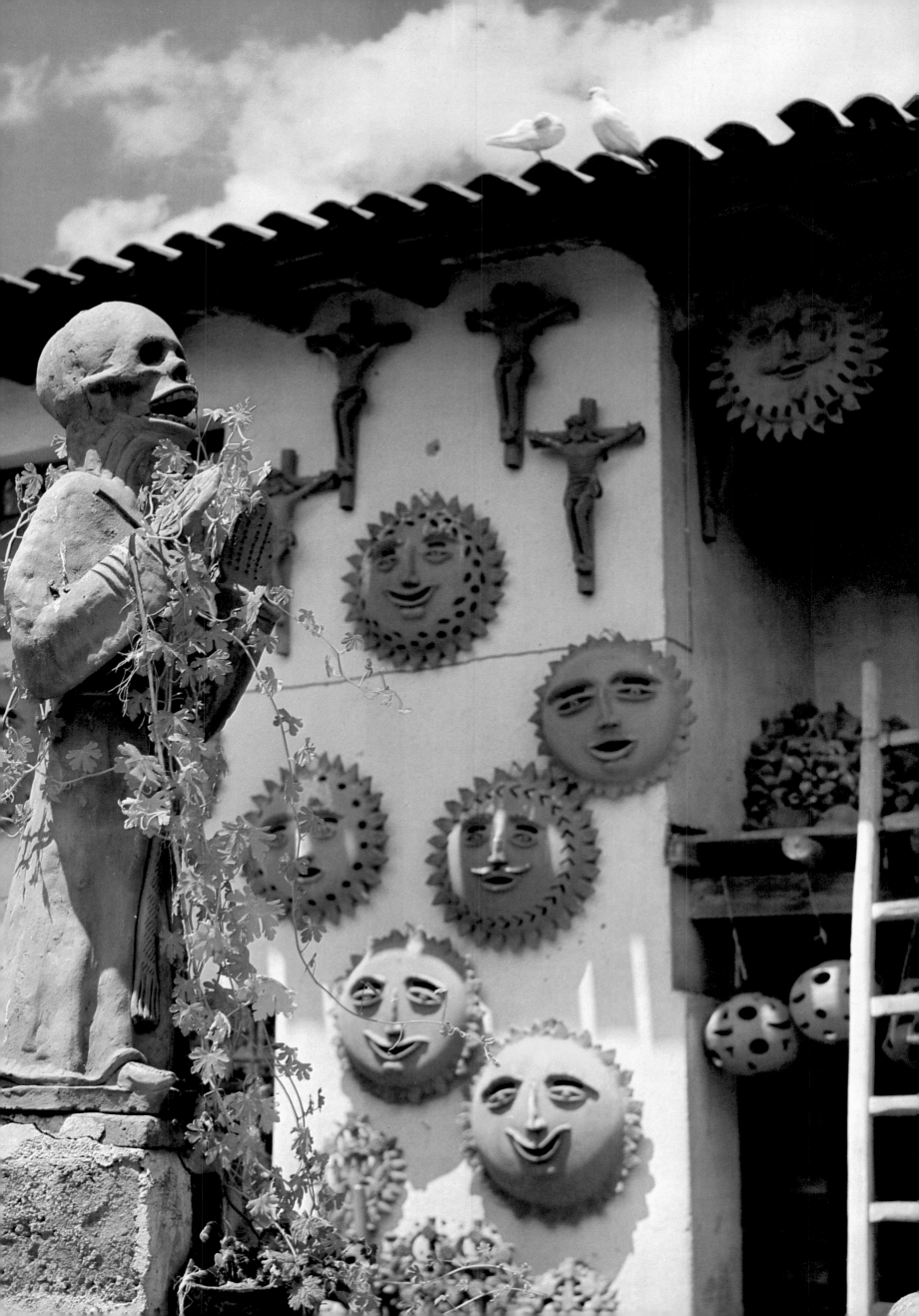

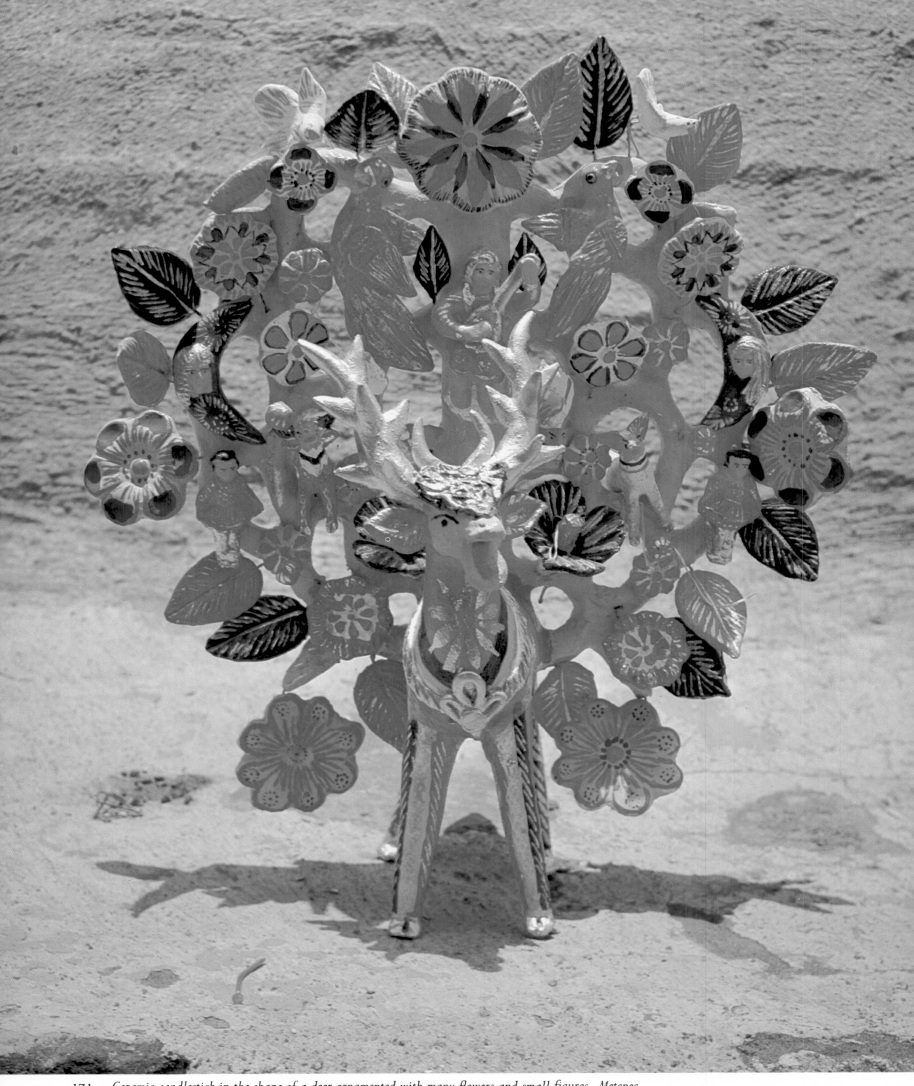

171. *Ceramic candlestick in the shape of a deer ornamented with many flowers and small figures. Metepec.*

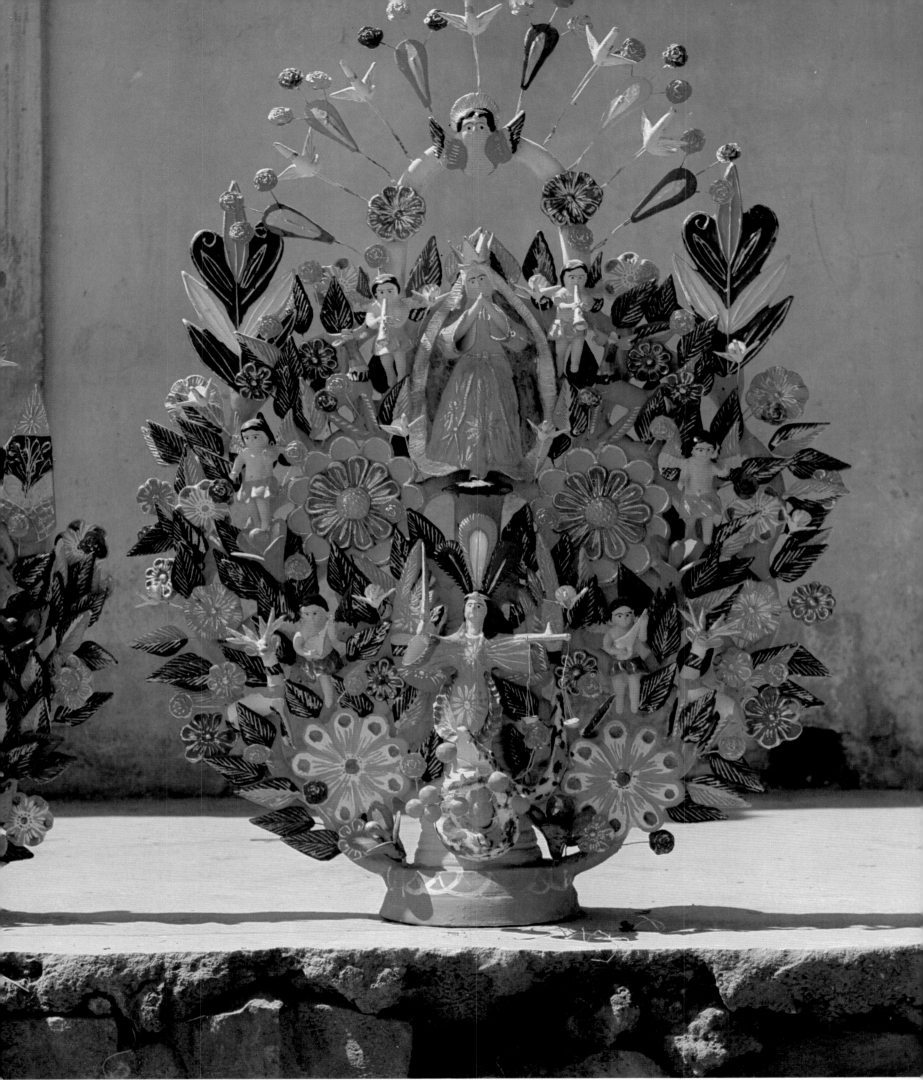

172. *Candlestick ornamented with religious figures. Metepec.*

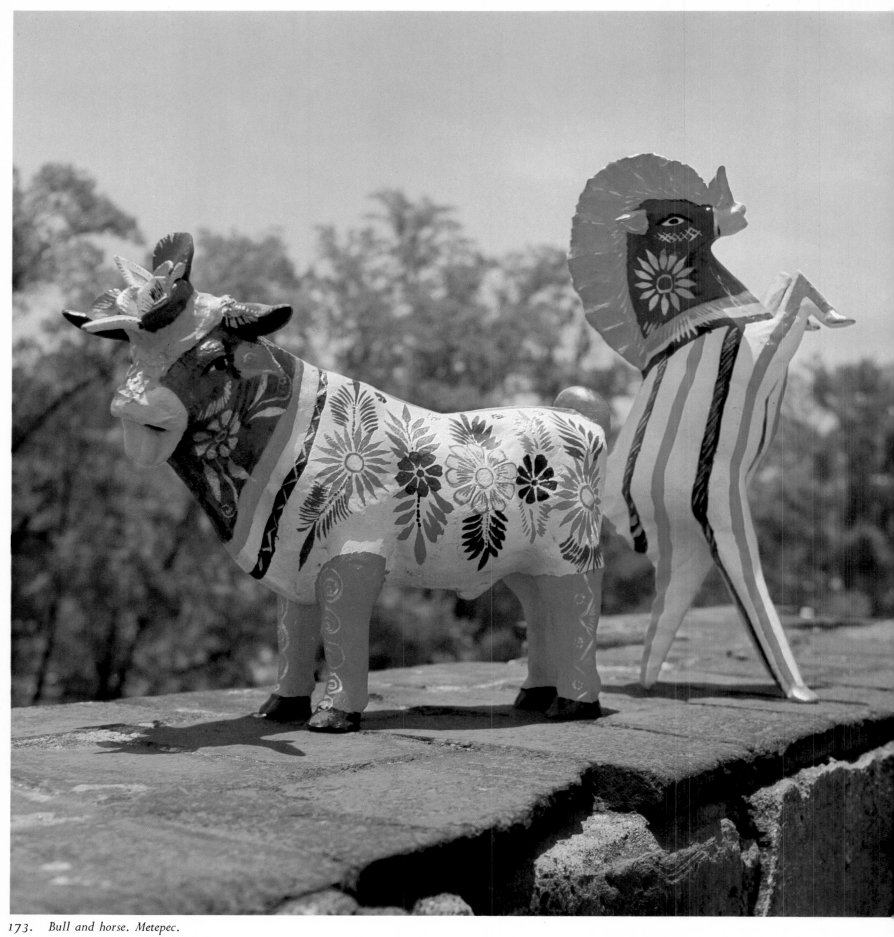

173. *Bull and horse. Metepec.*

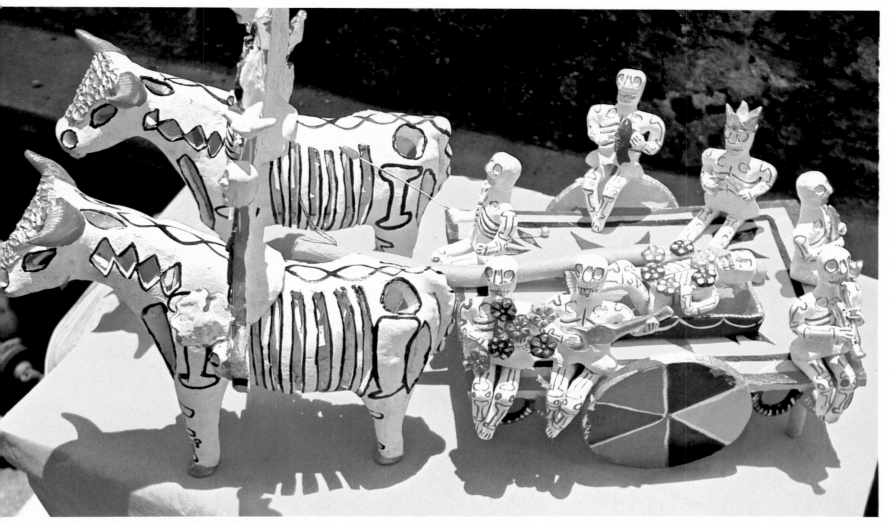

4. *Bulls pulling a hearse with skeleton riders. Metepec.*

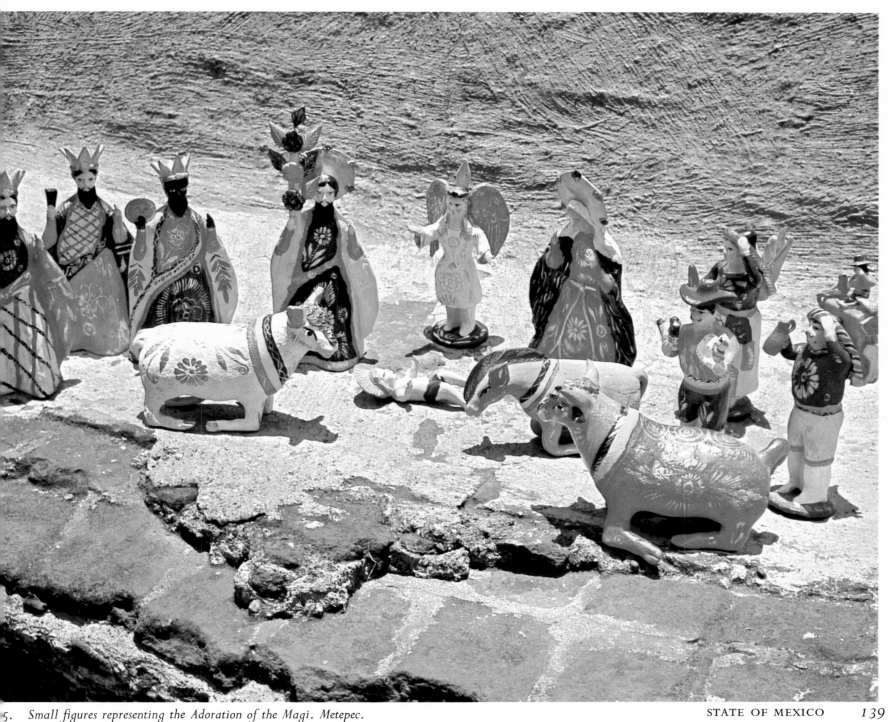

5. *Small figures representing the Adoration of the Magi. Metepec.*

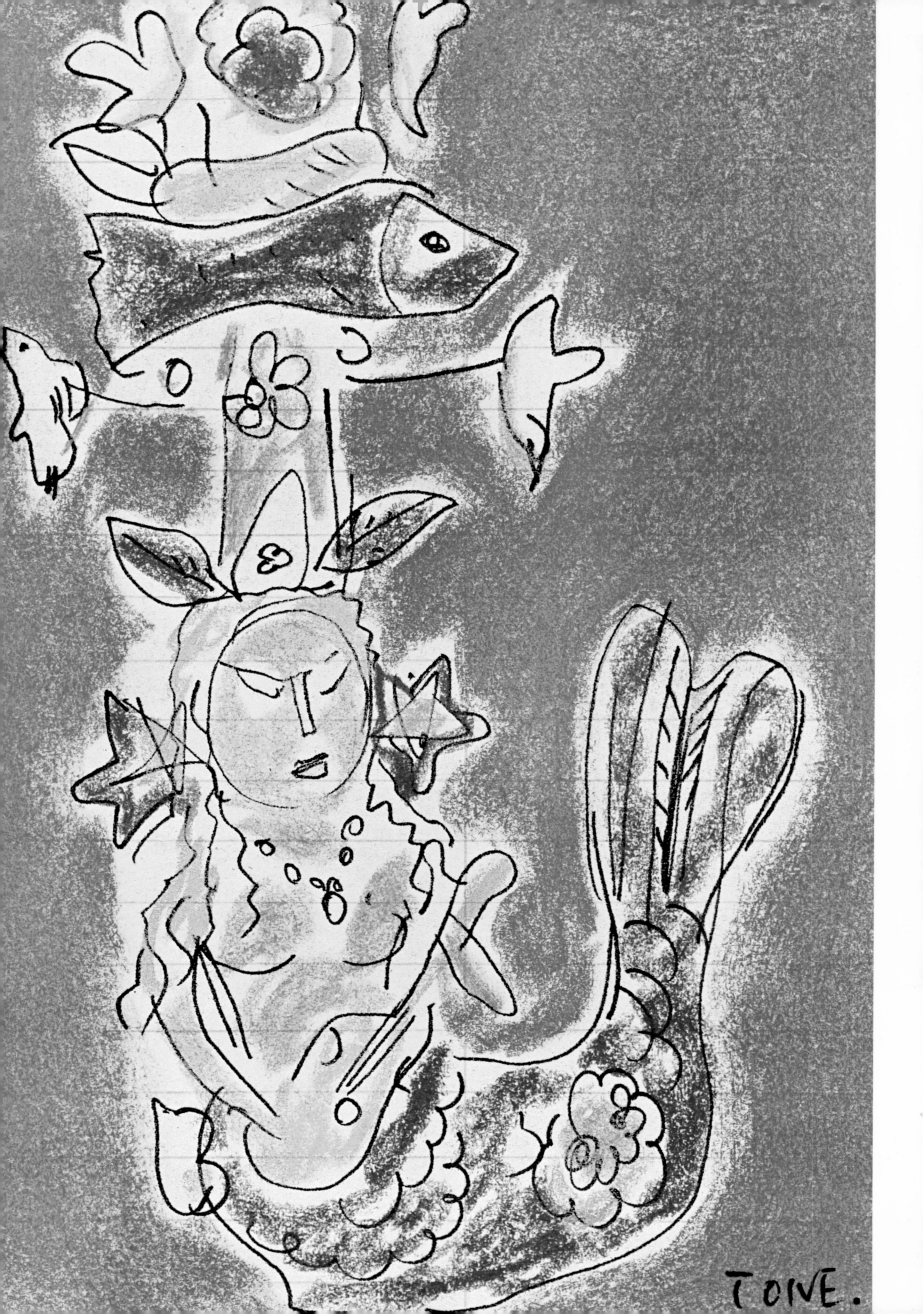

TOIVE.

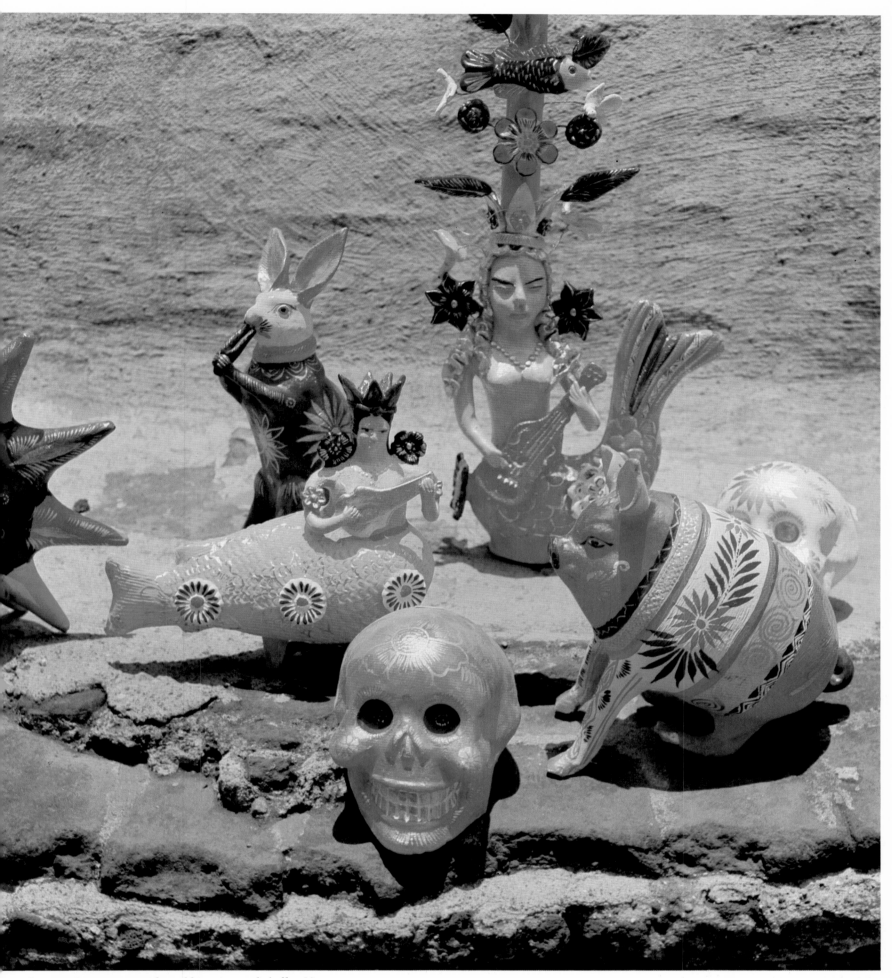

7. *Pottery objects: mermaids, rabbit, pig, and skulls. Metepec.*

6. *Mermaid. Sketch by author.*

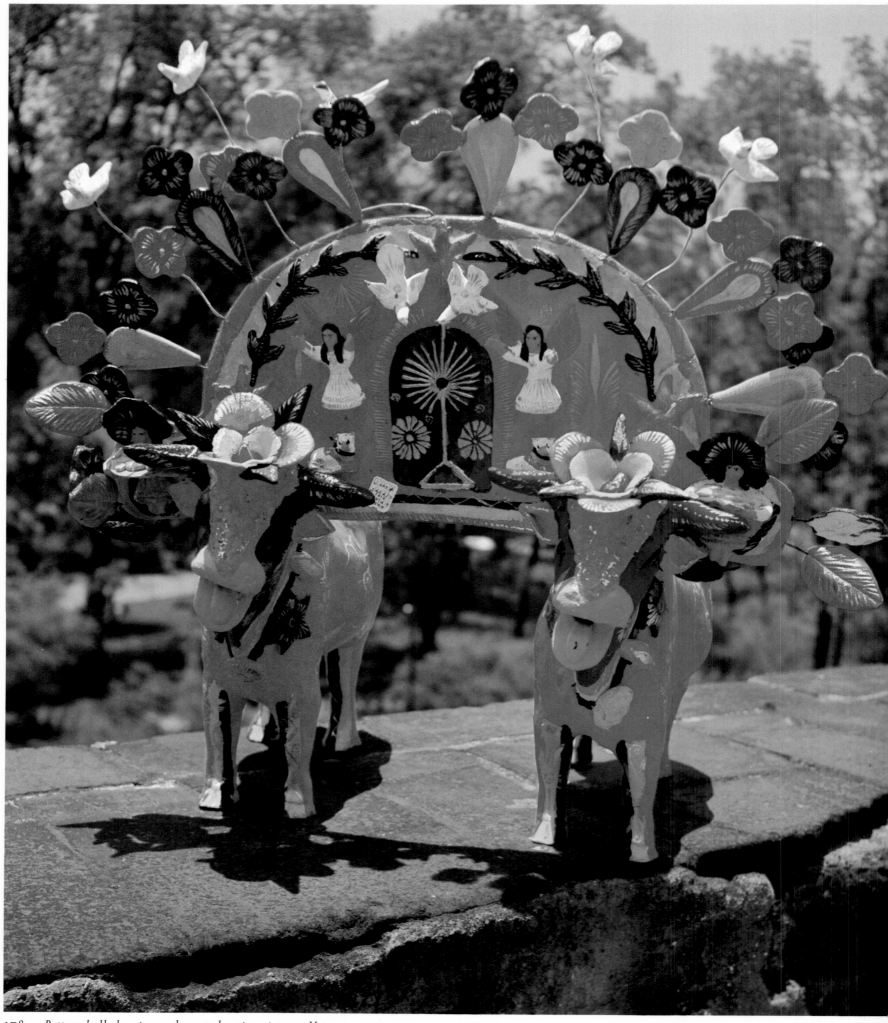

178. *Pottery bulls bearing a decorated votive picture. Metepec.*

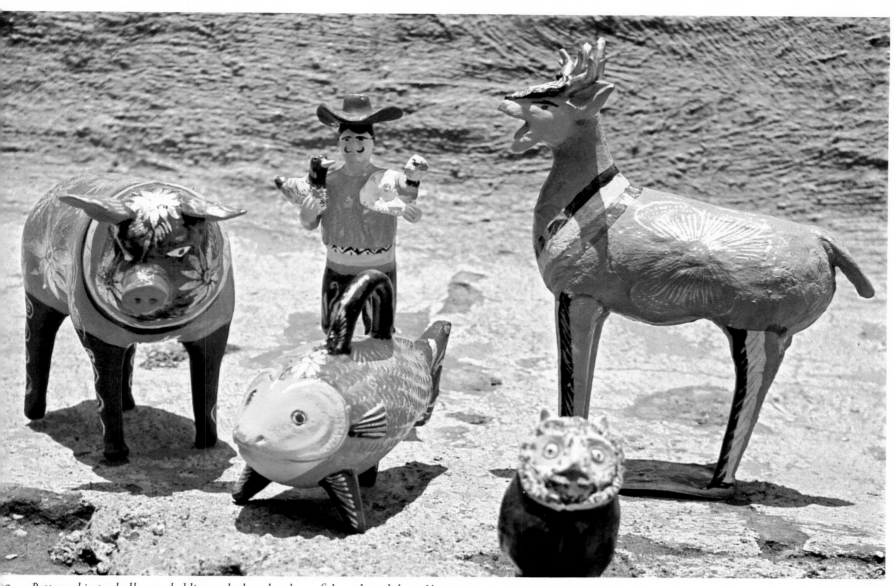

9. *Pottery objects: bull, man holding a duck and a sheep, fish, owl, and deer. Metepec.*

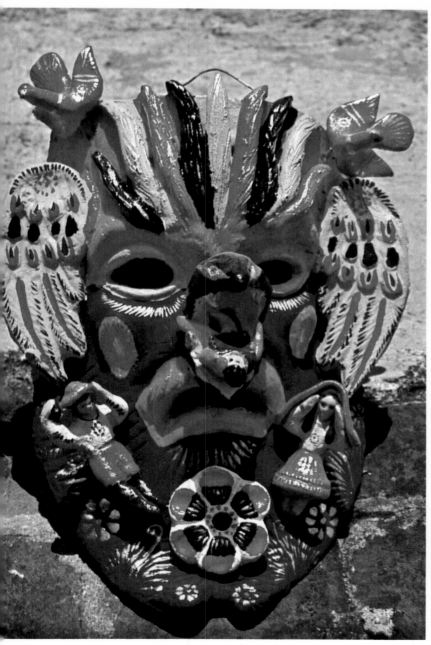

). *Pottery mask. Metepec.*

181. *Pottery lion. Metepec.*

STATE OF MEXICO 143

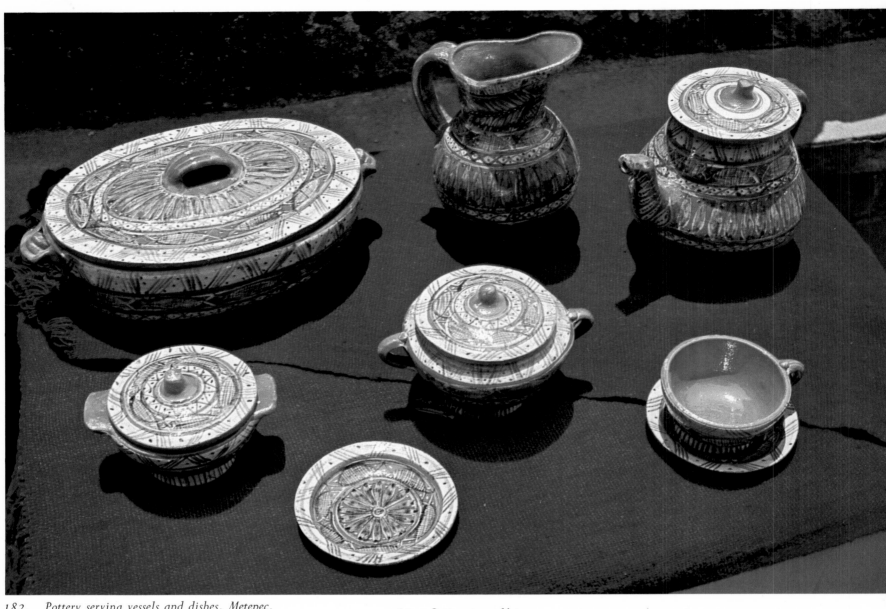

182. *Pottery serving vessels and dishes. Metepec.*

183. *Pottery jug. Metepec.*

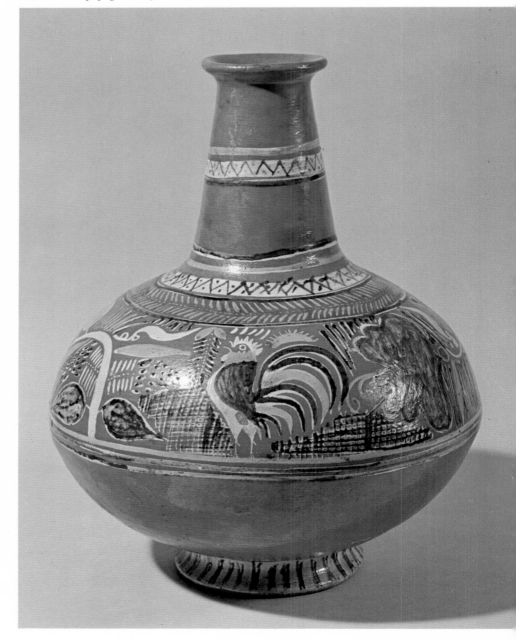

Glazed Pottery. The type of Metepec pottery shown here differs from the unglazed, brilliantly colored variety on the preceding pages. Its colors are more somber, and it is covered with transparent glazes.

Toluca. Capital of the State of Mexico, Toluca is located sixty-six kilometers west of Mexico City on a highland some 2,640 meters above sea level. The air is very cool, and every Friday, the people of the Mazahua and Otomí tribes gather in the city to hold a market where sarapes, shoulder bags, ceramics, basketwork, and other folk-craft objects are sold. In recent years, the Folk Art Center in Toluca has been completely redesigned and restocked.

184. Shoulder bag, used by the Mazahua tribe.

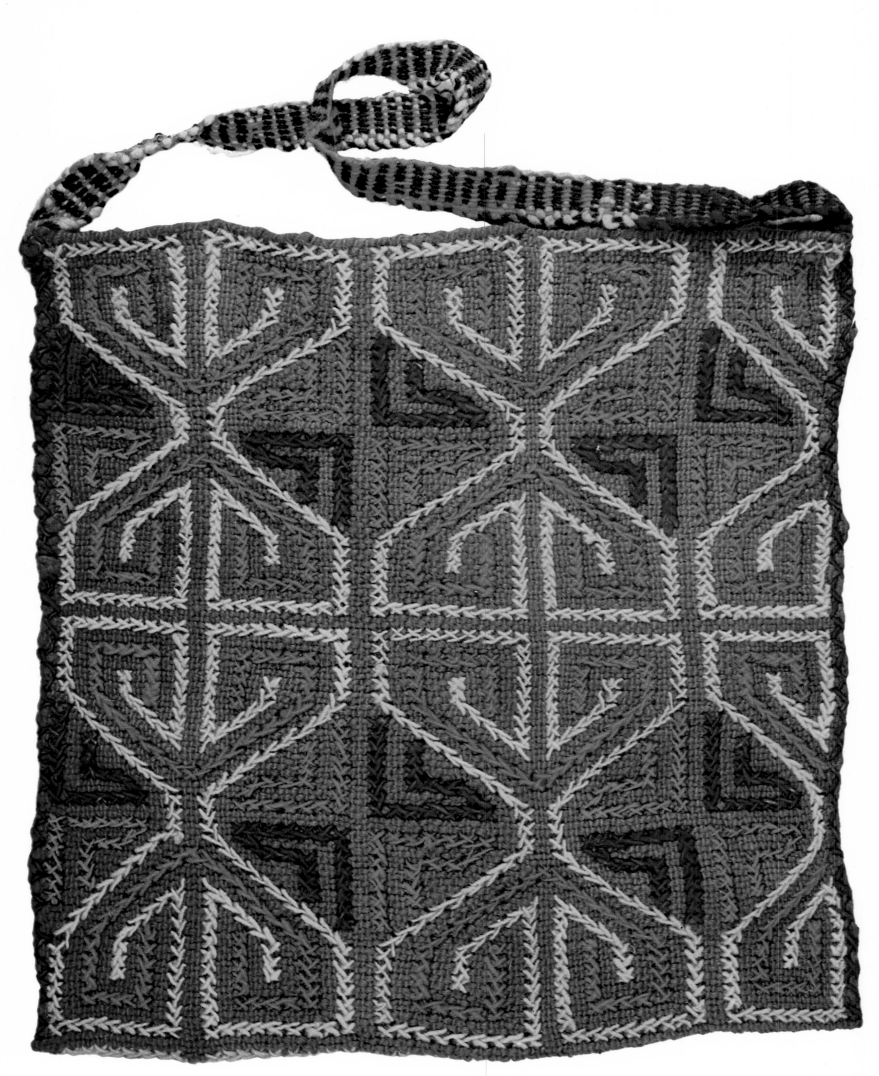

185. *Shoulder bag, used by the Mazahua tribe.*

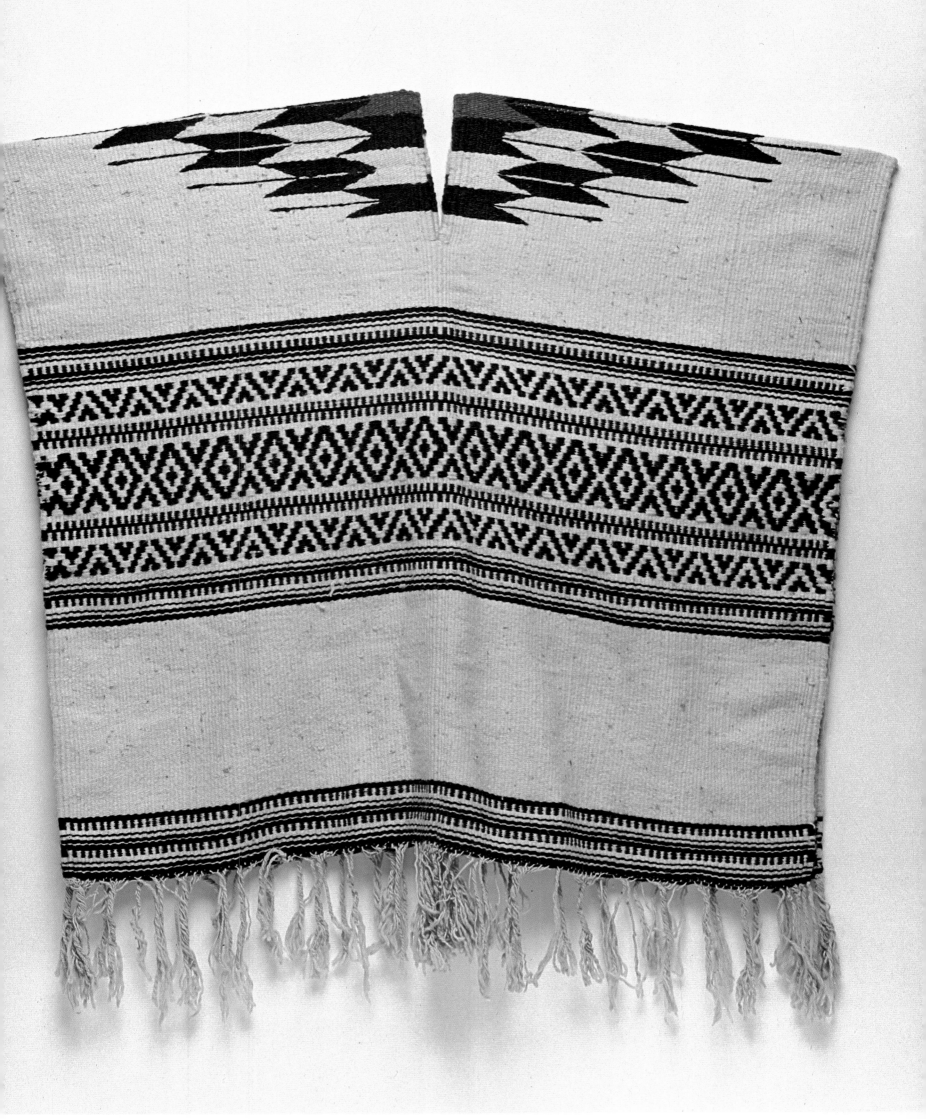

186. Poncholike garment called jorongo. *Toluca.*

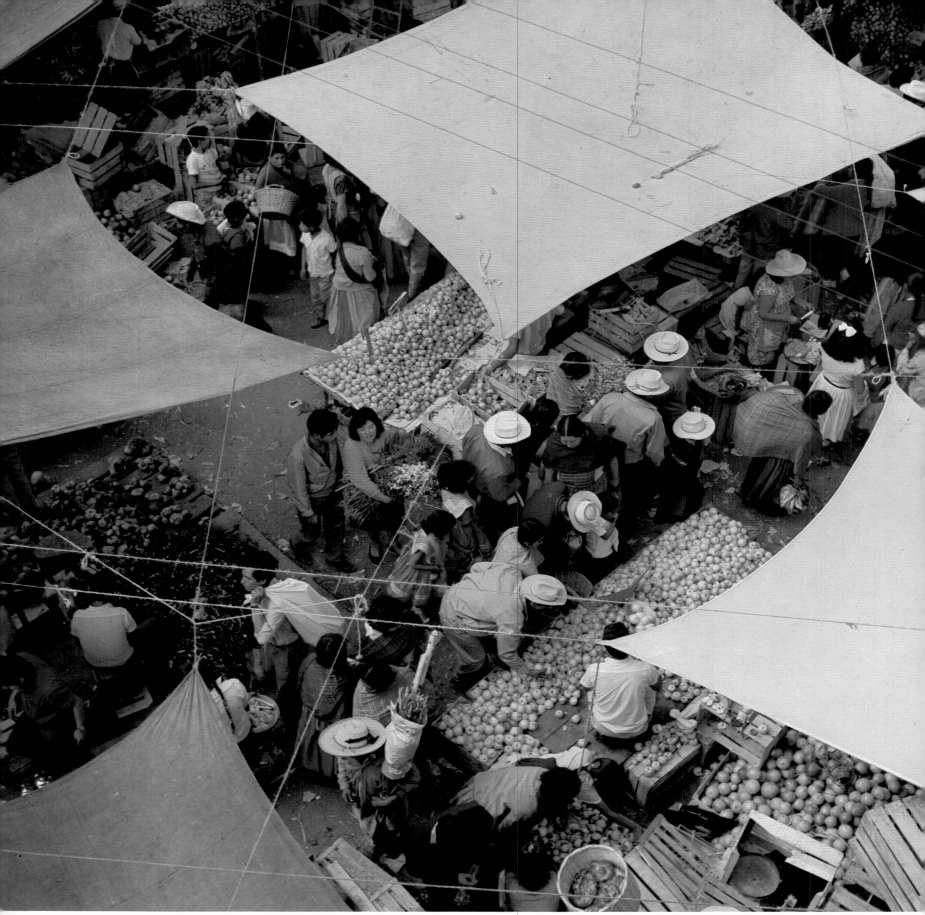

187. *Awnings cover market in Toluca.*

188. *Large earthenware pots. Toluca.*

189. *Open-air market. Toluca.*

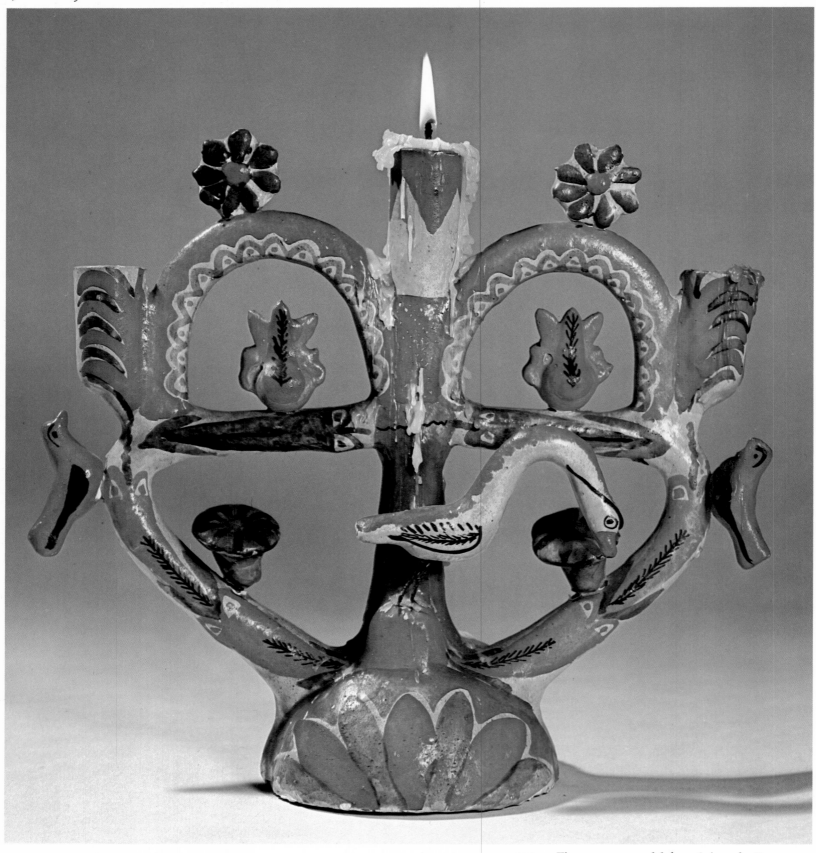

190. *Pottery candlestick. Izúcar de Matamoros.*

192. *Three pottery candelabra. Izúcar de Matamoros.* ▷

Puebla

Izúcar de Matamoros. Most of the distinctive candlesticks from the Puebla region are produced by the Castillo and Flores families living just outside the town of Izúcar de Matamoros. All of the members of the two households participate in the production process. Terra-cotta candlesticks are first fired in a kiln then painted with designs in brilliant colors applied by means of brushes made of mule hair. Finally they are coated with varnish.

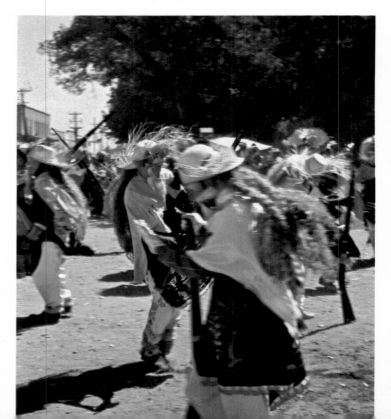

191. *Festival in Huejotzingo.*

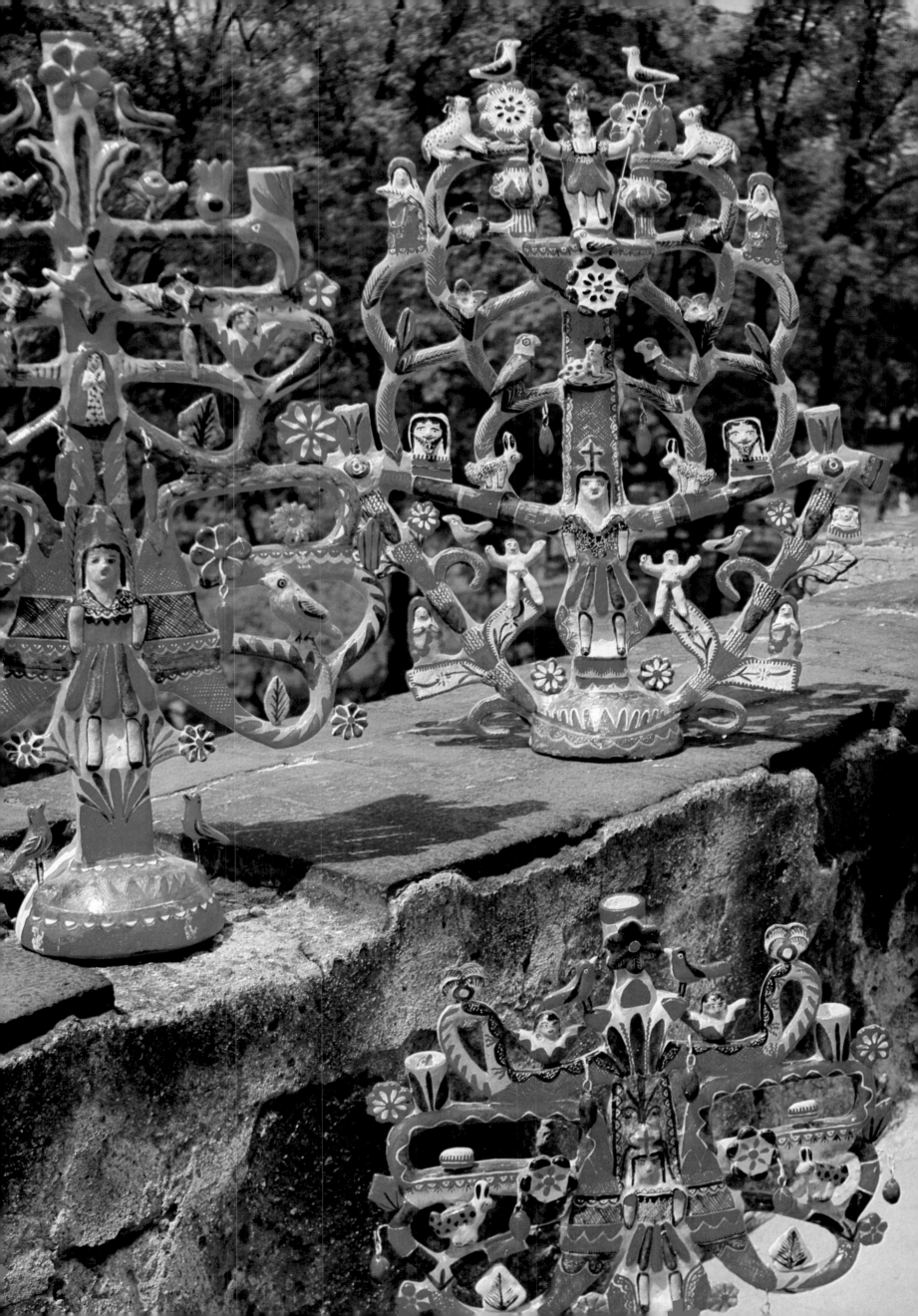

Hidalgo

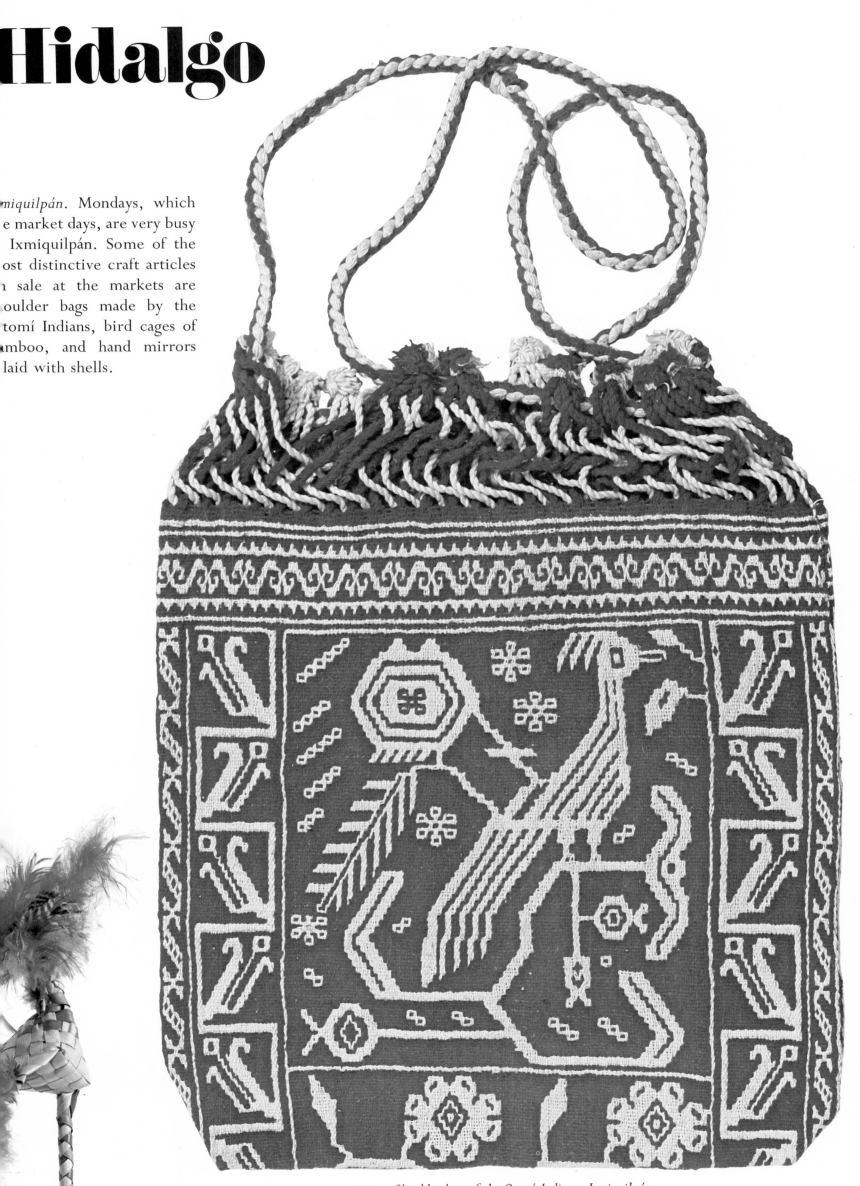

Ixmiquilpán. Mondays, which are market days, are very busy in Ixmiquilpán. Some of the most distinctive craft articles on sale at the markets are shoulder bags made by the Otomí Indians, bird cages of bamboo, and hand mirrors inlaid with shells.

219. *Shoulder bag of the Otomí Indians. Ixmiquilpán.*

218. *Rattan and feather toy in the shape of a rooster. Ixmiquilpán.*

Puebla

Cuetzalán. On the Feast of St. Francis (October 4) people from distant places as well as the local citizens throng the streets of Cuetzalán to see the famous quetzal and flying-pole dances. Coffee grows well in this subtropical hot and humid climate; it is harvested at about the time of the saint's feast.

Women of the Totonac tribe attend the festivities clad in white huipil blouses, dark skirts, red waistbands, and headdresses of purple and green woolen yarn. Infants are brought in distinctively designed cradles, and the celebration reaches its climax with the arrival of the young woman who has been chosen Huipil Maiden.

222. *A young boy wearing a feathered headdress for the quetzal dance. Cuetzalán.*

220. *Girl selected to be Huipil Maiden at the Feast of St. Francis in Cuetzalán.*

221. *Young Totonac women in Cuetzalán.*

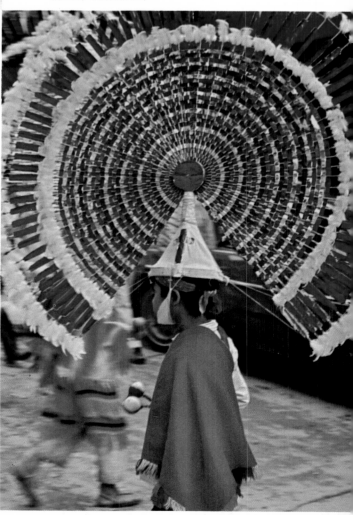

223. *Man with mask and bull headdress. Cuetzalán.*

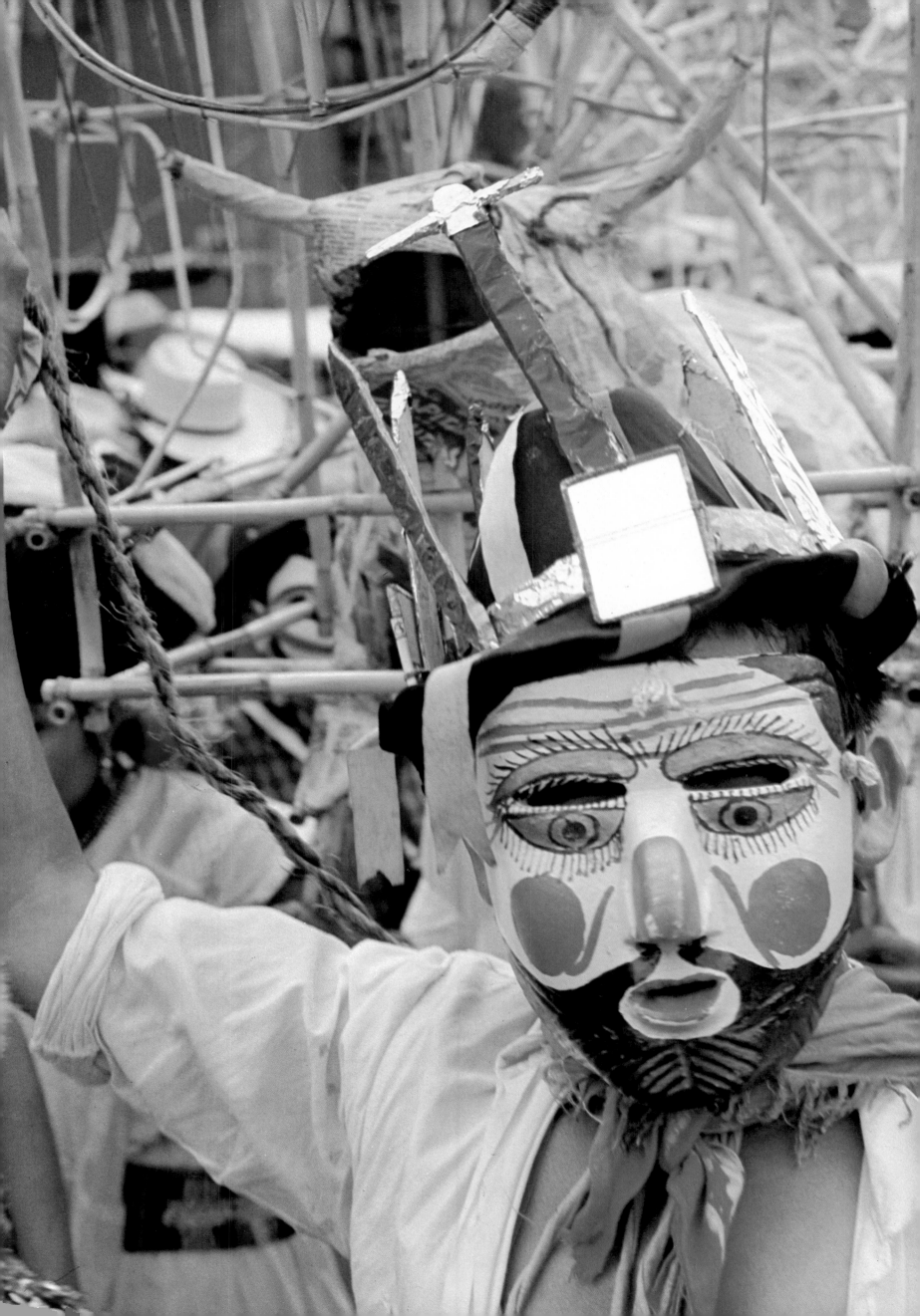

224. *Outdoor market. Acaxochitlán.*

Hidalgo

Acaxochitlán. The market in Acaxochitlán is primarily for the sake of the local people and caters very little to tourists. On market days—Sundays—brightly embroidered capes, shoulder bags, and the indigo shawls of men and women give the scene a flavor special to Hidalgo.

225. *Woman making quexquemetl. Acaxochitlán.*

Guana-juato

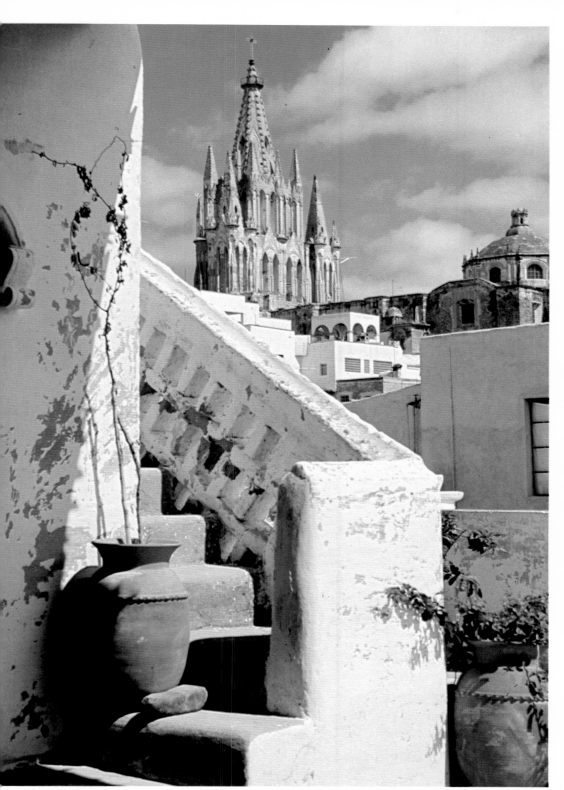

San Miguel de Allende. This town is as compact as a motion-picture set. The Gothic-style cathedral is visible from almost everywhere. Even today, Americans living in San Miguel de Allende are so numerous that one might almost mistake the town for a place in the southwestern United States. Tourists too come in large numbers, especially to see and buy the sarapes that are said to be the finest made in all Mexico.

6. *View of Church of San Miguel de Allende from roof of colonial-style building.*

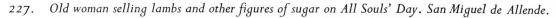

227. *Old woman selling lambs and other figures of sugar on All Souls' Day. San Miguel de Allende.*

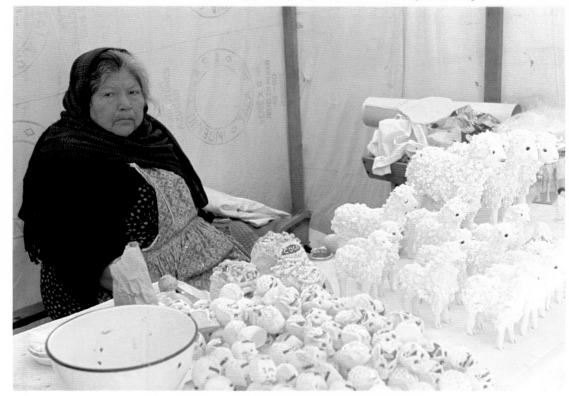

228 and 229. *Napkins with embroidered animal designs. San Miguel de Allende.*

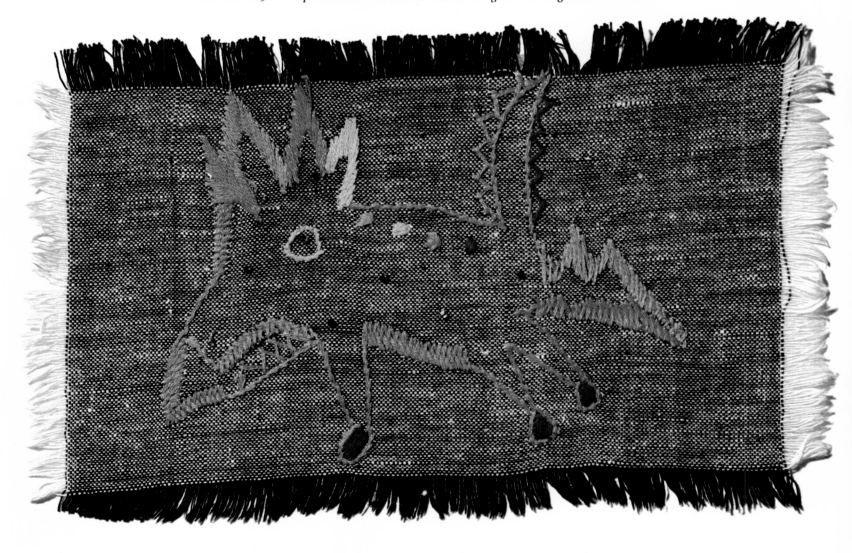

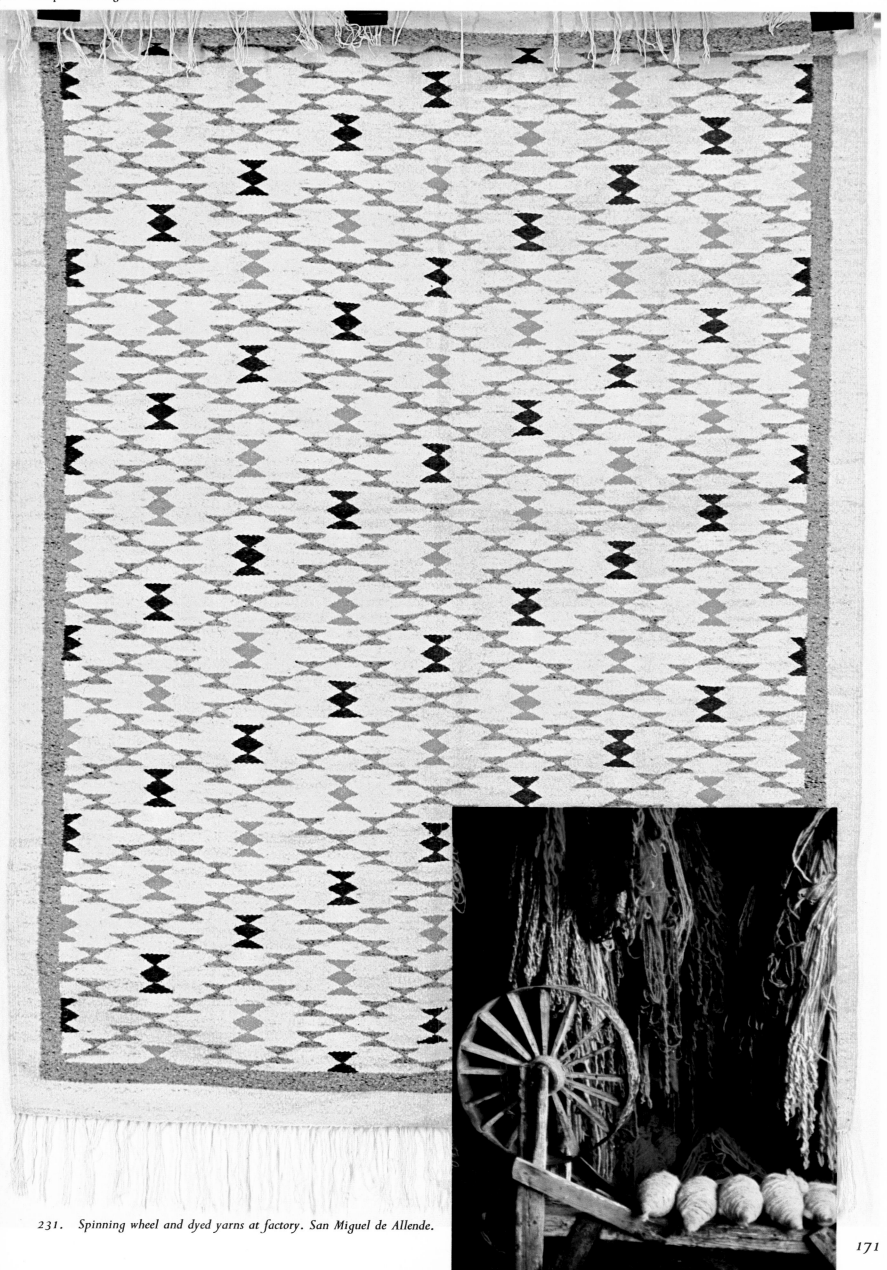

231. *Spinning wheel and dyed yarns at factory. San Miguel de Allende.*

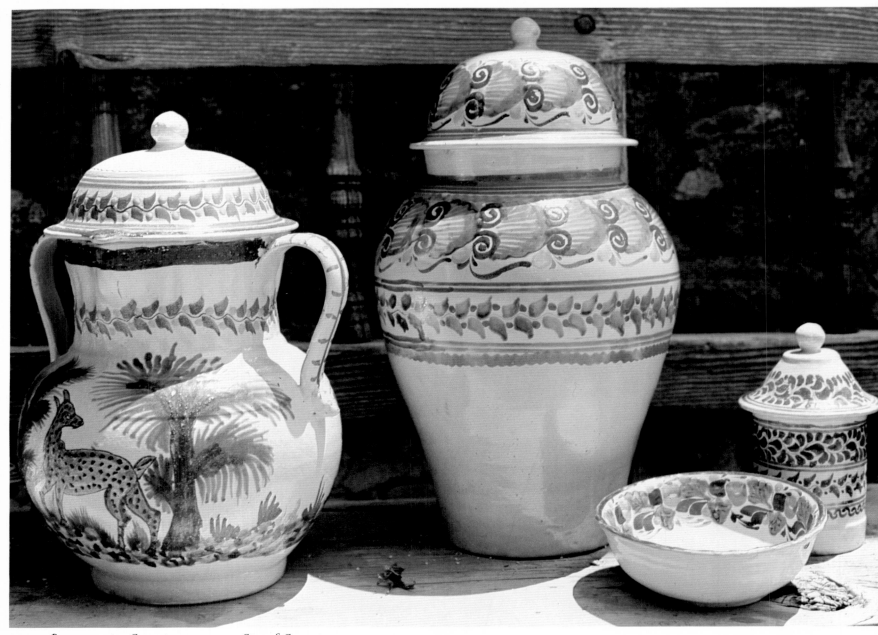

232. *Representative Guanajuato pottery. City of Guanajuato.*

City of Guanajuato. Once a famous gold- and silver-smelting center, Guanajuato, capital of the state of the same name, remains a prosperous town with a handsome church, a university, and an opera house. The painter Diego Rivera was born here. Today the González family continues to produce Guanajuato tiles belonging to the same tradition as the Talavera tiles of Puebla.

233. *University of Guanajuato. City of Guanajuato.*

Southern Mexico

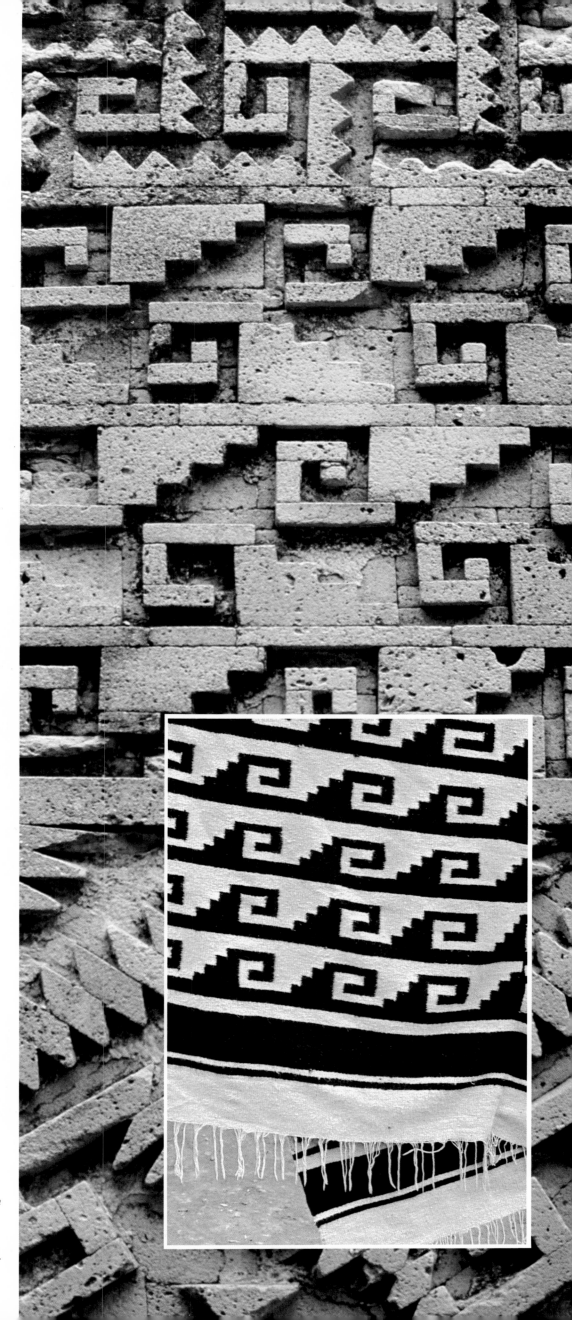

234. Brick-relief wall at Mitla, pre-Columbian
site near the city of Oaxaca.

235. Inset: Sarape design based on the Mitla wall.

236. *On festival days in July and September, men in Teotitlán del Valle adorn themselves with plumed ornaments and perform dances. Painting by author.*

Oaxaca Arts and Crafts. Oaxaca, capital of the state of the same name, is a lovely highland town where the air is clean and fresh. In the outskirts of the town are the ruins of Monte Albán, a famous pre-Columbian site. In the town plaza are sold serapes produced at Teotitlán del Valle, as well as many other articles of folk art from neighboring villages, such as Atzompa, Ocotlán, Jamiltepec, and Coyotepec.

237. *Freshly dyed fabrics being dried in the vicinity of Mitla.*

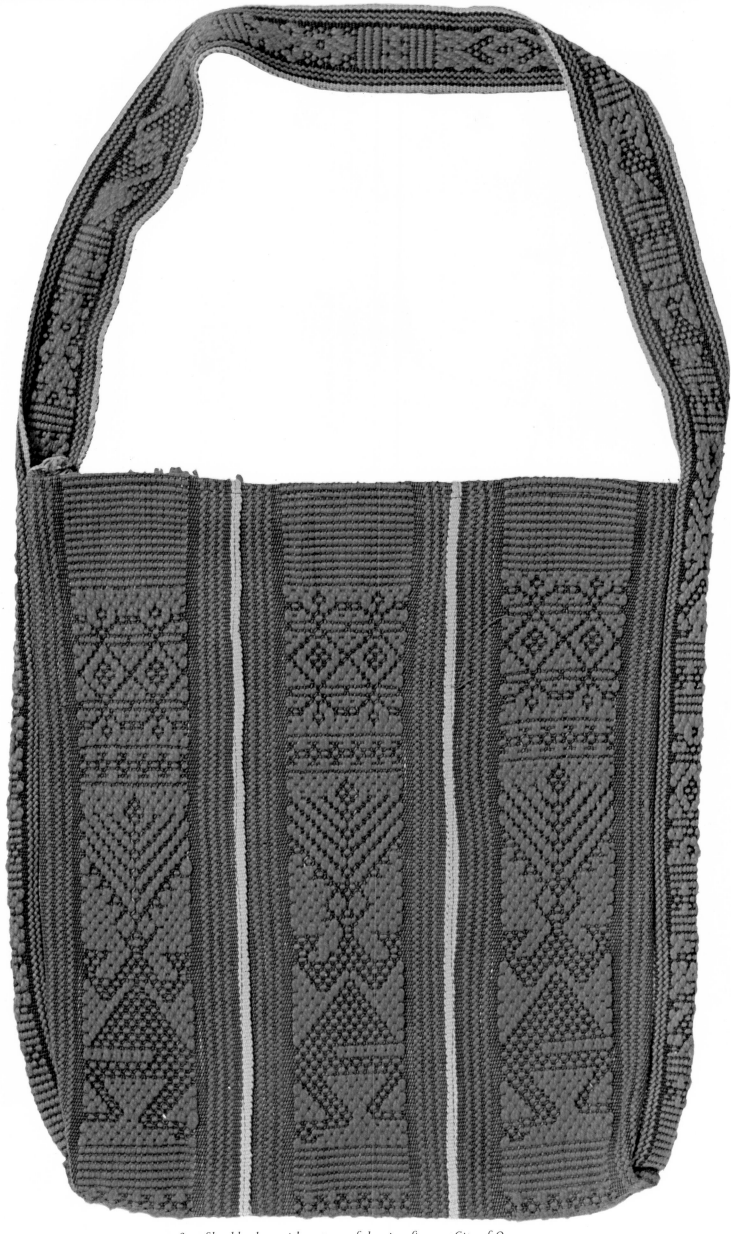

238. *Shoulder bag with pattern of dancing figures. City of Oaxaca.*

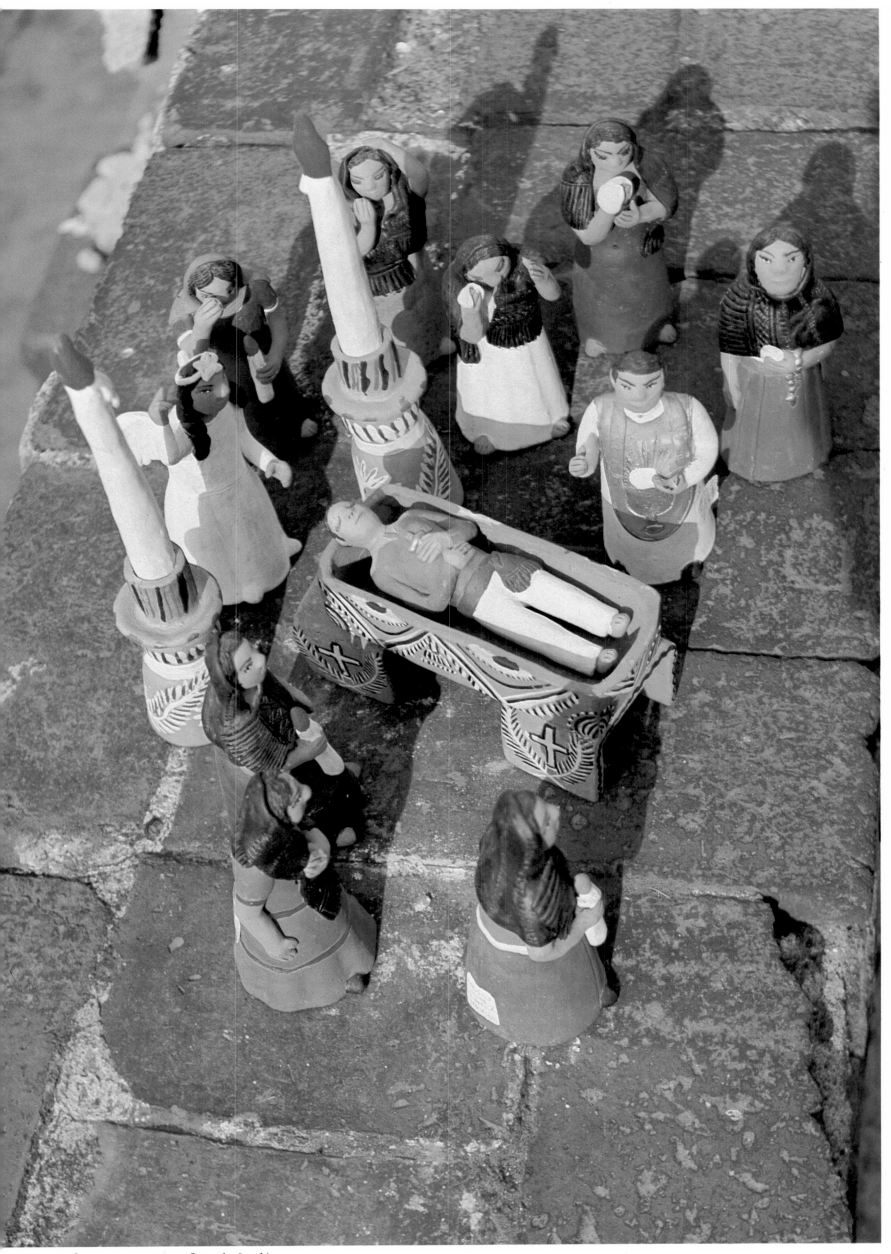

251. *Earthenware bells. Ocotlán.*

252. *Small painted pottery figures and vessels. Jamiltepec.*

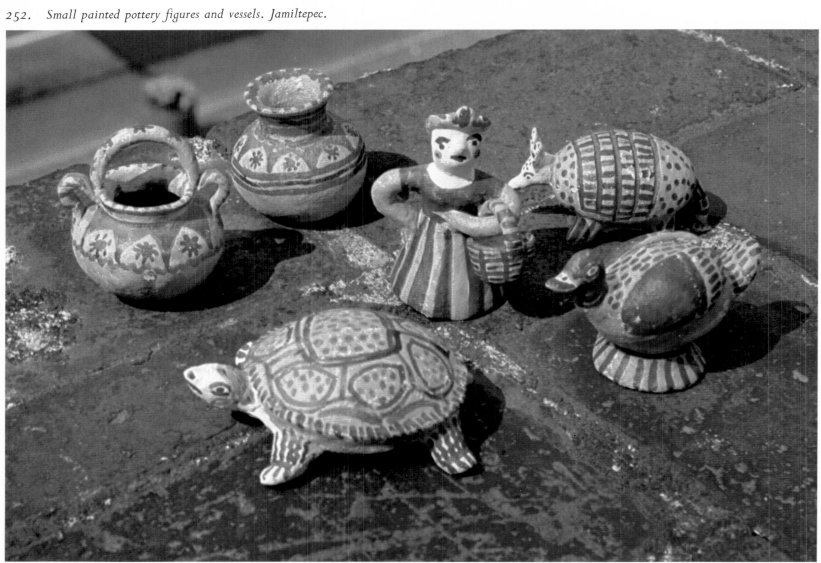

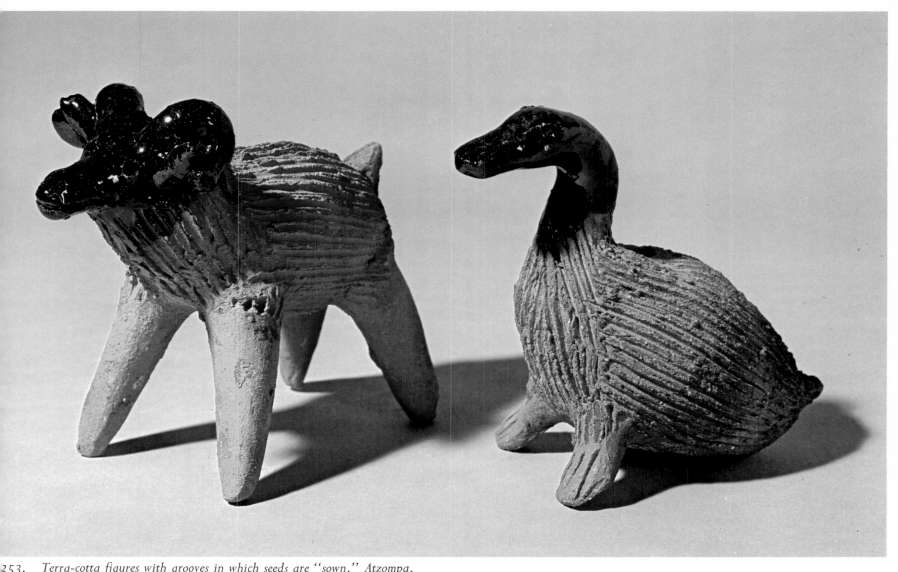

253. *Terra-cotta figures with grooves in which seeds are "sown." Atzompa.*

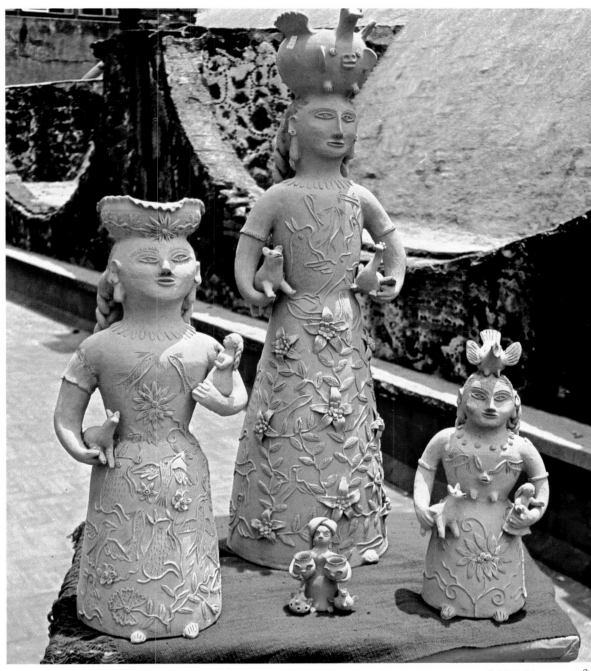

54. *Earthenware figures from Atzompa. Teodora Blanco, who made these figures, has been a potter for over thirty years, since the age of nine. Her fanciful creations spring from the primitive life of her surroundings.*

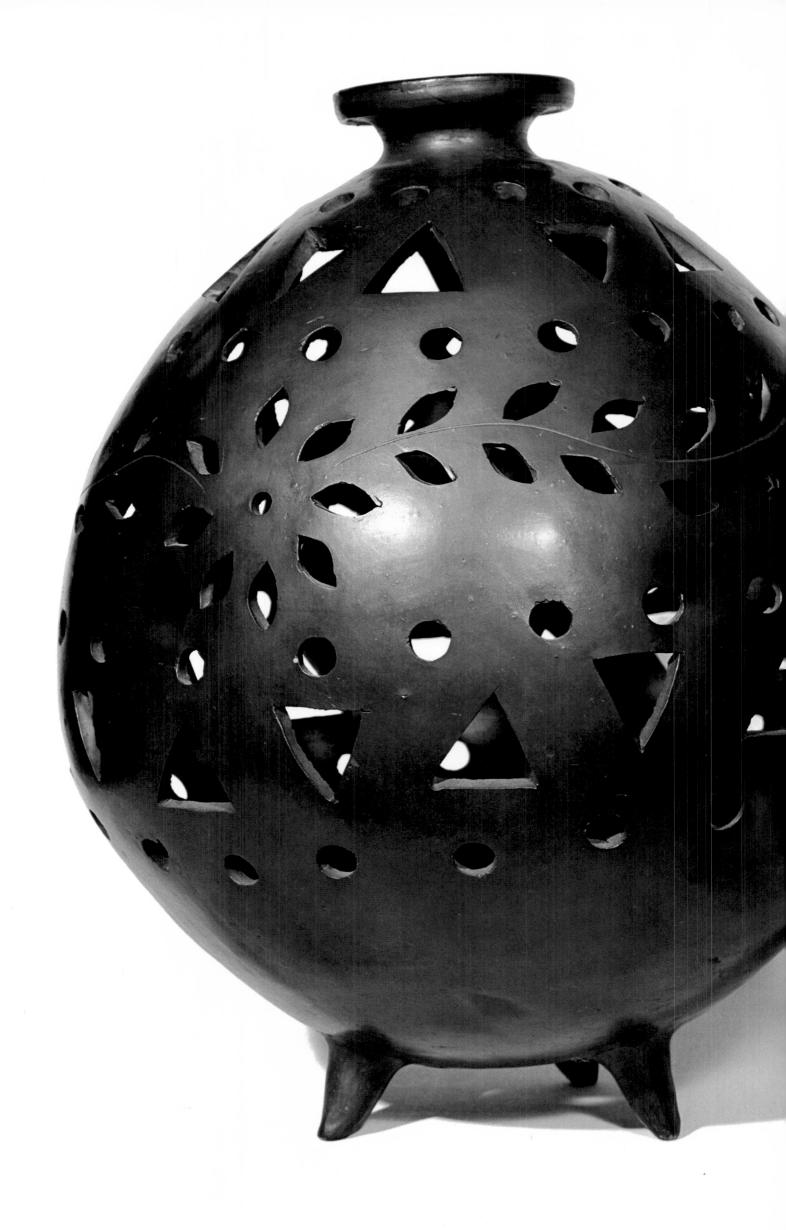

Coyotepec. The black vessels and figures of animals and mermaids from Coyotepec, in the outskirts of Oaxaca, are strikingly handsome. Before being glazed, the pottery pieces are polished with pieces of agate and patterns are cut or incised in them.

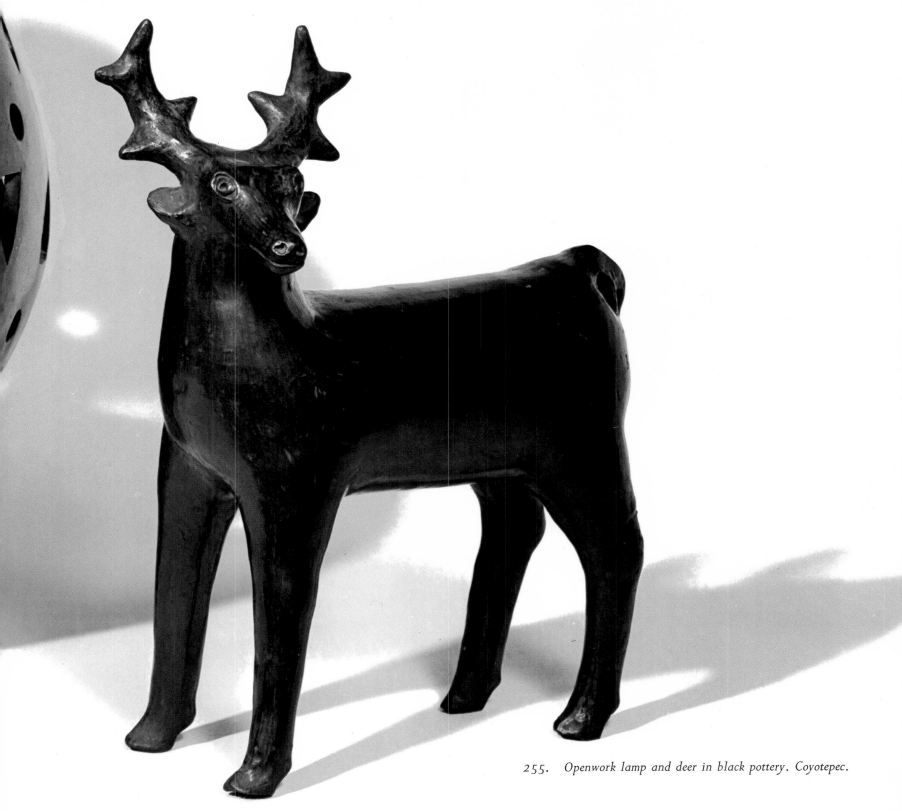

255. *Openwork lamp and deer in black pottery. Coyotepec.*

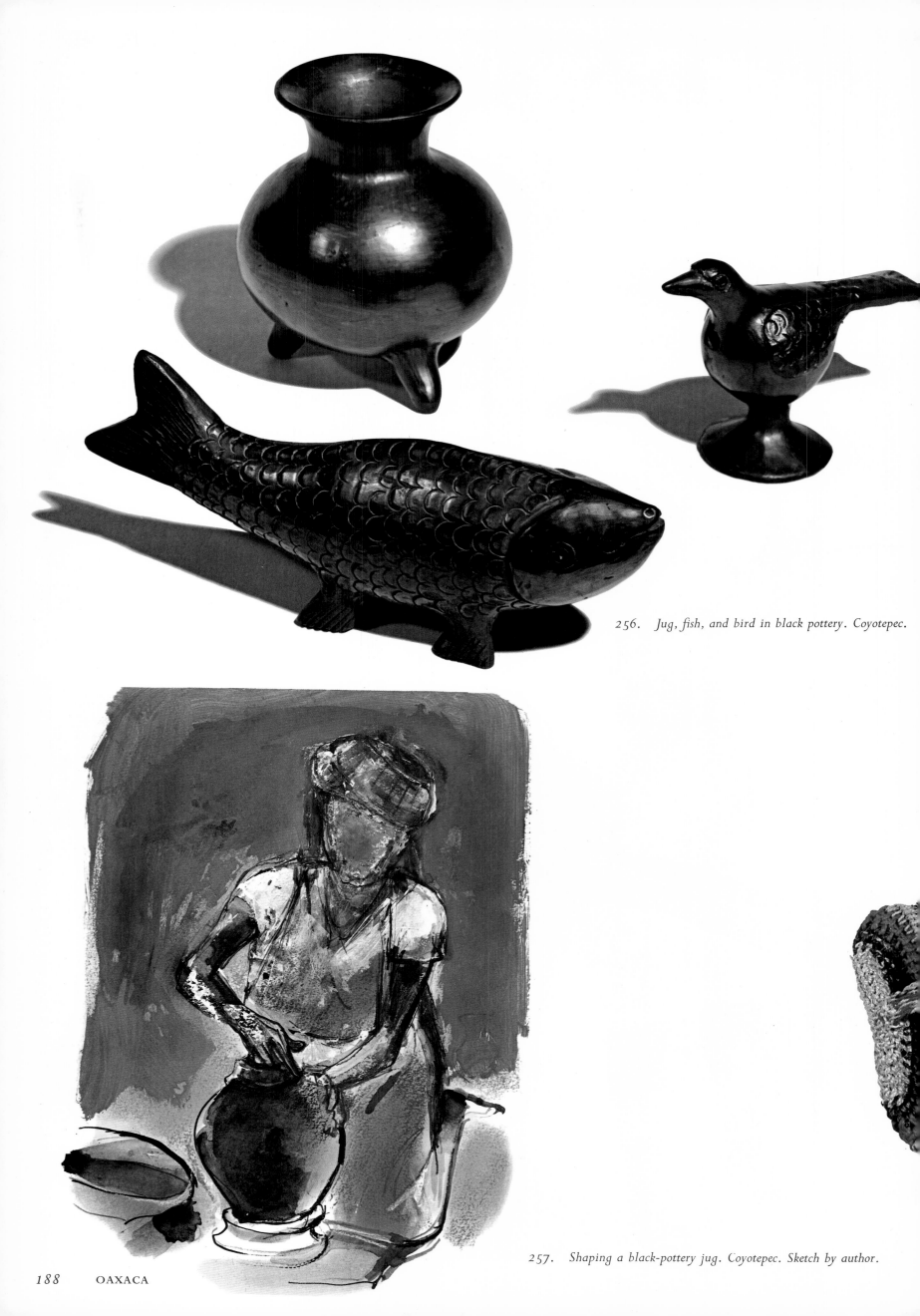

256. *Jug, fish, and bird in black pottery. Coyotepec.*

257. *Shaping a black-pottery jug. Coyotepec. Sketch by author.*

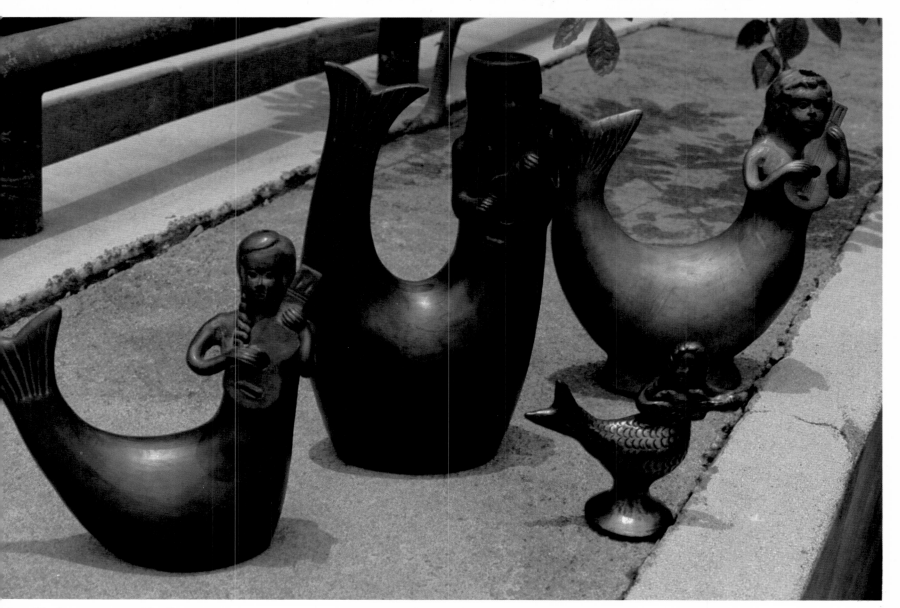

258. *Black-pottery mermaids. Coyotepec.*

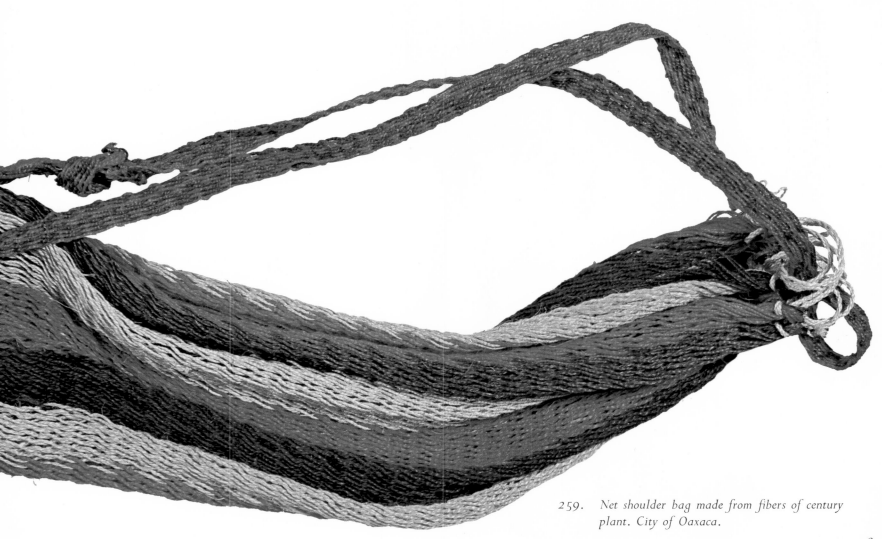

259. *Net shoulder bag made from fibers of century plant. City of Oaxaca.*

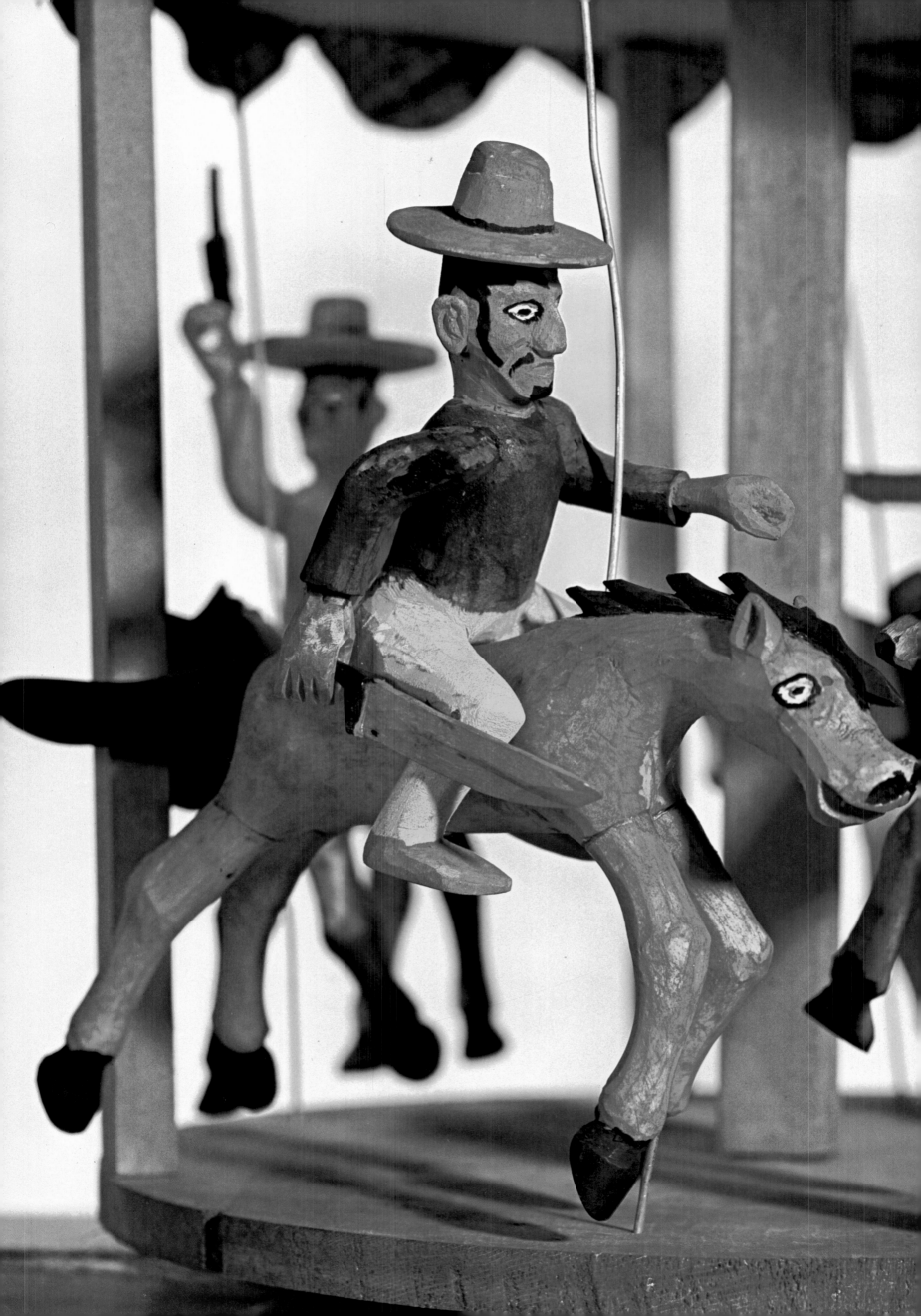

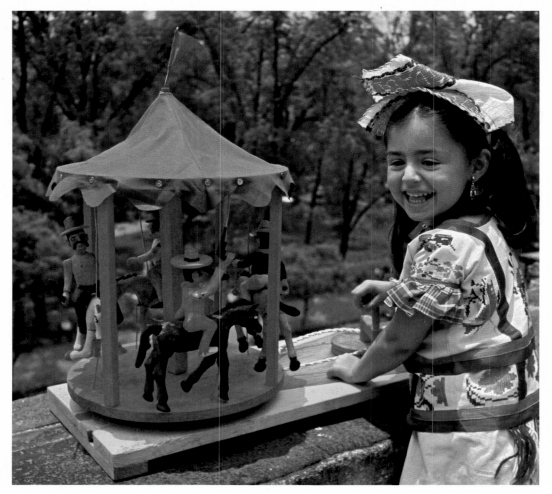

Woodcarvings. The plain, yet charming, woodcarvings of several small villages on the Oaxaca plateau are imbued with human emotion and with the mood of the natural setting of a land of spreading cornfields where spikey leaves of century plants point upward to a sky in which clouds continuously scuttle by.

261. Little girl in holiday dress playing with the merry-go-round of bandits. San Martín Tilcajete.

262. Wooden animal with wooden bird in its mouth. San Martín Tilcajete.

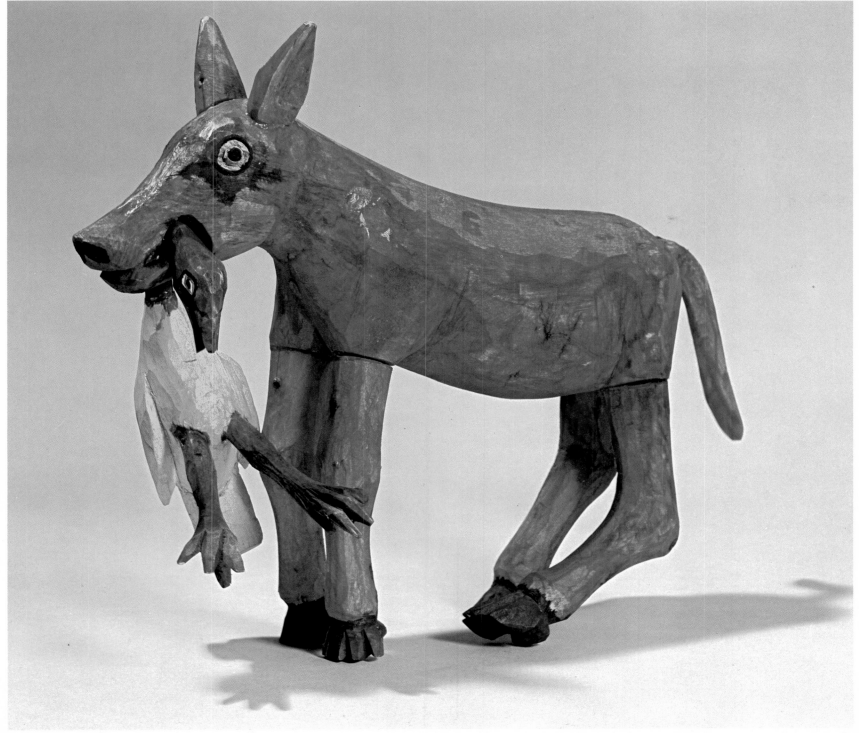

60. Wooden merry-go-round of bandits. San Martín Tilcajete.

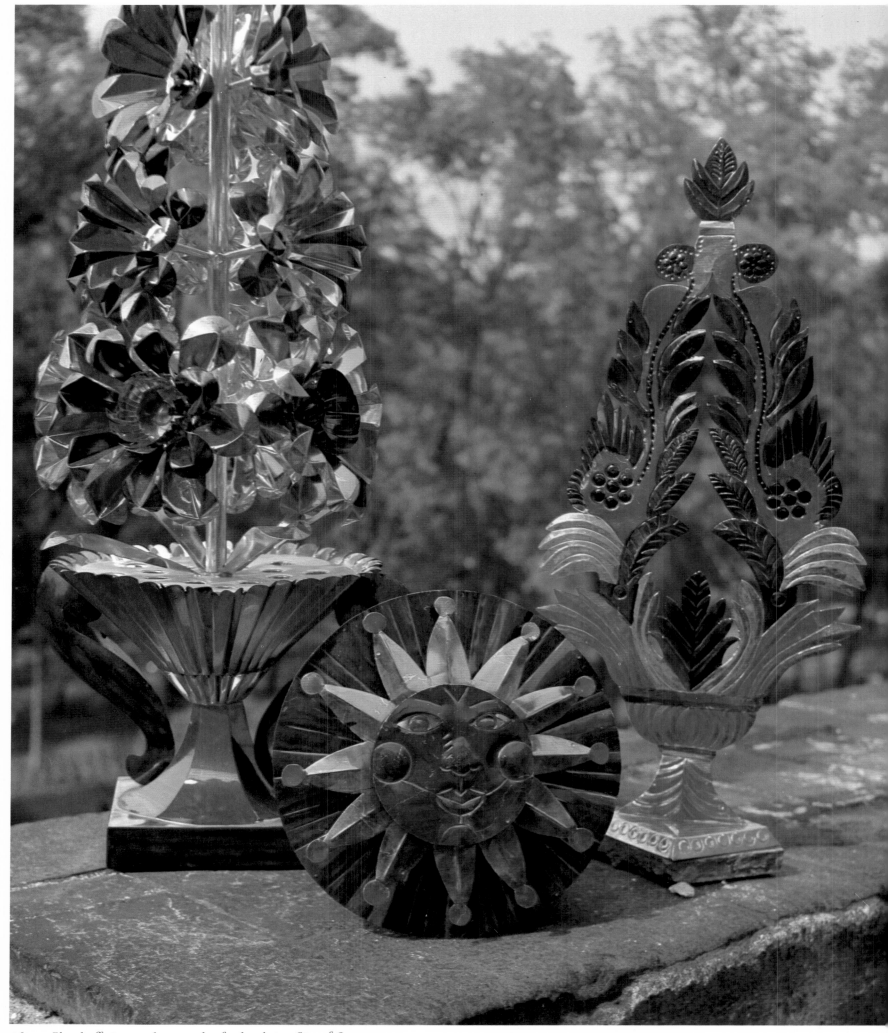

263. *Floral offerings and sun made of colored tin. City of Oaxaca.*

Tin Ornaments. Among the most striking of the many folk-art objects sold in the markets of Oaxaca are the figures and flowers made of brightly colored tin. Assembled from carefully trimmed and embossed tin sheets, the ornaments range from votive floral arrangements to animal and angel figures.

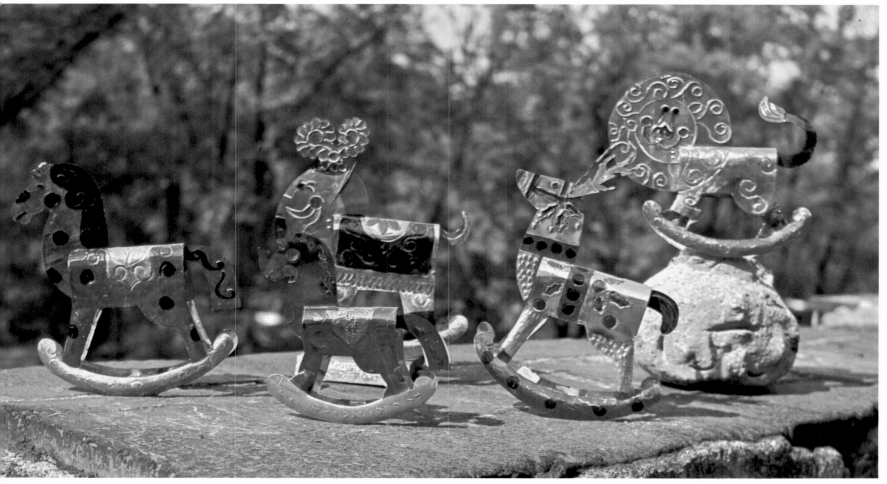

64. *Toy animals of tin. City of Oaxaca.*

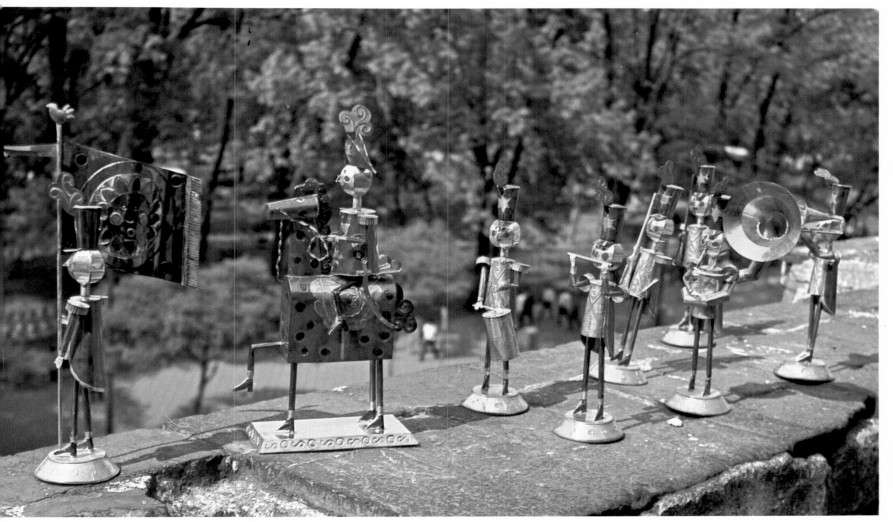

65. *Tin-soldier marching band. City of Oaxaca.*

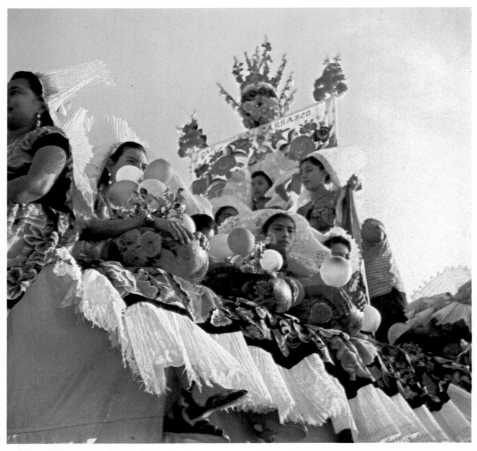

Juchitán. A place where the winds blow hot, Juchitán, Oaxaca, is notable for its tall, handsome women and their lovely native costumes, and for its markets where pottery and oranges literally spill into the streets. In May the people hold the Juchitán Festival, which continues for about two weeks. Not only the women, but even the cattle of the town are decked in fine ornaments; and men and women celebrate by drinking a locally made beer and by dancing and singing late into the night.

266. *Women at festival. Juchitán.*

267. *Women wearing huipils and a kind of shawl called* resplandor *(radiance). Juchitán.*

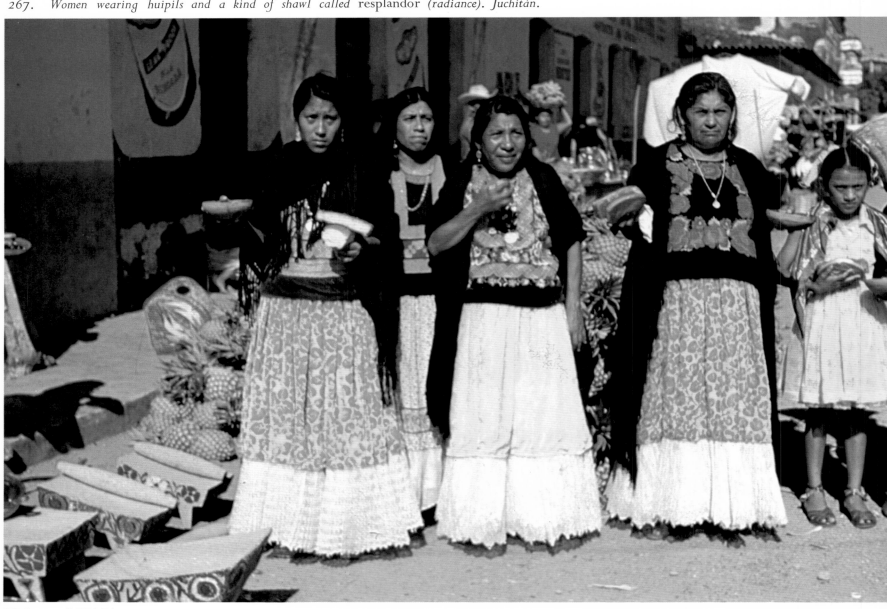

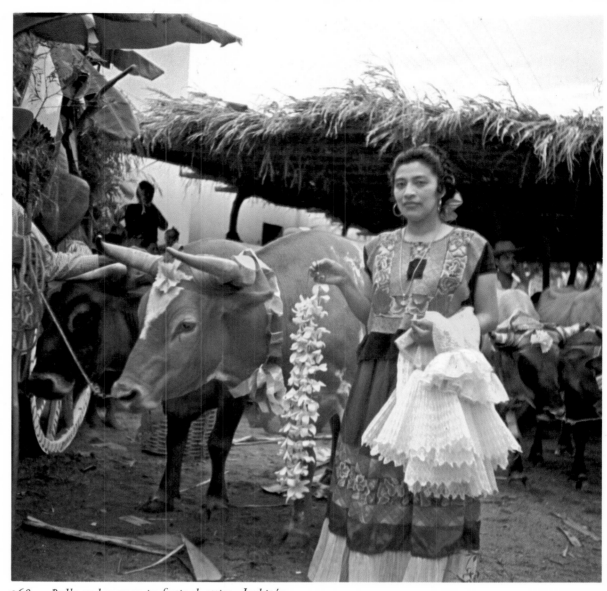

268. *Bulls and woman in festival attire. Juchitán.*

69. *On festival days, men throw nets over young women and children—and sometimes over tourists. Juchitán.*

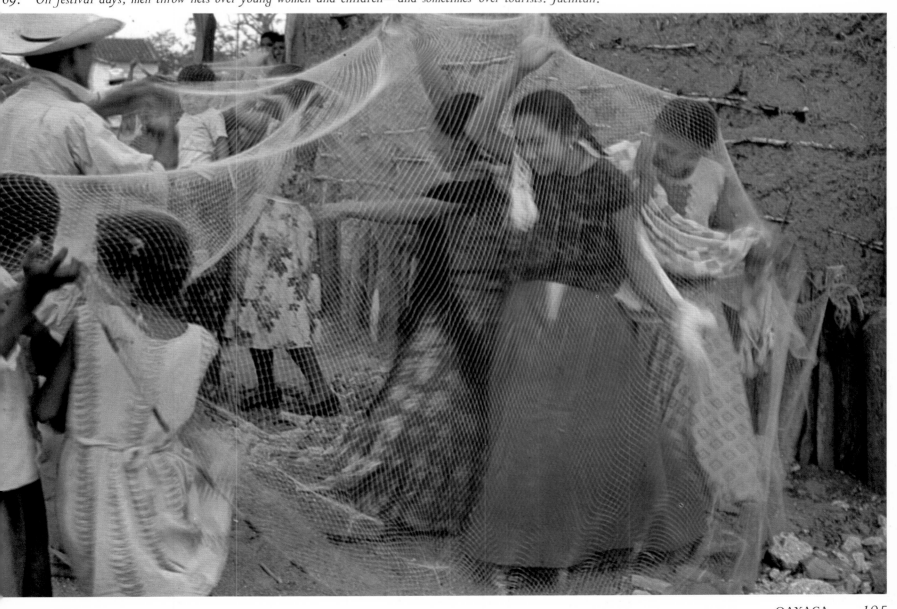

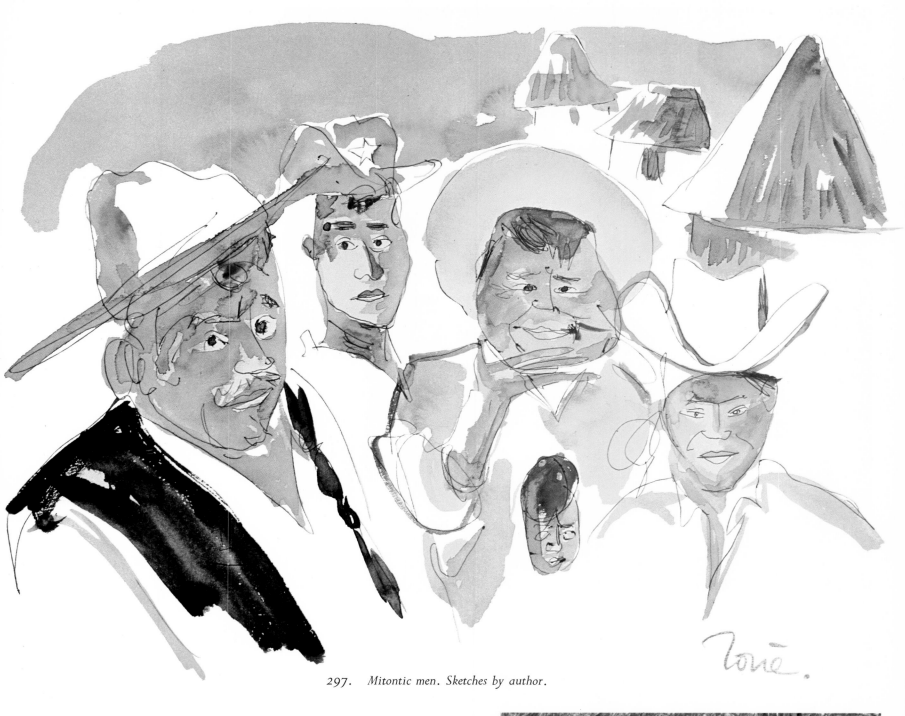

297. *Mitontic men. Sketches by author.*

Mitontic. This poor village, located about thirty kilometers from Chamula at the foot of rocky mountains, is aflame with the blossoms of thistles and salvia in January, which is like autumn in this part of Mexico. The men till the fields and tan hides in the shade of trees. The women, who are often mothers of two or more children by the age of seventeen, embroider beautiful wool-yarn patterns on blouses.

298. *Mitontic women.*

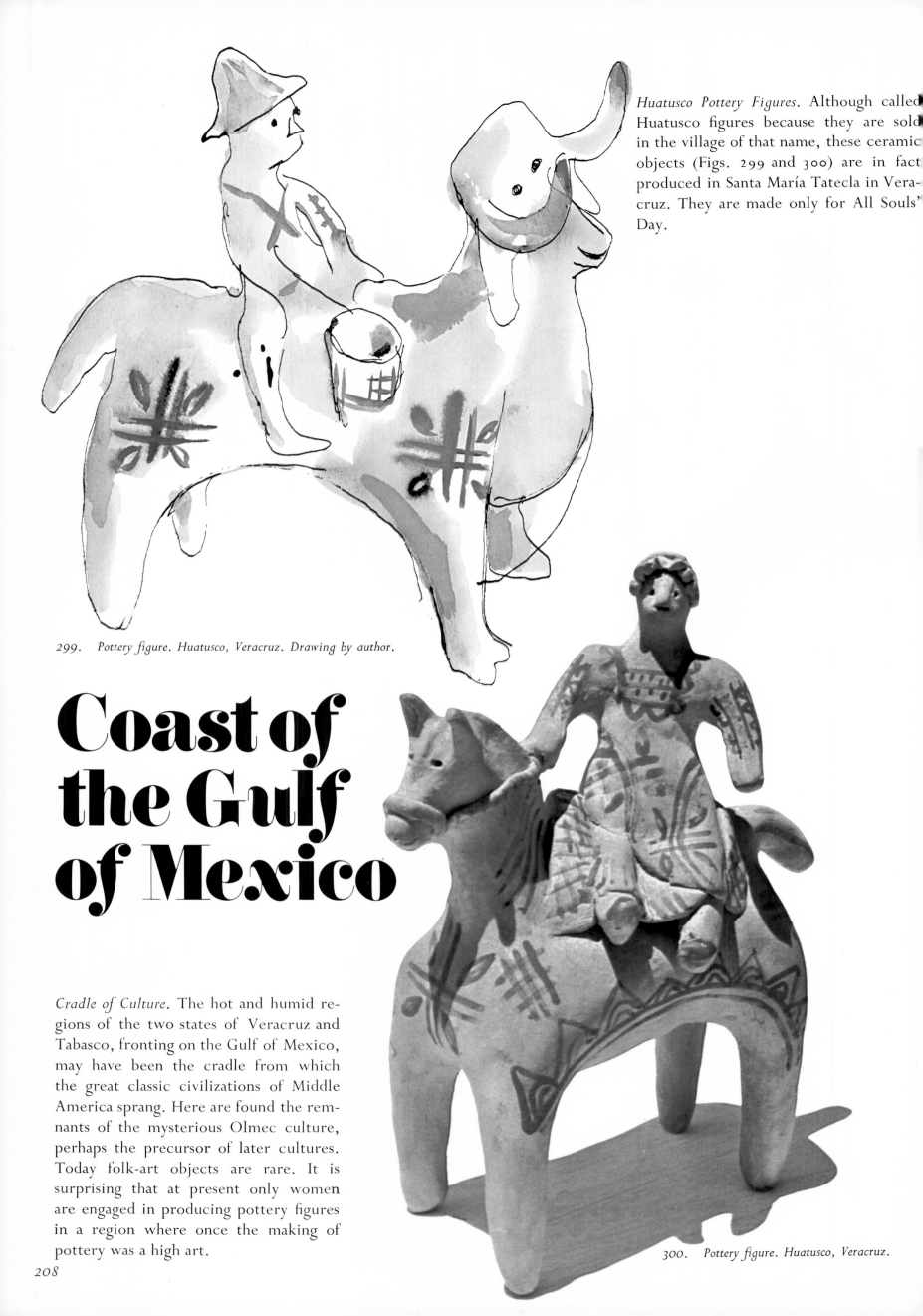

299. *Pottery figure. Huatusco, Veracruz. Drawing by author.*

Huatusco Pottery Figures. Although called Huatusco figures because they are sold in the village of that name, these ceramic objects (Figs. 299 and 300) are in fact produced in Santa María Tatecla in Veracruz. They are made only for All Souls' Day.

Coast of the Gulf of Mexico

Cradle of Culture. The hot and humid regions of the two states of Veracruz and Tabasco, fronting on the Gulf of Mexico, may have been the cradle from which the great classic civilizations of Middle America sprang. Here are found the remnants of the mysterious Olmec culture, perhaps the precursor of later cultures. Today folk-art objects are rare. It is surprising that at present only women are engaged in producing pottery figures in a region where once the making of pottery was a high art.

300. *Pottery figure. Huatusco, Veracruz.*

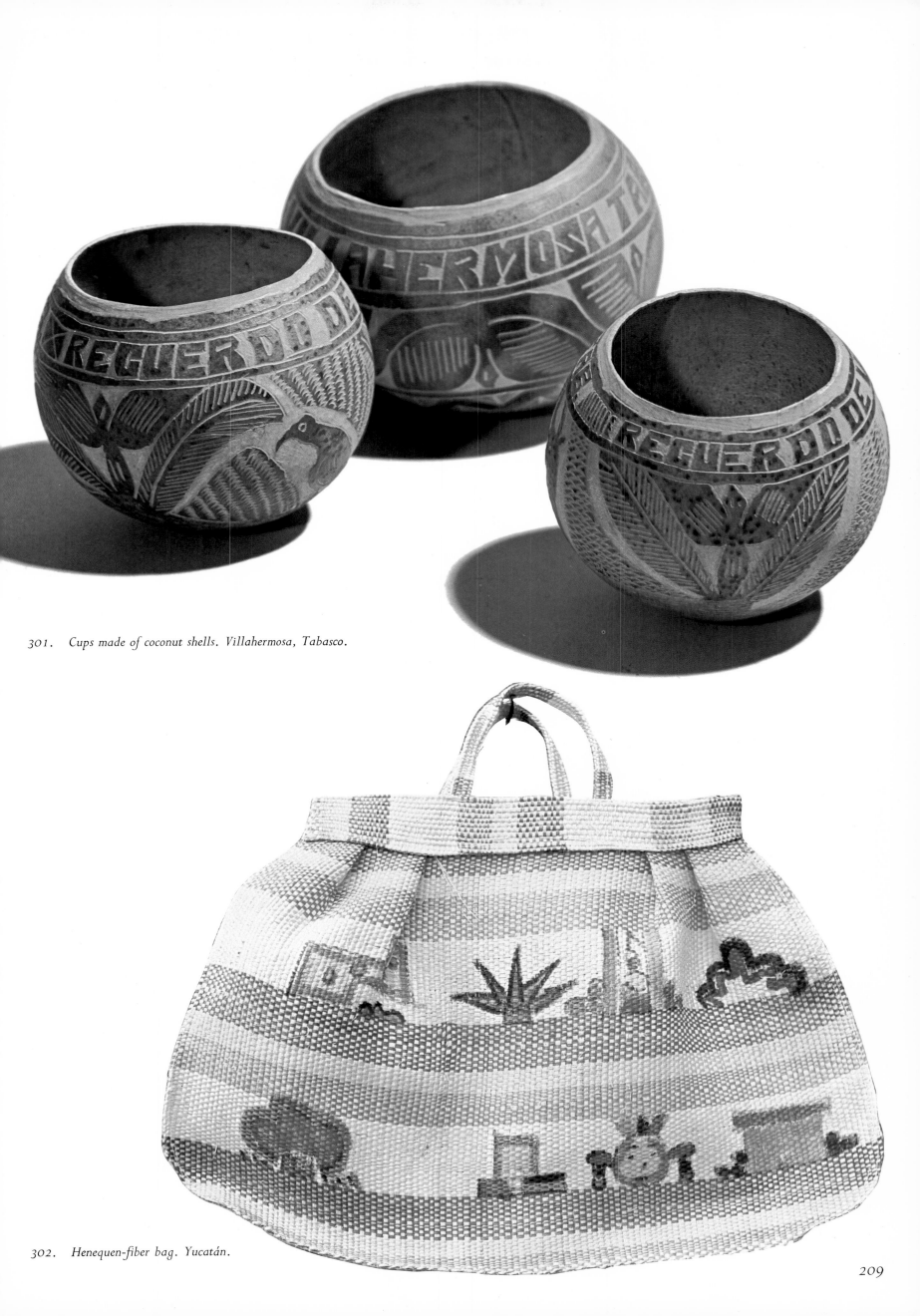

301. Cups made of coconut shells. Villahermosa, Tabasco.

302. Henequen-fiber bag. Yucatán.

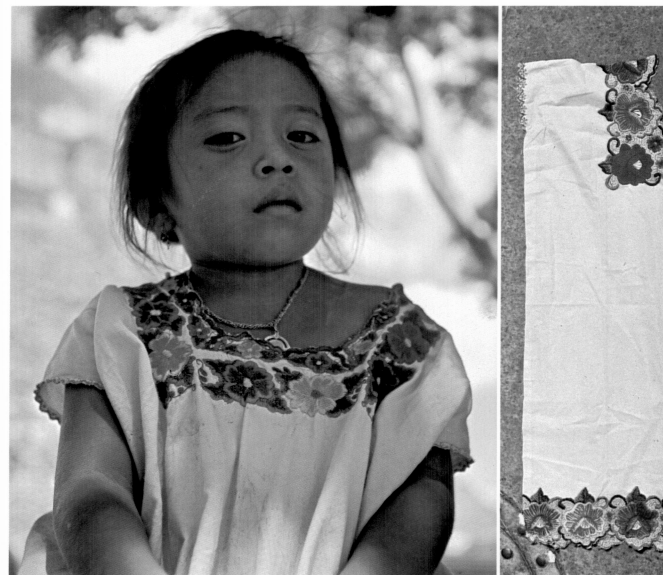

303. *Mayan girl. Uxmal, Yucatán.*

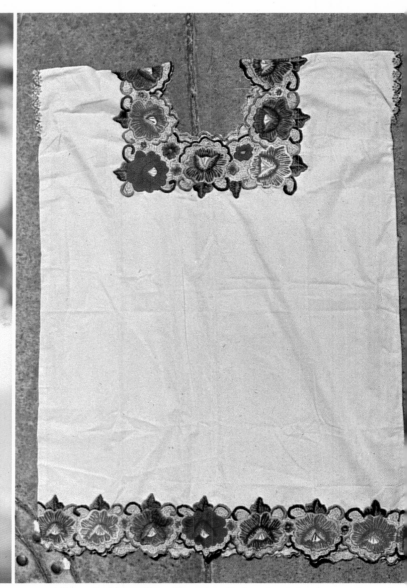

304. *Woman's blouse from Yucatán. Embroidered borders at the neck and hem are characteristic of the costumes of this region.*

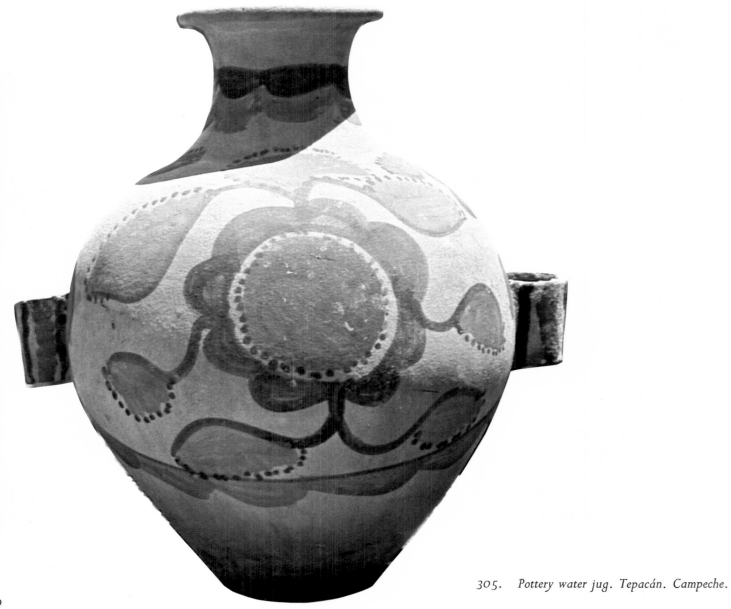

305. *Pottery water jug. Tepacán. Campeche.*

Notes on Modern Mexican Folk Crafts

by CARLOS ESPEJEL

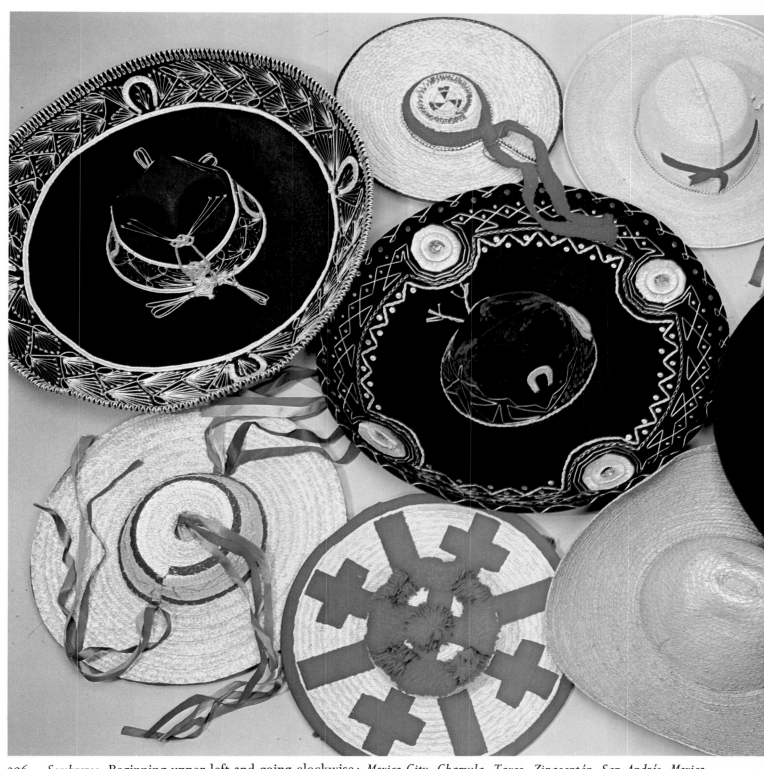

306. *Sombreros.* Beginning upper left and going clockwise: *Mexico City, Chamula, Taxco, Zinacantán, San Andrés, Mexico City.* Center: *Mexico City.*

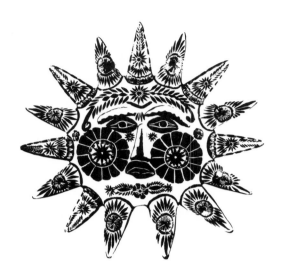

At some noontime, perhaps, while playing with clay at the edge of the water, man made the first pot . . .
—CARLOS PELLICER

INTRODUCTION

In the pages which follow, I have mentioned what I think are the most interesting of the folk crafts surviving in Mexico, and also the ones that are profoundly rooted in the traditions and conscience of the Mexican people. These crafts are pursued in regions where once great Indian empires or states flourished. The folk-craft objects produced in these regions are sometimes quite modest, but in them one can perceive the modern Mexican's cultural heritage—a heritage that defines him, guides him, and is a projection of himself.

CLAY

The making of pottery is the most widely-distributed craft activity in Mexico. There are many pottery centers which fill the great demand for items made of clay, and there are thousands of families involved in the production of ceramics. The pottery-making tradition is deeply rooted in the centuries before the Spanish Conquest, yet it still has a vigor that permits it to maintain itself as one of the finest forms of modern craft expression.

Today's pottery centers tend to reproduce traditional forms and to use traditional techniques, especially in the making of objects for daily use. But, during recent years, as I have noted in the Foreword, the world of pottery has been undergoing changes brought on by outside influences. For example, the introduction of high-firing techniques into Mexico City and Jalisco has given us a new line of aesthetically satisfying shapes and glazes.

Various techniques are employed by Mexican potters, but the most common is that of modeling the clay by hand. Here the artisan is guided solely by his imagination and by his manual dexterity. A number of artisans use molds, made of baked clay or of plaster, to produce a series of like objects. Finally, there are potters who use a rudimentary wheel to model their creations.

The characteristics of the clay at hand determine how it is used in each region. In some pottery centers, nothing is added to the clays used; in others, several clays are mixed together, or sand and, occasionally, reed (*tule*) chips are added to achieve a better cohesion.

Pottery is usually fired in round kilns made of brick or adobe. The tops of the kilns are open, and fuel—

either wood or oil—is introduced through one or more apertures in the bases. Most kilns are above ground, but in Coyotepec, Oaxaca, underground, circular-shaped kilns are employed. The openings of these kilns are level with the ground. Both types of kiln have racks on which the items to be fired are placed. In a few places, such as Zumpango del Río, Guerrero, and Amatenango del Valle, Chiapas (Figs. 274 and 276), the clay is fired on the ground itself, using firewood or cow dung as fuel. Few potters have modern gas kilns, which are used almost exclusively in the manufacture of high-fired stoneware.

When a kiln is loaded, it is covered with pieces of broken crockery to prevent heat loss. It takes from four to six hours to complete the firing of ordinary, unglazed pottery; glazed pottery requires a longer firing time, this varying according to the kind of kiln used.

The primitive firing techniques common in Mexico cause many problems which artisans are unable to solve. Sometimes a finished piece will be underfired; sometimes it will be overbaked. When firewood is used, should it not be dry, it produces smoke that blackens the items being fired. Because of the average artisan's lack of control over his kiln, he sometimes will lose all the contents of a single firing—a waste of time, money, and effort that could be avoided if the potters were persuaded to upgrade their manufacturing techniques.

The most common items made for household use are pots of various sizes and shapes, jars, cooking vessels, plates, and bowls. For ritual use, artisans produce such items as candle holders and incense burners. And there is a whole world of very ornate ceramic items, which includes candelabra, the so-called "trees of life" (which represent, principally, Adam and Eve in Paradise), animal, bird, and human figurines, and pieces, such as those of monsters, which are derived from fantasy.

Though modeling and firing techniques are similar throughout Mexico, each region has its own distinctive finish or finishes. Thus it is easy to identify the place of origin of any pottery object. The simplest finish is that of the natural color of the clay used (pieces employing this finish are fired but once). More complex are: finishes in which natural or synthetic paints are applied; those in which a single glaze—in yellow, brown, black, or green—is applied; those which are polished before firing; those in which two or more different colors of paint are applied and the whole varnished after firing; and, finally, black finishes, which can be obtained by closing the apertures of the kiln so as to produce enough smoke to blacken the pieces.

Artisans employ a wide variety of patterns—whether painted, incised, or scraped—to decorate their works. Decorations range from simple straight lines, frets, spirals, and geometric forms to the sophisticated botanical and zoomorphic designs of the potters of Tonalá, Jalisco.

There are about seventy-five important pottery centers in Mexico. Dozens of minor centers, which manufacture pottery for local consumption, can also be found, but they are distinguished only by their ordinariness. Outstanding pottery centers are found in the states of Puebla (Figs. 190–207), Oaxaca (Figs. 248–258), Michoacán (Figs. 81, 91–94, and 96), Jalisco (Figs. 64–73, 75, and 76), and Mexico (Figs. 164–183, 188, and 189).

In Puebla, the leading centers are Acatlán, Izúcar de Matamoros, Huaquechula, the city of Puebla, Amozoc, and several towns in the Indian areas of the Sierra of Puebla. Acatlán (Figs. 193 and 194) is the most important. This town's main output consists of items for domestic use. The pieces are fired once, and they are either blackened in the firing or they are left to show the natural color of the clay. Sometimes a piece may be decorated with a number of simple, white lines. Certain works of the artisan Herón Martínez go well beyond the usual items produced in Acatlán, for he makes large-sized clay sculptures for purely ornamental purposes. The pottery of Izúcar de Matamoros (Figs. 190 and 192) is polychrome-painted and varnished. One should single out mold-made candle holders and handmade animal figures and little dolls. In spite of the town's proximity to urban areas and to other pottery centers, the work of its artisans has not been touched by outside influences. Huaquechula produces small mold-made figures, which are used in celebrations held for All Souls' Day (November 2) and for Christmas. These figures are painted with aniline water-paints.

From the city of Puebla (Figs. 196–199 and 201–207) come the finest ceramic objects to be found in

Ceramic figure of farmer. Ameyaltepec.

Mexico: they are subsumed under the general term Talavera, taken from the name of the Spanish city of Talavera de la Reina, which gave to Puebla in the sixteenth century the techniques for making and decorating the ceramics for which the Spanish city was famous. The craftsmen of Puebla, however, do not confine themselves to the basic designs and colors of Spanish-inspired Talavera; they also employ patterns and decorations more in harmony with the sensibility of indigenous traditions. Both sets of influences are seen today in dinner services, vases, large dishes, and in the glazed tiles used to adorn buildings and houses (Figs. 201 and 203–207). The city also produces a very popular glazed pottery made in the quarter known as Barrio de la Luz (Fig. 202). In this part of the city, a few potters continue to work in traditional ways, but the once common technique—called *pastillaje*—of ornamenting objects with strips of clay or small figures made by hand or in molds has almost vanished. Also almost a thing of the past is the making of clay miniatures. Today only the family of artisan Angel Torija makes miniature Nativity scenes, kitchens, animals, and nuts decorated with country scenes.

Amozoc manufactures some of the glazed pottery which is sold in and associated with Barrio de la Luz. The town also produces small, painted animals and mold-made fruits, the last being used as coin banks. In the Sierra of Puebla, one can single out the glazed ceramics made in San Miguel Tenextatiloyan, and the earthenware plates, pitchers, bowls, and animals produced in Zautla and other places in the Sierra.

The leading pottery centers in the state of Oaxaca are Coyotepec, Ocotlán, Atzompa, Jamiltepec, Ixtaltepec, Tehuantepec, Juchitán, and Santo Domingo Tonaltepec. Coyotepec is noted for its unpolished and polished black pottery, worked in a variety of traditional forms (Figs. 255–258). Ocotlán's main pottery (Figs. 249–251) is all handmade and decorated with aniline water-paints. One can find representations of women selling fruits and vegetables, Nativity scenes, funerals, and baptisms, as well as bells with animal heads and incense burners. Most of the pottery of Atzompa (Figs. 248 and 253) is finished with a green glaze, although a few items are finished with a red wash. Among the manufactures are pots, jars, cooking vessels, salt shakers, and a number of other small household objects. The work of artisan Teodora Blanco and her sisters is outstanding. They make dolls and household items, which they carefully ornament with clay strips. As one continues towards the Pacific Coast of Oaxaca, one encounters a number of pottery-making towns and villages, but the most interesting is Jamiltepec (Fig. 252). Here clay miniatures are made in a distinctively indigenous style. The items are handmade and decorated with aniline water-paints applied on a white slip. Ixtaltepec is the main source of pottery objects for the Isthmus of Tehuantepec. From a fine white clay, fired only once, the town makes a wide variety of items for household use, which are sold throughout the Isthmus. In the city of Tehuantepec, one finds dolls called *tanguyús* and small, white horses, both of which are decorated in white and gold on a red wash. Near the city is San Blas Atempa, which makes doll-shaped vessels for cooling water, and, further towards the east, is Juchitán, where oil-painted, tanguyú-type dolls are made.

In Michoacán, Capula is an important center for glazed ceramics, including dinner sets, flower pots, and other items for domestic use. They are decorated with frets and flower or animal designs, painted on with brushes. Zinapécuaro produces mold-made, glazed flower pots, which are either left unadorned or are decorated with leaves and flowers. In Tzintzuntzán (Figs. 81 and 87), one finds ceramics with white, black, and green glazes, as well as once-fired, polished pieces in red and black. The glazed ware is ornamented with brush-painted fish, birds, deer, and lacustrine scenes of great simplicity. The pots, punch bowls, water sets, pitchers, and candlesticks of Santa Fé de la Laguna are black-glazed and are decorated with mold- and handmade pottery flowers and leaves. Patambán (Figs. 91 and 92) is famous for the fineness of its green glazed ceramics. The designs, which may be painted or scratched on, are based on old-fashioned motifs. The town also makes attractive thin-walled jars of red clay; the style is known as "cambric" or "egg shell." In San José de Gracia (Fig. 93), Emilio Alejos Pérez and other craftsmen make vessels called *piñas* (pineapples) and punch bowls decorated with mold-made ornaments of various kinds. Huánsito produces polished red pitchers bearing indigenous designs, and Ocumicho offers fantastic figures of devils and bloody monsters, all oil painted.

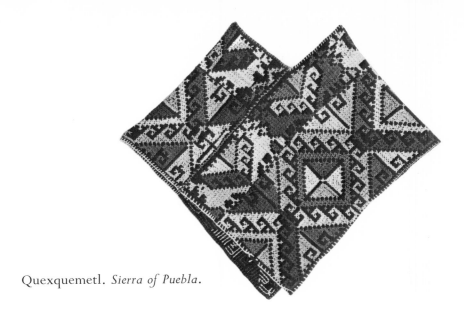

Quexquemetl. *Sierra of Puebla.*

There are two main pottery centers in the state of Jalisco: Tonalá (Figs. 64–73) and San Pedro Tlaquepaque (Fig. 76). Tonalá is best known for its *petatillo* style of glazed ceramics. The style includes traditional shapes and an ornamentation based on crosshatched lines in combination with flower and animal representations which bear the authentic stamp of an art of the people. Tonalá also produces what is perhaps the most beautiful polished pottery in Mexico. This pottery is noted for the wealth of its designs, the high quality of its finishes, and the immense variety of its shapes. In Tonalá, one also finds the so-called *barro bandera* (flag pottery): the name comes about because the potters use the three colors of the Mexican flag—red for backgrounds, white for floral decorations, and green for edgings. During recent years, Tonalá's prestige has been enhanced by the artistic works of Jorge Wilmot. He deals with a great variety of forms and utilizes the skills of Tonalá painters in decorating his high-fired ceramics.

Near Tonalá are two other pottery centers: El Rosario, noted for its *canelo* (cinnamon tree) pottery, so called because it is decorated in reddish brown colors on beige backgrounds; and Santa Cruz, which manufactures sewer tubing, as well as most of the toys sold in Tonalá's market. Artisan Candelario Medrano of Santa Cruz ought to be mentioned here, since his animals, churches, bridges, and other works show a high degree of plasticity and technical mastery.

Until not too many years ago, San Pedro Tlaquepaque was a first-class pottery center. Its artisans dedicated themselves almost exclusively to making clay sculptures. Today there is one leading artisan, Angel Carranza, who works in miniatures. He does scenes from rodeos, bullfights, cockfights, weddings, baptisms, and other events of frequent occurrence in Mexican life. Historically, the pieces once made by the Panduro family are of great interest, for they are true records of times past in that they faithfully reproduce the costumes of the figures shown.

In the state of Mexico, the most important centers are Metepec (Figs. 164–183), Tecomatepec, Valle de Bravo, Santa Cruz de Arriba, and the area occupied by the Mazahua Indians. Metepec is widely known for its "trees of life," highly ornate, polychrome-painted representations of, mainly, Adam and Eve in Paradise. In recent years, the artisans of Metepec have been turning out a larger variety of forms than before, due to the great demand for their products. They have also increased the number of colors used, so that there is a marked difference between "traditional" and "modern" pieces. In addition, Metepec also produces a range of glazed pottery for domestic use. Tecomatepec produces a distinctive jar, the form of which can be easily recognized. The usual adornment for this type of glazed jar is either a floral pattern done in black lines or an animal or bird design done in colors. The town also makes whistles in many shapes. In Valle de Bravo, dinner sets and fruit plates are finished in dark-brown, yellow, or green glazes. Finally, Santa Cruz de Arriba, near Texcoco, also produces glazed ceramics.

The most important centers in the state of Guerrero are Ameyaltepec (Figs. 40 and 41), Tolimán (Figs. 42–45), and San Augustín. They produce a wide range of utilitarian items, indigenous in inspiration. The pieces are fired once, then they are brush painted. Other places worth citing are: Chilapa, for mold-made glazed ceramics; Ayahualco, for once-fired, painted kitchenware; Tecpan de Galeana; Goacoyul; El Zarquito; Ajuchitlán, which specializes in vessels for cooling water; San Marcos; San Cristóbal, with its pitchers decorated with red flowers painted on a white slip; and Atzacoaloya, which produces most of the standard items sold at Chilapa's Sunday market.

In Guanajuato, capital of the state of the same name, artisan Gorky González manufactures majolica ware (Fig. 232). He is dedicated to reviving old forms, designs, and techniques. The town of Dolores Hidalgo produces dinner sets with modern floral designs, and from San Felipe come large flowerpots, green glazed and decorated with molded clay forms.

The Indian town of Amatenango del Valle (Figs. 274–276) in the state of Chiapas produces very beautiful, once-fired, handpainted ceramics. San Cristóbal de las Casas manufactures glazed earthenware, either painted

Woolen-yarn painting. San Andrés.

or adorned with molded clay figures; the forms used in San Cristóbal remind one of similar ones seen in Spain. In Chamula, where until recently only a rough pottery was manufactured, glazing techniques have been introduced. Comitán makes once-fired jars and coin banks decorated with simple red lines.

In the state of Veracruz, Santa María Tatecla produces a special type of pottery, one which is based upon very old models. Production is limited and the demand for the town's dolls, animals, candlesticks, and other items is therefore high.

Ocotlán, in the state of Tlaxcala, makes polished red pottery in the form of zoomorphic vessels. Floral designs are incised in the finished surfaces (Fig. 208).

In conclusion, I should say that there is no state in Mexico which does not have its own type of pottery, but, as I have noted before, most items produced for local consumption are relatively undistinguished. They serve a useful purpose but cannot be classified as objects of art.

WOOL AND COTTON

Weaving is one of the oldest crafts in Mexico. Today, handwoven wool and cotton textiles are used in the manufacture of clothing, blankets, rugs, tablecloths, napkins, and other items.

The craft is no longer entirely pure. The clay spinning whorl (*malacate*) inherited from pre-Conquest days is no longer used. Instead, yarn is made on spinning wheels or by machines. Synthetic dyes have almost entirely replaced natural ones. Indian communities still favor the horizontal loom with one end tied to a tree or post and the other to a belt around the weaver's waist; factories where wool cloth is woven prefer the upright loom with a wooden frame (introduced by the Spaniards; Fig. 241).

Garments worn by women include the *rebozo* (shawl), the *huipil* (essentially a straight and sleeveless blouse, although a small version is also used as a mantillalike headdress in the states of Puebla and Oaxaca), the *quexquemetl* (a capelike garment that covers the upper half of the body), the *enredo* (a wraparound skirt), and the blouse with sleeves.

The most versatile item in a woman's wardrobe is the rebozo (Figs. 200, 242, and 281). It takes the place of a hat and coat; it is used to carry a baby on the back; and it is often used simply as an adornment, especially by young women. The rebozo is made of wool or cotton; it may be a solid color or woven with contrasting stripes, as in Mitla, Oaxaca, and Tepeaca, Puebla; or it may bear colored embroidery in the forms of animals or flowers, as in Hueyapán, Puebla. The most famous rebozo-making centers are Tenancingo, state of Mexico, and Santa María del Río, San Luis Potosí. In the former, rebozos are made of fine cotton threads; in the latter, they are made of silk. It may take months to make a single, heavily decorated rebozo.

The huipil (Figs. 221, 243, 244, 246 and 267) is made of cotton, although it may be embroidered with woolen thread. Especially noteworthy are the embroidered huipils from the mountains of Chiapas and the Isthmus of Tehuantepec. Quexquemetls (Figs. 213–216 and 225) made of wool are especially colorful in the Sierra of Puebla. Enredos to be singled out are: those made in the Sierra of Puebla and in Michoacán of black wool; those made along the coast of Oaxaca of cochineal-dyed cotton; and those made in Acatlán, Guerrero, of cotton bordered with designs in silk thread. The designs used on embroidered blouses (Figs. 209, 278, and 304) vary from state to state, but those used in the Sierra of Puebla are unusually attractive.

Both men and women wear *fajas* (sashes) made of wool or cotton on horizontal looms. Sashes made in the Sierra of Puebla are worked with colored woolen yarns and decked with spangles; those made by the Huichols (Fig. 24) are also colorful and come in a wide variety of designs. (In fact, Huichol men are noted for their love of ornate clothing.)

Ceñidores (belts) of cotton are made for men's use. In the Sierra of Puebla, they are decorated with tassels; in Chiapas, they are richly embroidered; and, among the Huave group in the Isthmus of Tehuantepec, they are simple bands of cotton.

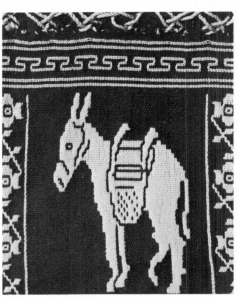

Shoulder bag. Ixmiquilpán.

Men wear a poncholike garment called a *jorongo* (also known as a *gabán*; Figs. 86 and 186) in the country. The jorongo is open on both sides and has a hole in the center so that it can be slipped over the head. This country-man's overcoat is produced in a variety of colors and designs, with the finest examples being from: San Francisco Xonacatlán and Coatepec Harinas, state of Mexico; Santa Ana Chiautempan, Tlaxcala; Teotitlán del Valle, Oaxaca; Jocotepec, Jalisco; Malinaltepec, Guerrero; and Paracho and Charapan, Michoacán.

The *sarape* (Figs. 133, 230, 235, 239, and 240) is perhaps the best known of the products of Mexico's weavers. It has many uses: as a blanket, as protection against the elements, and as a floor mat. Noteworthy are those made in: Teotitlán del Valle, Oaxaca; San Miguel de Allende, Guanajuato; Chiconcuac and Gualupita, state of Mexico; and Santa Ana Chiautempan and San Bernardino Contla, Tlaxcala.

The *bolsa* (bag, also known as a *morral*; Figs. 21–24, 184, 185, 219, and 238), often worn hanging from the shoulder, is used throughout Mexico. Made of wool or cotton, the most interesting types are produced by the Huichols and Coras of Nayarit.

Tablecloths (Fig. 210), napkins (Figs. 228 and 229), and rugs are manufactured in many parts of Mexico. A government sponsored project to produce handmade knotted rugs is going on in Temoaya, state of Mexico.

OTHER FIBERS

The making of various objects from vegetable fibers is another old and widespread craft in Mexico. Artisans work with a reed called *tule,* palm, straw, henequen, and other materials to produce baskets, hammocks, hats, bags, and other items. The major manufacturing centers are located near the sources of the raw materials. (See Figs. 80, 120, 125, 145–147, 217, 218, 259, 302, and 306.)

Tzintzuntzán, located on the shores of Lake Pátzcuaro, Michoacán, produces many objects made of reed. Among them are bottle stoppers in human and animal shapes, table mats, and star-shaped mats used as floor coverings. Lerma, state of Mexico, uses reed to make mats, chairs, bags, and a variety of small human and animal figures. Tultepec, also in the state of Mexico, sends little mules made of reed, maize leaves, and banana-trunk leaves to Mexico City for the Feast of Corpus Christi.

Palm takes many forms. In Santa Ana Tepaltitlán, a village near Toluca, state of Mexico, dishes and baskets for a variety of uses are made of colored palm. They are most beautiful. Painted palm baskets are also produced in Tlamacazapa, Guerrero. In Santa María Chigmecatitlán, Puebla, palm is employed to make table mats, flowers, necklaces, and figures of *charros* (Mexican horseback riders), musicians, and animals. On Palm Sunday, artisans take specially made objects to churches to be blessed; the most beautiful come from Arantepacua, Michoacán.

The palm industry provides work for a good many people, especially since palm leaves are used in the manufacture of the *sombrero,* the ubiquitous hat of Mexico. Each region has its own hat style; the variety seems infinite. Some of the important hat-making centers are in Oaxaca, Guerrero, Guanajuato, Yucatán, and Campeche. The last state makes a hat lighter and more flexible than any other produced in Mexico.

Panicua (wheat straw) is used in Tzintzuntzán to make figures of doves and of Christ and the Virgin Mary. *Popote* (broom straw), a compact, round, and slim straw, is employed exclusively in Mexico City by a few artisans to make representations of landscape scenes. The techniques they use are uncomplicated. The pieces of straw are first dyed, then left to dry. On a piece of paper a design is traced; over this a layer of wax is applied. The dried straw, in different colors and sizes, is then pressed into the wax to complete the "drawing." Unfortunately, this art is gradually disappearing, since few young artisans care to take it up. Henequen, the fiber of an agave plant raised in Yucatán, is used in the manufacture of handbags, wallets, belts, table and floor mats, rope, and many other items. *Ixtle,* the fiber of the maguey plant, is utilized in the making of *ayates* (carrying cloths). Ixtle is also used for bags, hammocks, sandals, and rope. The type of bag known as a *red* (net) made in the Valley of Oaxaca is famous. It is adorned with bands of colored and undyed ixtle.

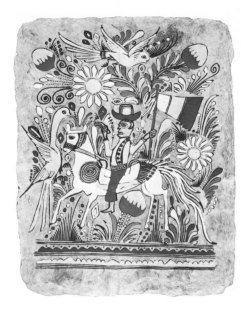

Painting on bark paper. Xalitla.

Mexican artisans seem to be able to work with almost any natural fiber or product, for in addition to the materials already mentioned, they make good use of grasses, twigs, crushed maize stalks, chicle (which is made flexible with hot water in order to produce baskets, fruits, flowers, and representations of the Virgin Mary), dried flowers (interestingly used in San Antonio, Oaxaca, to make doves, eagles, angels, lyres, and other figures), seeds (used for necklaces, rosaries, toys, and a variety of figures), coconut husks (now used only in Colima and Tabasco), and nutshells.

Three items deserve separate mention. The first is the *jícara,* a gourd bowl usually lacquered or carved. Of ancient origins, the jícara is used mainly to serve liquids, although the Huichols decorate the inside of jícaras with bead paintings (Figs. 18–20) and use them as offerings during religious festivals.

The second is amate paper. This is made in San Pablito, Puebla, from the bark of the amate tree. In pre-Columbian times, the paper was used at first for clothing but later was utilized as a writing paper to record tributes and national histories. Today it is employed in making charms for ritual use (Figs. 211 and 212) and, in Ameyaltepec and Xalitla, Puebla, imaginative paintings (Figs. 47–51) are done on it.

The third is a kind of paste image once made in Michoacán. The great Vasco de Quiroga, the Bishop of Michoacán in the sixteenth century who did so much to revive craft traditions in the towns surrounding Lake Pátzcuaro, particularly encouraged the manufacture of images—mainly of Christ—from a special vegetable paste that the Indians had used before the Conquest to make idols. The skeleton of the image was built up of maize leaves; it was then covered with a spongy paste made of the marrow of maize stalks and thickened with a gum obtained from orchid bulbs. Once the sculptured paste had dried, it was given a layer of plaster, and this was then painted and rubbed with oil. Of the images made under the inspiration of Tata Vasco (as his charges called him), two of the most outstanding are the Virgen de la Salud, still worshipped in Pátzcuaro, and the Cristo de la Conquista, found in San Miguel de Allende, Guanajuato. The full technique is lost today, but in Pátzcuaro, Baldomero Guzmán, who is ignorant of the old-time technique, does make images from maize stalks held together with nopal gum. When a sheaf is dry, he carves, plasters, and paints it to make the desired figure. Except for an artisan in Zacatecas, capital of the state of the same name, who works from crushed maize stalks, the paste-image tradition is but a memory.

METAL

Indian craftsmen before the time of the Conquest used gold and silver to make a wide variety of ornate objects—animal figures, wheels representing the sun and moon, jewelry, and many others. Copper was reserved for more mundane things, such as axes and tweezers. The pieces done in precious metals astonished the Conquerors, not only because of their quantity but also because of their technical excellence. Although uncomplicated pieces were produced by hammering, the more elaborate works were made by the lost-wax technique. The last requires a thorough knowledge of metallurgy and a firm control of the manufacturing process.

The Spaniards consigned most of the gold pieces they found in Mexico to the melting crucibles, since they could then more easily give a precise value to the shares of the booty which had to be allotted to the Crown and to the conquerors themselves. Most of the pre-Conquest gold objects were thereby lost, although examples have recently been found in unviolated tombs in the Mixtec area of the state of Oaxaca.

The Indians obtained their precious metals from river beds or from open gravel or sand deposits. Only after the Conquest were mines worked, the most productive being in Guanajuato and Taxco. The flow of gold and silver from the mines helped to develop a new craft of working in precious metals, one in which the combination of Spanish influence and indigenous talent produced a strong and unique style, especially well seen in jewelry.

In Guanajuato today, gold jewelry is made in old-fashioned styles; individual pieces are decorated with gold flowers and doves, and sometimes with turquoises. In Oaxaca, gold is employed in the manufacture of replicas

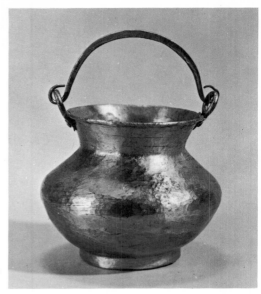

Copper vessel. Santa Clara de los Cobres.

of pre-Conquest objects, as well as in the making of items in filigree adorned with pearls and corals. Juchitán, Oaxaca, and Valladolid, Yucatán, are also centers of gold-filigree work.

Silver is widely used today. In Pátzcuaro, Michoacán, necklaces (Fig. 82) and earrings are made of red porcelain beads and silver; old-fashioned earrings with pendants are produced in Zitácuaro, Michoacán; silver filigree is worked in Oaxaca; in Mitla, Oaxaca, Félix Bautista fashions his famous Yalalag crosses in fine silver; and in the state of Mexico are found necklaces and earrings using indigenous designs.

The leading production centers for silver items are: Taxco, Guerrero, noted for its jewelry done in sophisticated, international styles (Fig. 38); and Mexico City and the city of Puebla, both of which make coffee sets, pitchers, trays, and other items adorned with engraved or repoussé designs.

Special note should be made of a line of jewelry developed in Mexico City by Matilde Poulat and a group of skilled artisans. Individual pieces bear designs in repoussé, and are decorated with amethysts, turquoises, and corals.

Copper was worked in pre-Conquest times, as has already been noted. After the Conquest, the Spaniards discovered rich deposits of copper in Michoacán and began immediately to mine them. Santa Clara de los Cobres, Michoacán, was founded as a copper center in 1553; thus, the copper industry began to flourish in Mexico within just a little over three decades after the Conquest.

At present, fifty workshops, employing more than three hundred artisans, are operating in Santa Clara. The workers will hammer pieces of copper with rhythmical, smooth movements for hours before the desired objects are completed. The sound of copper being beaten is all-pervasive in Santa Clara.

Steel was introduced by the Spaniards. The Aragón family of the city of Oaxaca is renowned for the steel items it produces. Among them are *machetes* (the straight or curved knives which are the basic work tools of the rural population), swords, and a great variety of other blades which have beautiful designs of flowers and fruits and, sometimes, popular sayings etched into them with acid.

Ironwork was also a gift of the Spaniards. Examples of antique ironwork can be seen in window grilles, railings, and balconies. The craft has, however, declined. Today, a limited number of high-quality items are produced in San José de los Herreros, Michoacán. Locks, nails, and fittings for doors and furniture are made in San Cristóbal de las Casas, Chiapas. Iron lamps inset with blown glass are manufactured in the city of Guadalajara, Jalisco (Fig. 79), and in Mexico City.

Items made of tin (Figs. 36, 141, 263–265), brass, and bronze are found throughout Mexico. They take many forms: candlesticks, lamps, plates, trays, boxes, etc.

Figures made of wire and covered with papier-mâché (Figs. 112–118) are still produced in Mexico City. The artisans who work with these materials turn out animals, demons, and monsters. It is a most singular craft.

LACQUER

The art of making lacquerware was well developed before the arrival of the Spaniards in 1519. The craft declined somewhat in the nineteenth century, but revived in this century, principally because of tourist demand. Nowadays, lacquerware is produced in Michoacán, Guerrero, and Chiapas. The art has completely disappeared from Peribán, Michoacán, but that town gave the generic name of *peribana* to a kind of round tray still made elsewhere.

Uruapan, Michoacán, is known for inlaid lacquerware. The artisan first lacquers on the background, usually black, and this is allowed to dry. Then he cuts into the black lacquer coat a design, using the tip of a knife or a steel point. Next, "aje wax" is applied as a fixer. (This wax is obtained from a parasitic insect found in tropical trees in Michoacán and Chiapas. Batches of insects are thrown into boiling water; when the water has boiled away, the brown oily paste which is left is the wax.) The artisan then applies colored pigments; each pigment must be rubbed into the design with the palm of the hand and allowed to dry before the next is applied. The

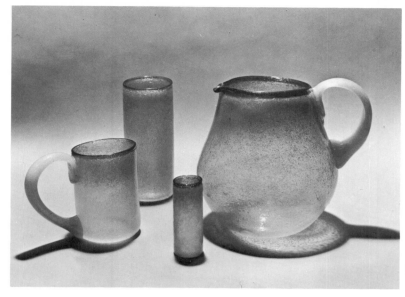

Wooden mask. Michoacán.

Glassware. Mexico City area.

work demands great patience and skill, but the artisans of Uruapan are not yet remunerated as they should be, since the demand for the objects they produce is low.

In Pátzcuaro, Michoacán, the artisan traces rather than engraves his design on the lacquer background. He then applies a mordant to the traced lines and on this gold leaf is pressed. He complements the gold-leaf design with painted floral and animal motifs.

Olinalá, in the mountains of Guerrero, is the most important lacquer center in Mexico. Its technique is so old that the implements and materials employed have retained their Indian names. A fragrant wood called linaloa is used. Unlike the case of Uruapan, the lacquerware made in Olinalá is in great demand (Figs. 55–62).

The Olinalá artisan first applies a coat of lacquer to the piece at hand and allows this to dry. A second coat in a contrasting color is then put on. While the second coat is still fresh, the artisan incises into it a design with the tip of a thorn attached to a feather, so that the color of the undercoat is exposed. A layer of earth is then laid on, and the piece is allowed to "air" for a time. The earth is removed, and the grooves are scraped again, so that the areas containing the design elements stand out in relief.

It should be noted that the fixer used in Olinalá is derived from the seeds of the *chía* plant (*Salvia chian*). The artisan makes chía oil by toasting the seeds, grinding them into a fine powder, and dissolving the latter in water.

Formerly, the artisans of Olinalá used gold leaf as an ornament; it was applied with a brush. Nowadays, a yellow paint is used in place of the leaf, but the wares are still described as "gold-leaf-decorated."

WOOD

Before the Conquest, various woods were utilized to make furniture, canoes, trays, weapons, and any number of items for daily and ceremonial use. After the Conquest, wood was used as well in the construction of houses and in the building of altars. In all of this work, the imagination and skills of Indian artists found expression.

At present, wood is used mainly in the manufacture of all kinds of furniture, especially the so-called "Mexican colonial" produced in Mexico City, Cuernavaca, Taxco, and San Miguel de Allende. In Michoacán, furniture carved from pine wood is decorated with angels, animals, and flowers.

The use of masks for religious ceremonies is old in Mexico. Today masks are made of wood (Fig. 33) in many parts of the country. They are used primarily during festivals, and may or may not any longer have a religious significance, but at least, the mask tradition has survived.

Wood is carved into animal and other shapes (Figs. 89, 90, 97, 98, 120, 149, and 153) in various towns. Notable are the painted works done in San Martín Tilcajete (Figs. 260–262), Arrazola, and San Juan Chapultepec (all in Oaxaca), and the unpainted carvings of El Naranjo, state of Mexico (Figs. 143 and 144). In the city of Oaxaca, Pedro Paz, and other artisans, carve wooden combs; the techniques used are primitive, but the combs are attractive.

Musical instruments (Fig. 294) are manufactured in Michoacán, Mexico City, Chiapas, and Veracruz. Boxes of inlaid wood for the storage of rebozos are made in Santa María del Río, San Luis Potosí, along with tables and chests. In Tepoztlán, Morelos, miniature houses and a variety of figurines are made of a reddish brown wood. In Guanajuato, one finds wooden models, which are used to decorate *tortillas* (the tortilla being the indigenous bread of Mexico). At festival times, the molds, brushed with edible dyes, are pressed to hot tortillas to transfer the dyes. Either floral or religious motifs are used. Finally, note should be made of the gilded mirrors (Fig. 142), picture frames, and furniture produced by many cabinetmakers.

STONE

In the many relief carvings and sculptures in the round to be found in temples and buildings dating from pre-Conquest times, one finds abundant evidence of the skill with which Indian artisans worked stone. In spite of technical limitations, the carvers produced works of outstanding beauty. Stone is still worked today by profes-

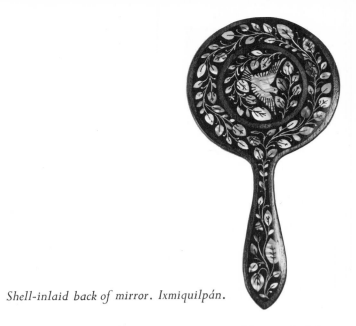

Shell-inlaid back of mirror. Ixmiquilpán.

sional sculptors and by artisans who turn out such things as fountains, garden ornaments, and household utensils.

The extraction, cutting, and polishing of semiprecious stones to be used in making jewelry provides work for a great many artisans today. Three major centers are Zacatecas and Querétaro, both capitals of states of the same name, and Taxco, Guerrero.

Onyx has been worked for many years in Tecali and Texcala, Puebla, even though the raw material has to be brought from Oaxaca. Onyx lends itself to the creation of a variety of objects, such as vases, glasses, bowls, boxes, book holders, chess sets, ashtrays, tables, and ornamental figurines.

Obsidian, serpentine, amethyst, turquoise, and malachite are among other stones also worked.

GLASS

The Spaniards brought the knowledge of glass blowing to Mexico. The first factories were established in the city of Puebla and Mexico City. Today the industry is widespread, and major factories can be found in the states of Mexico and Jalisco.

Although pressed glass is made in the city of Puebla, hand-blown glass is the usual material for making dinner and tea sets, jars, pitchers, and glasses in beautiful forms and colors (Figs. 77 and 78). Artisans also make purely ornamental objects such as human and animal figures and miniature sets of dishes in small closets.

PAPER

Mexicans delight in fantasy, and nowhere is this more clearly seen than in the so-called Judas dolls, made for Holy Week, and other figures produced from cardboard and papier-mâché, the last sometimes in combination with wire (Figs. 101–118). Especially fantastic are the many weird animals and monsters created by the Linares family in Mexico City (Fig. 112).

BONE, HORN, SEA SHELLS, AND TORTOISE SHELL

Bone, horn, sea shells, and tortoise shell have been used by popular artists in Mexico for centuries. For example, bone was worked before the Conquest to make knives, spatulas, musical instruments, necklaces, and other items. Such objects were sometimes sculpted or engraved. Today, bone is used for chess and domino sets, buttons, and even for miniature skulls and skeletons. Mexico City and Teocaltiche, Jalisco, are the main centers of production.

In the states of Mexico and Guerrero, horn is made into combs, hair ornaments (Fig. 119), and vessels for storing *mezcal,* a fermented intoxicant. Horns themselves may be finely engraved, as by Enrique Ruiz Orbe in Tecpan de Galeana, Guerrero, or they may be painted. And horn is popular for machete and knife hilts.

Various types of shells are used by Mexican Indians for personal adornment and as currency. Abalone shell is utilized to decorate a number of items; in Ixmiquilpán, Hidalgo, Santiago Pedraza makes wooden furniture with abalone shell inlays.

From tortoise shell are made combs, bracelets, and earrings; the shell is also used for inlays. In Mexico City, Pedro Guerra makes elegant jewelry of tortoise shell inlaid with silver.

LEATHER

The Spaniards brought the art of leather working with them, and the craft is now widely diffused in Mexico. Leather is made into saddles, bags, shoes, sandals, jackets, coats, belts, purses, billfolds, and card and cigarette cases, and is also employed in various items of furniture. Leather may be decorated by tooling, carving, appliquéing, or embroidering.

FEATHERS

The art of feather work was highly developed in pre-Conquest times, not only in Mexico but in all of Middle

Puppet. Mexico City.

America. Feathers were used to make crests, banners, shields, and bucklers, and they were used to adorn clothing. In some areas, they served as currency.

Only a few examples of pre-Conquest feather work have been preserved, although the beauty of the art is suggested in a number of feather representations of religious figures done after the Conquest. The use of feathers today is limited; one sees them in the headdresses of those who perform native dances (Figs. 139 and 222), and in the ruffles of a kind of dress made in Chiapas. Otherwise, feathers are used only in minor or incidental ways.

WAX

Wax was first used in colonial times to make candles. Gradually, the material came to be used in the creation of figures of historical personages and of ordinary citizens, shown exercising their professions or pursuing some social activity. These genre figures are to be found today mostly in museums and private collections, and, by virtue of the minutely observed and scrupulously executed details of costumes and settings, they provide a record of times past of great ethnographic value. Unfortunately, the genre tradition began to decline in the early part of this century and has since disappeared, although Nativity scenes modeled in wax were still to be seen in the nineteen-forties. However, they too are no longer made. Of the once-flourishing tradition, the only true vestige left is to be found in the works done in Mexico City by the descendants of Luis Hidalgo. Otherwise, the making of plain or decorated candles is the main artistic use to which wax is put today.

TOYS AND MINIATURES

Handcrafted toys are still in great demand in spite of the competition provided by inexpensive plastic ones. The world of the Mexican toy is characterized by bright colors, ingenuousness, and improvisation, since artisans will make use of any materials at hand when shaping a toy. (See Figs. 43, 44, 73, 95, 97, 98, 120, 121, 131, 158, 195–198, 217, 218, 248–252, 260–262, 264, and 265.)

Toys are usually given to children, but many Mexican adults avidly collect toys and miniatures as souvenirs. Among popular items, the most interesting are: Nativity and animal figures made in the city of Puebla and in San Pedro Tlaquepaque, Jalisco; wooden musical instruments inlaid with abalone shell from Ixmiquilpán, Hidalgo; copper dinner sets and other items from Santa Clara de los Cobres, Michoacán; glazed crockery from Tonalá, Jalisco, and the city of Guanajuato; silver, copper, and brass tea sets and glasses from Mexico City; tiny pigs made of nutshells, in which flies are placed to make the ears and tails move; and dried fleas dressed in human costumes, now done only by one artisan in Mexico City.

The state of Guanajuato produces a large number of toys. Santa Cruz turns out boxers, tin whistles, wooden furniture, boxed snakes, birds that perform the motions of eating from a bowl, a variety of clay items, including spiders, horses, witches, and monks, all with wired limbs. Irapuato produces wooden toys, and Celaya makes paper and cardboard masks and dolls (including Judas ones) as well as toy soldiers, cages, and candelabra made of lead.

Other toy centers meriting mention are: Acatlán, Guerrero, with its painted and varnished clay whistles; Coyotepec, Oaxaca, for a variety of clay toys; Atzompa, Oaxaca, where green glazed miniature crockery is made; Tonalá, Jalisco, with glazed crockery, polished clay animals and vessels, and women's heads (used as coin banks); Janitzio, Tzintzuntzán, and Zirahuén, all in Michoacán, for wooden and cloth toys; Ixmilquilpán, Hidalgo, which makes rattles of palm decorated with colored feathers; and San Cristóbal de las Casas, Chiapas, where Isaías Ruiz does tiny tables, chairs, small boxes, and wardrobes of hand-painted wood.

Mexico City is a center for many kinds of toys, but worth special attention are the clay puppets dressed in brightly colored costumes made by Manuel Ibarra, the last puppeteer in Mexico, and small cages made of straw, with colored cardboard for roofs and floors and with each cage housing a wax bird.

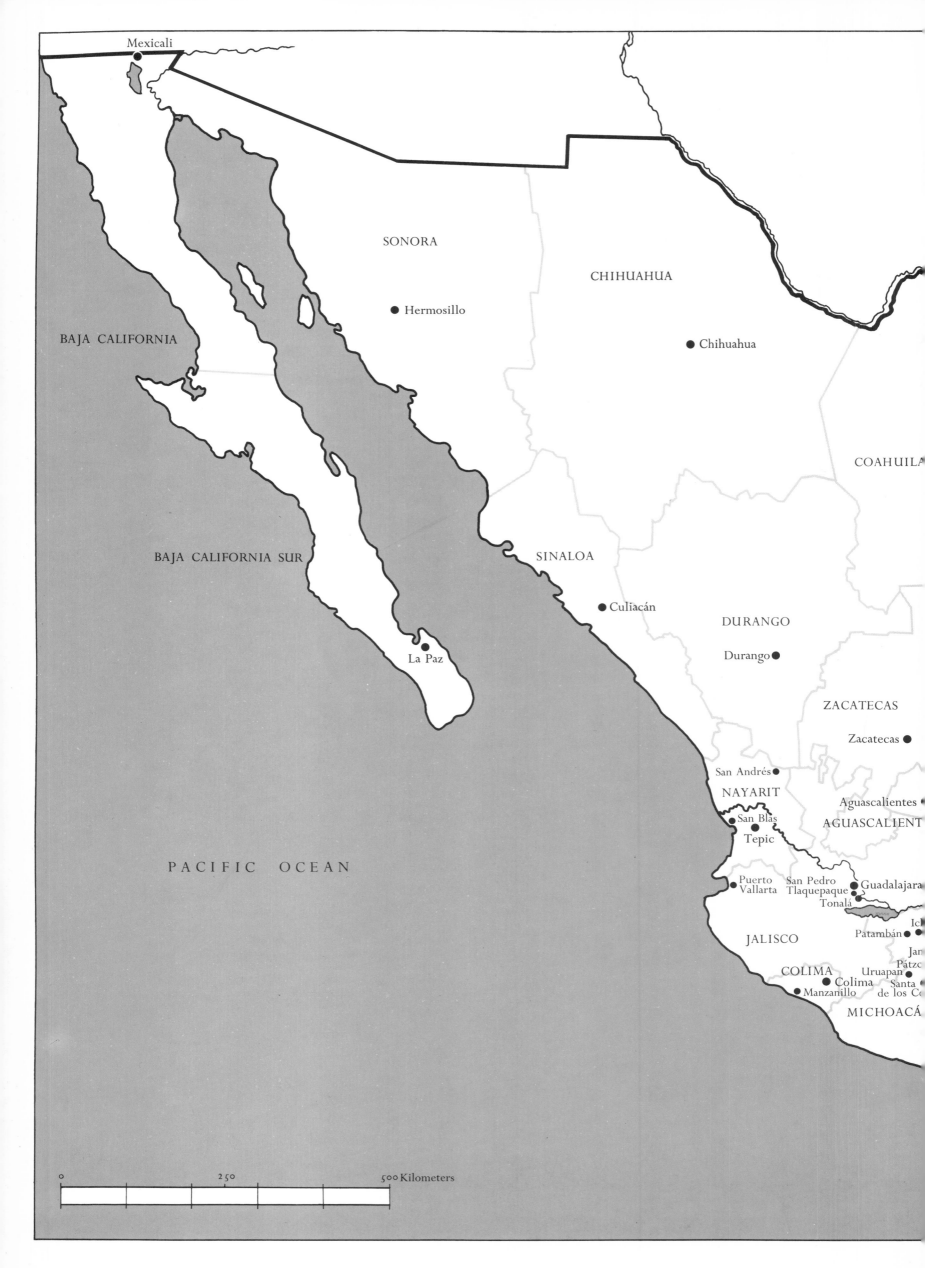

Mexicali

SONORA

CHIHUAHUA

BAJA CALIFORNIA

● Hermosillo

● Chihuahua

COAHUILA

BAJA CALIFORNIA SUR

SINALOA

● Culiacán

DURANGO

Durango ●

La Paz

ZACATECAS

Zacatecas ●

San Andrés ●

NAYARIT

Aguascalientes ●

San Blas ●
Tepic ●

AGUASCALIENT

PACIFIC OCEAN

Puerto
Vallarta ●

San Pedro
Tlaquepaque ●
Tonalá ●

Guadalajara ●

Ic

Patambán ●

Jar

JALISCO

Pátz

COLIMA

Uruapan ●

● Colima

● Manzanillo

Santa
de los C

MICHOACÁ

0 250 500 Kilometers

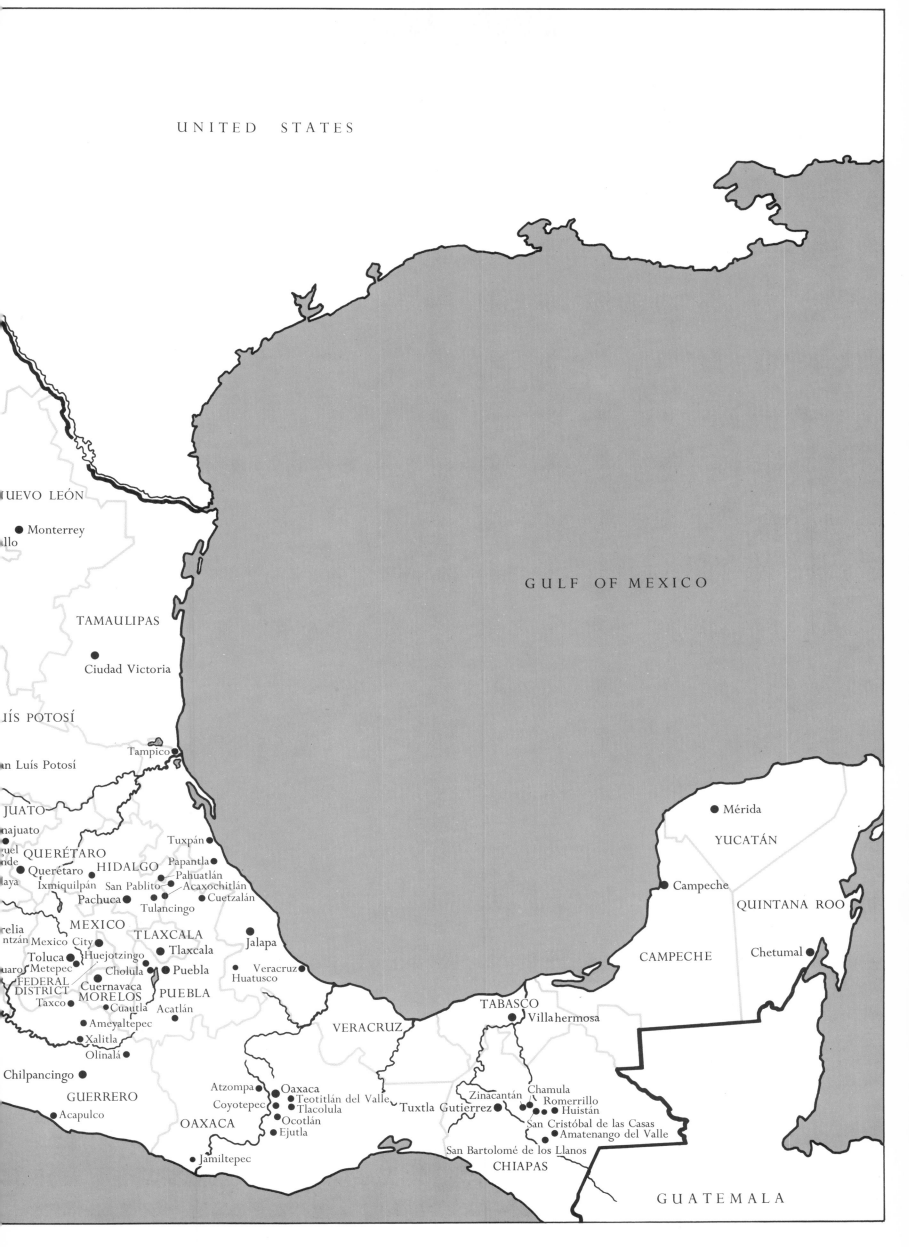

UNITED STATES

UEVO LEÓN

● Monterrey

llo

TAMAULIPAS

● Ciudad Victoria

GULF OF MEXICO

ÍS POTOSÍ

an Luís Potosí

● Tampico

JUATO

najuato

uel

relia

ntzán

uaro

QUERÉTARO

● Querétaro

laya

HIDALGO

Ixmiquilpán

Pachuca ●

Tuxpán ●

Papantla
Pahuatlán
San Pablito ● Acaxochitlán
Cuetzalán
Tulancingo

MÉRIDA ●

YUCATÁN

Campeche ●

QUINTANA ROO

CAMPECHE

Chetumal ●

MEXICO

Mexico City

Toluca ●

Metepec

FEDERAL
DISTRICT

Taxco ●

TLAXCALA

Huejotzingo ● Tlaxcala

Cholula
Cuernavaca ● Puebla

MORELOS

PUEBLA

Cuautla

Acatlán

● Jalapa

Veracruz

Huatusco

VERACRUZ

TABASCO

● Villahermosa

Ameyaltepec

Xalitla

Olinalá

Chilpancingo ●

GUERRERO

● Acapulco

Atzompa
Coyotepec

Oaxaca
Teotitlán del Valle
Tlacolula
Ocotlán
Ejutla

OAXACA

Jamiltepec

Tuxtla Gutierrez ●

Zinacantán

Chamula
Romerrillo
Huistán
San Cristóbal de las Casas
Amatenango del Valle

San Bartolomé de los Llanos

CHIAPAS

GUATEMALA

225

The "weathermark" identifies this English-language edition as a publication of John Weatherhill, Inc., publishers of fine books on Asia and the Pacific. Editor in charge, Charles R. Temple. Book design and typography, Dana Levy. Layout of color plates, Tsutomu Matsumori. Production supervision, Yutaka Shimoji. Composition, General Printing Company, Yokohama. Color platemaking and printing, Inshokan Printing Company, Tokyo. Text and black-and-white photographs, Kinmei Printing Company, Tokyo. Binding, Makoto Binders, Tokyo. The text is set in fourteen-point Perpetua.